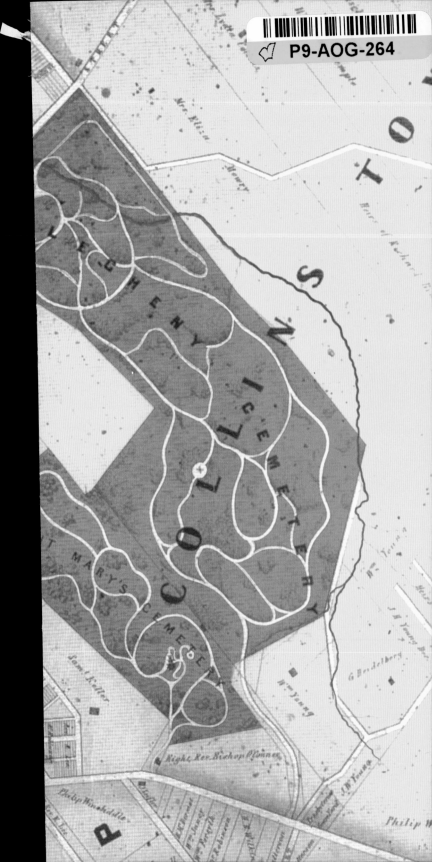

STORIES IN STONE

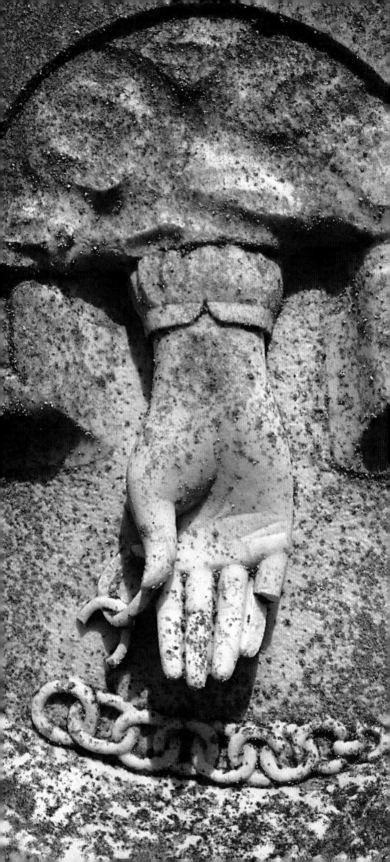

STORIES IN STONE

A Field Guide to
Cemetery Symbolism and Iconography

Written and Photographed by
Douglas Keister

Gibbs Smith, Publisher
Salt Lake City

For Sandy
Wife, Friend, and Boneyard Buddy

Frontispiece:
 "Hand Coming Down,"
 Hills of Eternity Memorial Park,
 Colma, California

08 07 06 05 10 9 8 7 6 5 4 3 2

Text and photographs © 2004 Douglas Keister

Published by
Gibbs Smith, Publisher
P.O. Box 667
Layton, Utah 84041

1.800.748.5439 orders
www.gibbs-smith.com

Designed and produced by J. Scott Knudsen, Park City, Utah
Printed and bound in China

Library of Congress Cataloging-in-Publication Data

Keister, Douglas.
 Stories in stone : a field guide to cemetery symbolism
 and iconography / written and photographed by
 Douglas Keister. — 1st ed.
 p. cm.
 Includes bibliographical references and index.
 ISBN 1-58685-321-X
 1. Sepulchral monuments. 2. Symbolism in art.
 I. Title.
 NB1800 .K45 2004
 731'.549—dc22

 2003020482

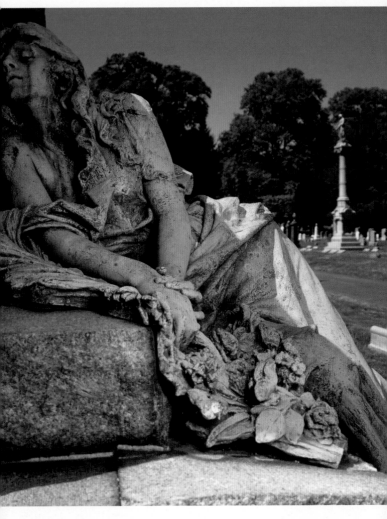

Merello/Volta Monument,
Green-Wood Cemetery,
Brooklyn, New York

PREFACE

Pip, the narrator and central character of Charles Dickens' classic Victorian novel *Great Expectations,* informs us early in the story that, as he never knew his parents or saw any pictures of them, he drew his first impressions of what they must have looked like from the shapes of the lettering on their gravestones. Certainly, as the author intended, this tells us a great deal about Pip's fanciful imagination, but quite incidentally it also reveals a fundamental truth about the nature of grave markers. In a very real sense, memorials erected to the dead are the material representatives of those now departed, and we, like Pip, often draw our impressions of what these persons must have been like from the things we find upon them.

Taken in this manner, we may say that grave markers themselves are symbols, for they meet the most basic definition of a symbol: something that stands for and represents something else. At times, the very shape and positioning of the markers themselves can suggest this correspondence to us. I can recall quite clearly the eerie sensation I felt one moonlit night, standing amidst the silent "congregation" of an eighteenth-century New England churchyard, the clusters of multisized stones with their period-characteristic "heads" (tympanums) and "shoulders" (capitals) giving the strange impression that one was surrounded by a community of souls who straddled the boundaries between life and death, between past and present.

But, as if that were not enough, gravestones and other memorials to the dead, symbolic themselves of the generalized humanity of the departed, very often display upon their surfaces a variety of other emblematic devices that point to more specific elements associated with the commemorated individuals themselves. Verbal inscriptions such as epitaphs may account for part (and, in some cases, all) of this process of individualization, but a great deal of it is accomplished through the use of an elaborate vocabulary of visual symbols, the subject of this remarkably detailed and enlightened volume by Douglas Keister.

Visual symbolism on grave markers has been present as long as such memorials have existed, and the process remains vital and ongoing in our own time. In America, as elsewhere, it is possible to read in broad terms the great shifts in cultural values that have occurred over the course of time by closely examining the changing nature of these carved, sculpted, and engraved images. In the seventeenth and early eighteenth centuries, a preoccupation with mortality resulted in a proliferation of emblems that suggested the imminence of death and the tenuous uncertain nature of life itself. The visitor to these early graveyards encounters seemingly endless variations on the basic symbolic representations of these predominant cultural messages meant to continuously remind us of our impending end (skulls, skeletons, coffins, scythes, spent hourglasses). Only rarely do life-oriented images appear, sculpted portraits, perhaps, or indicators of highly valued professional status (ministers, sea captains, military figures).

As attitudes softened over the next several centuries, harsh mortality symbolism began to give way to a gentler form of mourning imagery (draped urns, weeping willows, clasped hands, floral arrangements) and, even more tellingly, a variety of visual symbols suggesting resurrection and everlasting life (winged cherubs, upward-pointing fingers, heavenly gates). During this same time period, children's markers began to receive their own special symbolic devices (lambs, doves, broken rose stems), and the tendency to seek ways in which to visually indicate occupational, social, and professional associations was evermore in evidence.

These days, indicators of mortality have all but disappeared. While prospective imagery suggesting the life to come may still be found, it has most definitely taken a backseat to the astounding number and variety of highly personalized retrospective symbols referencing occupational and recreational pursuits that are, in many ways, the most distinguishing features of contemporary grave markers.

Seeking out and interpreting more than four centuries worth of American mortuary symbolism is indeed a challenge, but without question it is also one of the most powerful factors that underlies the

intense fascination many of us have with our nation's burial places. Here, within these outdoor repositories of art and history, we ponder the beauty and the meaning of the many ways our ancestors and contemporaries have found to express the values and fundamental truths that have marked them both as individuals and as members of a collective society. Sometimes there can be little doubt as to what a given symbol is communicating to us—who would question, for instance, the self-evident meaning of a finger pointing upwards toward heaven—but in other situations we may find ourselves puzzled by images that are obscure or ambiguous. Gravestone scholars have been known to disagree about the interpretation of a particular symbol, and this should not be surprising, as it is in the nature of symbolic expression not only to sometimes change over time but also in certain instances to have entirely different meanings for different people. As frustrating as this may prove to some, especially those with an obsessive need for closure, it has always seemed to me one of the very things that makes the cemetery such a fascinating place. All significant art, as the poet John Keats once observed, "doth tease us out of thought," from which derives no small amount of the pleasure we feel when encountering it. Still, as we all surely know, if we want to fully appreciate the territory we are exploring, it greatly helps to have a good map, and this we now have for the first time, thanks to the author. Enjoy the journey!

Richard E. Meyer
Editor, *Markers: Journal of the Association for Gravestone Studies*
Salem, Oregon
November 2003

INTRODUCTION

In 1887, one Dr. L. L. Zamenhof created a language called Esperanto. His goal was to develop an international language that would enable better communication and understanding between cultures and nations, hopefully resulting in a more peaceful world. Although Esperanto still has a number of followers, it never really caught on in a big way.

But we still have an international language, and it's one that has been with us from the beginning of recorded history—the language of symbols. Our everyday life is full of symbols. We see many of them when we are driving: arrows point us in the right direction, upside-down pyramids tell us of a slow-moving vehicle, and octagons tell us to stop. There are also the multitude of business symbols we encounter in everyday life. Whether you are in Moscow or Muncie, a stylized M representing a pair of golden arches tells you where Big Macs are to be found. Another trademark, a stylized check mark called a *swoosh*, tells you its owner is wearing a Nike product. Want to buy an Apple computer? Look for a polychrome apple with a bite taken out. Want to trade your television for some cash? Look for a storefront displaying three balls, the symbol for a pawnshop.

Sometimes, the meanings of symbols change over time. The familiar cross known as the *swastika* in India, the *fylfot* in England, the *cramponnee* in France, the *gammadion* in Greece, the *wan* in China, and the *Hakenkreuz* in Germany is one of humankind's oldest symbols and has been used by many cultures. Its various forms often represented the highest attainment possible in both spiritual and worldly pursuits. Unfortunately, the swastika was also used by power-hungry rulers such as Charlemagne and Hitler and is now associated with evil. But, the meaning of most symbols has remained fairly steady through the centuries: crosses for Christians, six-pointed stars for Jews, the yin-yang symbol for Buddhists, and hearts speak of love, lambs of innocence, and circles of completeness and immortality.

Nowhere is the language of symbols more apparent than in cemeteries, which are virtual encyclopedias of symbolism. Dead men may tell no tales, but their tombstones do. Besides informing us of names and dates of birth and death, tombstone symbols often tell us a person's religion, ethnicity, social membership, occupation, and thoughts on the afterlife. Companies like the Monumental Bronze Company of Bridgeport, Connecticut, distributed catalogs that were jam-packed with symbols that could be purchased as removable inserts for their zinc, or "white bronze," tombstones. These tombstones were not unlike modern-day modular cabinets: the arrangement and selection of the tombstone and panels resulted in thousands of possible combinations. Thus, a tombstone could be custom-made with little effort to suit the needs of the deceased and their families. And should additions, changes, or deletions need to be made at a later date, it was simply done by unscrewing a panel.

With the advent of power tools and laser cutting devices, there has been a resurgence of decorated tombstones in recent years. This new type of symbol is a literal symbol, perhaps depicting a favorite vehicle such as a tractor or semi-truck, or sports equipment like golf clubs, tennis racquets, or bowling pins. The decorations are limited only by one's imagination and budget.

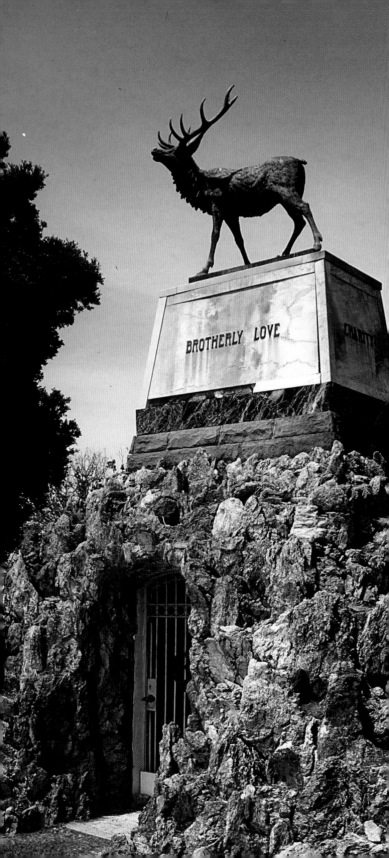

Mausoleums
Chapels
Offices

CEMETERY enthusiasts know that cemeteries are a vast treasure trove of art and architecture. The fact is, cemeteries are America's most unspoiled resource of historic architecture. It would take many hours of strolling in a city's downtown historic district to find the number of styles of architecture that one can find in a few minutes' walk in most large historic cemeteries.

Most cemetery architecture is a mirror of the urban architecture of the time. Gothic cathedrals, Classical Revival city halls, Art Deco theaters, and rustic cast-iron garden furniture can all find their counterpart in the cemetery. And there are some styles of architecture that can be found only in cemeteries; we'll call this architecture "uniquely funerary."

Up until the Reformation in the sixteenth century, most cemeteries consisted primarily of randomly placed headstones. Wealthy folks purchased their way into being buried within the walls and floors of their church. But a series of edicts and a slowdown of church construction during the Reformation essentially put an end to burial within the church. Moneyed types started looking outside the walls of the church to erect a suitable memorial to themselves and their families. Elaborate statuary, tombs, and monuments slowly began to find their way into formerly stark churchyards and city cemeteries. When garden cemeteries with vast landscaped expanses began to be developed in the early nineteenth century, they became a new architectural frontier for America's architects, artists, designers, and builders.

Although it's hard to put all cemetery architecture in specific categories, most American cemetery architecture can be divided into six broad groups: ancient pagan architecture, such as the tumulus; Egyptian architecture; Classical architecture; Gothic architecture; late-nineteenth- and early-twentieth-century architecture, such as Art Nouveau, Art Deco and modern classicism; and uniquely funerary architecture.

Mountain View Cemetery, Oakland, California

This columbarium (vaults lined with recesses for cinerary urns) in the form of a grotto (a cave-like structure) is the centerpiece of the Elks plot.

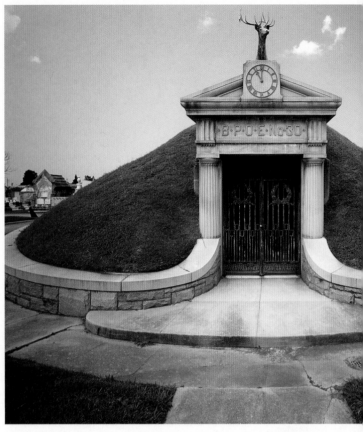

The Tumulus

The tumulus is one of mankind's oldest burial monuments, dating back to 4,000 to 5,000 years B.C. Examples of tumuli can be seen peppering the landscape all over Western Europe. The foundation of most ancient tumulus-style monuments are assemblages of large rocks, known as megaliths. These rock megaliths are not unlike Stonehenge, but are smaller in scale. A megalith is transformed into a tumulus with the addition of rubble or earth to form a large, imposing mound. At one time, many megaliths seen today were tumuli. Time and erosion have worn away their earth and rubble coverings to reveal their megalithic foundations.

Many large cemeteries will have a tumulus or two. When found in modern American cemeteries, they are often used for members of fraternal societies or military organizations because of their association with warriors. But there are some notable exceptions, like the Mayer family tomb in Kensico Cemetery, Westchester County,

Greenwood Cemetery, New Orleans, Louisiana

The tumulus had its beginnings more than 7,000 years ago as a burial monument for ancient warriors. This tumulus holds the remains of fallen members of the Elks in New Orleans.

New York. The tomb is actually *in the form of* a tumulus since it is made of stone that is carved to look like a cross between a tumulus and a cave. There are also a number of rock assemblages in cemeteries (often containing cremains of the members of a fraternal society) that are built in the spirit of the tumulus. These tumulus-like monuments are akin to grottoes, which are miniature cave-like chapels containing small altars and religious statuary. Grottoes are often seen in areas with a large rural Catholic population.

Egyptian Architecture

While it's debatable if the tumulus can really be called architecture, another tomb style of antiquity, Egyptian, is perhaps the most funerary of all architecture. After all, almost all architecture in ancient Egypt had something to do with death and the afterlife.

American cemeteries have often had a schizophrenic attitude toward Egyptian Revival architecture. While there is no denying that Egyptian Revival architecture is jam-packed with funerary symbolism, its obvious pagan origins have made many a cemetery superintendent bristle at the reaction he might get from the local churchgoing community. Cemetery explorers will find fewer and fewer examples of Egyptian Revival architecture the closer they get to the Bible Belt.

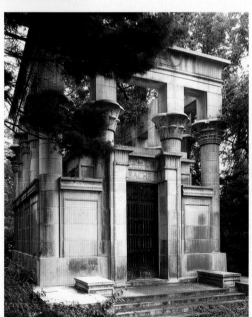

Woodlawn Cemetery, Bronx, New York

The Bache mausoleum is a replica of the Kiosk of Trajan, located east of the Temple of Isis on the Nile River in Egypt. The mausoleum is bursting with symbolism: lily-topped columns for the unfolding of life, vulture wings for maternal care, twin cobras for death, and papyrus leaves for knowledge and rebirth.

When Cincinnati businessman David Lawler erected a sphinx on his family's plot in Spring Grove Cemetery in 1850, one of the directors on Spring Grove's board objected, declaring that "the monument's heathen symbolism was offensive in a Christian nation."

Egyptian Revival architecture is the easiest architecture to identify, pyramids being the most obvious. Almost every Egyptian Revival tomb is adorned with a pair of vulture wings sprouting from a circle (symbolizing the sun) and flanked by twin cobras (symbolizing death). Often a pair of male sphinxes (female sphinxes are Greek) guard the entry to the tomb. Above the entry, usually circling the entire tomb, is an architectural element called a cavetto cornice (flared with curve). Other hallmarks of Egyptian Revival architecture are the tapered (battered) entry and hieroglyphics. Since Egyptian architecture doesn't make use of the strength of arches or tapering columns, its dimensions are quite massive. To provide strength, the walls of the Egyptian temple-style mausoleums taper in at about 70 degrees.

Another very popular form of Egyptian architecture in the cemetery is the obelisk, which is representative of a ray of sunlight. Obelisks were first seen in Egypt during the time of the Old Kingdom, approximately 2650–2134 B.C. The earliest excavation of an obelisk, dated around 2500 B.C., is at Abu Ghurob. It was a massive, fairly squat pyramidal structure set upon a high plinth and was the focal point of the sun temple. During the time of the Middle Kingdom, approximately 2040–1640 B.C., obelisks made of single slabs of Aswan granite became much taller and slimmer. They were typically erected in pairs in front of selected temples as part of a celebration of a Royal Jubilee. The sides of the obelisk were often inscribed, and the pyramidal top was sheathed in gold to radiate the light of the sun.

To appease the religious community, most designers of Egyptian Revival tombs have added selected Christian symbols in front of or on the tomb to soften the pagan demeanor. Quite often, angels, Jesus, and the Virgin Mary will be found guarding the entrance to these tombs.

Classical Architecture

The most common type of cemetery architecture is Classical Revival. It is easy to identify by its columns and column capitals, which are classified into "orders," generally recognized as Doric, Tuscan, Ionic, Corinthian, and Composite. Doric and Tuscan architecture developed about the same time, but most scholars think that Doric, despite having more ornamentation, emerged first.

Doric architecture can be divided into Grecian Doric and Roman Doric. The best known Doric building is the Parthenon, built in Athens around 450 B.C. Doric architecture is identified by its tapering, fluted columns that rise directly from the base (stylobate) and are crowned by plain capitals. Roman Doric columns are also fluted and crowned by plain capitals but have a base.

Tuscan architecture is a stripped-down form of Doric architecture. The columns on a Tuscan building are smooth, with a notable absence of ornamentation.

Ionic architecture, which was developed around 600 B.C., is

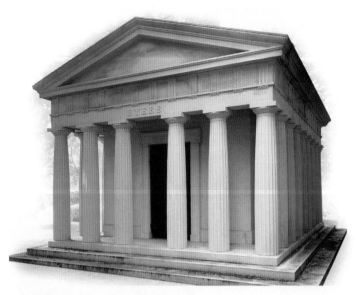

Allegheny Cemetery, Pittsburgh, Pennsylvania

The Byers mausoleum is modeled on the Greek Parthenon. Like the Parthenon, the mausoleum is ringed by Greek Doric columns.

characterized by relatively slender fluted columns that have a molded base. The column capitals are surmounted by a volute (a spiral, scroll-shaped ornament). Architects assign more feminine characteristics to the Ionic form. When writing about his design of the Manger mausoleum in Woodlawn Cemetery, Bronx, New York, architect Franklin Naylor wrote in flowery prose: "Ionic columns are used in the portico, as they are feminine in character, architecturally speaking; the volutes in the capitals represent the curls in the hair of the sex. It [the Ionic form] is also repeated in the pediment overhead, right below the statue. On account of making this entrance entirely feminine, it is very appropriate, since man can only enter the portal of death by being born of woman."

The most ornamental of all of the orders is Corinthian and its hybrid cousin, Composite. The Corinthian order was an Athenian invention from around 500 B.C., but it was developed into its full ornamentation by the Romans. In pure examples of Corinthian columns, the column capitals are carved representations of leaves of the acanthus, one of the plants most often associated with funerary architecture. Its leaves represent overcoming the trials of life and death. Caught up in the allusions to nature in the Corinthian capitals, designers and carvers often added chirping birds, flowers, ferns, and other assorted flora and fauna to the acanthus leaves. When Ionic volutes are added to the design, the capitals officially cross the line from Corinthian to Composite.

Islamic Architecture

Islam originated with the prophet Mohammed, who lived from A.D. 570–632. During the next few centuries Islamic architecture developed gradually. The style has never really died out and variations of it continue to be used to this day. Developed in Arabia, the architecture spread to North Africa, Spain, India, and much of the rest of Asia. Even though there was not a very large Islamic population when many of America's large mausoleums were built, many fine examples can be found in our cemeteries. Look for onion domes, horseshoe arches, and surfaces adorned with mosaics, carvings, and inlays.

Byzantine Architecture

Byzantine architecture, which shares many characteristics with Islamic, developed after Constantine established his imperial capital at Byzantium (now Istanbul, Turkey) in A.D. 330. Since they are Christian, Byzantine churches have a Greek cross as a floor plan. The most famous is the Hagia Sophia, built in what is now Istanbul in A.D. 532–537, which is now a mosque. Byzantine architecture usually has flat, lacy ornamentation, typically with some sort of a dome. Interiors of mausoleums often have elaborate mosaic tile murals.

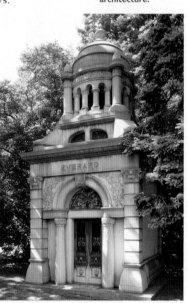

Romanesque Architecture

A few centuries after Byzantine architecture was developed, Romanesque architecture appeared. It is most widely characterized by rounded arches and intricately carved, but judiciously used, ornament, which is primarily used on column capitals, around doors and windows, and on moldings. Near the end of the nineteenth century, American architect Henry Hobson Richardson modified the Romanesque form by using rough rather than smooth stones. This "rusticated" Romanesque architecture, now called Richardsonian Romanesque, has a heavy, authoritative look. It was widely used in buildings that demanded respect, such

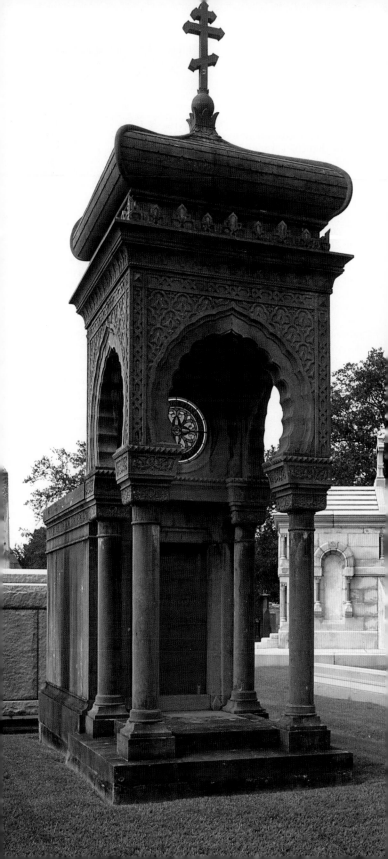

as courthouses, schools, churches, and mausoleums.

Architects of the Middle Ages used the Romanesque forms to build massive cathedrals, but the physical limitations inherent to this style meant that the cathedrals could only be built so large. Eventually, architects developed the pointed arch and ribbed vaults that led to the birth of the Gothic style in France in the twelfth century.

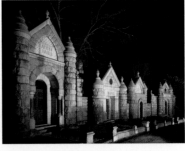

Mountain View Cemetery, Oakland, California

Gothic Architecture

Perhaps no style of architecture is so closely associated with cemeteries as Gothic. Its towers, spires, and flying buttresses are the stuff of ghost stories, dark and stormy nights, and evil sorcerers. The structural advantages of the Gothic style over other types of architecture enabled architects and designers to construct buildings and cathedrals of just about any size their time and budgets would permit. Because Gothic architecture did not borrow heavily from any of the pagan Classical styles, it is most closely associated with Christianity. It is, in fact, the first purely Christian architecture.

Romanesque architecture first emerged around the eighth century. Near the end of the nineteenth century, American architect Henry Hobson Richardson incorporated rusticated surfaces with Romanesque architecture, which came to be known as "Richardsonian Romanesque."

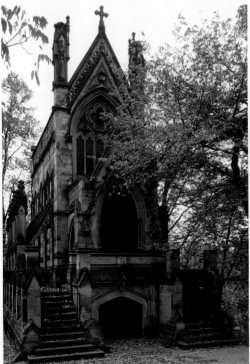

Spring Grove Cemetery, Cincinnati, Ohio

It took four years (1865–1869) for Cincinnati architect James Keyes Wilson to design this Gothic Revival combination chapel and mausoleum for the Dexter brothers, with the chapel above and the crypts below. Although the Dexter brothers wanted a structure that was reminiscent of Sainte Chapelle in Paris, Wilson may also have been inspired by Chichester Cathedral in England.

Gothic architecture is easy to identify by its vertical emphasis, pointed arches, and heavily ornamented spires.

Gothic architecture was not without its critics. In fact, the term *Gothic* was actually a derisive term uttered by the Italian architects who were developing a new style of their own: Italian Renaissance. When viewing the massive cathedrals that the French were building, the Italians were said to exclaim that the cathedrals were so ugly, only a Goth could possibly have built them; hence the term *Gothic*.

Funerary architecture in the Gothic style was much more widely used in the nineteenth century than it is now, simply because of the significantly higher prices to manufacture a heavily ornamented Gothic Revival monument or mausoleum. Another persistent problem is that the Gothic ornament can become a maintenance nightmare. The cracks, joints, and attachments are a magnet for ivy, nesting animals, and moisture. It is rare indeed to see a Gothic structure more than a few decades old that doesn't have some sort of ongoing structural maintenance problems.

Italian Renaissance Architecture

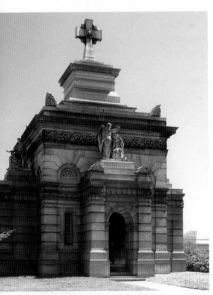

Green-Wood Cemetery, Brooklyn, New York

The Mackay mausoleum is one of the finest examples of Renaissance Revival architecture in America's cemeteries.

While the Italians were criticizing Gothic architecture, they were developing a new style of their own during the fifteenth century. Advocating a return to the Classical styles, they blended Corinthian and Ionic columns, Classic forms, and some of the ornamental styles that were popular at the time to invent Italian Renaissance architecture. This new style rapidly took hold and soon spread all over Europe, taking on regional names and mutating to other styles, such as German Renaissance and French Renaissance. It is important to note that, unlike today, art and architecture were considered to be essentially the same science. Famous artists like Michelangelo were also trained architects. When they designed the structural elements of a building, paintings and sculpture would be included in the overall design. Italian Renaissance architecture

was one of the highest achievements in blending art and architecture. Renaissance-style mausoleums and funerary architecture can be identified by their Classical forms and an abundance of ornament. Some of the most elegant mausoleums in America are in the Renaissance Revival style.

Spring Grove Cemetery, Cincinnati, Ohio

Baroque architecture, as seen here in the Burnet mausoleum/vault, is known for its fluid form and profusion of ornament.

Baroque Architecture

By the end of the sixteenth century, Renaissance architecture gave way to Baroque architecture, which reached its zenith in the late seventeenth century and was most widely used in Germany, Spain, and Italy. The most extreme examples of the Baroque style have a bounty of ornamentation nestled in flowing forms. More restrained examples of the Baroque style such as St. Paul's, Christopher Wren's London masterpiece, were employed by French and British architects. Baroque architecture in the cemetery is sometimes hard to identify; some examples lean toward Renaissance architecture, while others lean toward Neoclassical architecture. Look for mausoleums with an abundance of curves and decoration.

Neoclassical Architecture

By the beginning of the eighteenth century, Western architecture entered a period that is best described as eclectic. The dominant architectural styles relied on the classical forms of the past, and are thus termed Neoclassical. But architects of the time often incorporated elements of other Classical-like styles of architecture. By the nineteenth century, Neoclassicism was the dominant form. This time period also coincided with the development of the garden cemetery, and cemetery explorers will find a profusion of Neoclassical architecture there. Most funerary architecture in this style is characterized by clean, elegant lines and restrained ornament. By the end of the nineteenth century, the blending of different Classical Revival styles of architecture resulted in a style of architecture known as Beaux-Arts.

Facing: Cimitero Monumentale, Milan, Italy

The Pierd'Houy family mausoleum is, according to the guidebook, "one of the most extravagantly fanciful marriages of architecture and sculpture, utterly unclassifiable from a stylistic point of view." Contrary to the dictates of modern architecture, the mausoleum is certainly a triumph of form over function.

Uniquely Funerary Hybrid Architecture

Not all architecture fits into the customary architectural styles. Architects often blended totally unrelated styles and sometimes created styles of their own. At the end of the nineteenth century, modern architecture was making its first beginning, but not before an architectural free-for-all known as Eclecticism burst upon the scene. Nowhere is this architectural grab bag more apparent than in the cemetery. Indeed, many mausoleums and funerary structures are a triumph of form over function. The closest type of architecture that these whimsical structures can be compared to are the "follies" of Victorian architecture. A folly is defined by Penguin's *Dictionary of Architecture* as "a costly, but useless structure built to satisfy the whim of some eccentric and thought to show his folly."

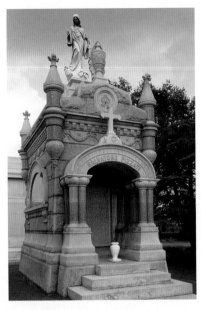

Above:
Metairie Cemetery, New Orleans, Louisiana

It appears as if the designer of the uniquely funerary Pizzati mausoleum ordered one of everything from a mausoleum supply catalog: blind windows, an angel, a draped urn, an alpha/omega emblem, medieval turrets, garlands, stars, and a cross. All envelop the remains of Salvatore Pizzati, who is spending eternity inside his mausoleum with his favorite rocking chair.

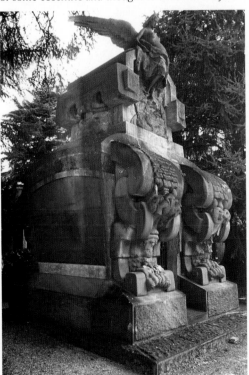

Art Nouveau Architecture

Emerging at the end of the nineteenth century from this architectural morass was Art Nouveau. The style had a relatively short run on the scale of world architectural history. The best examples of Art Nouveau, which is described as naturalistic and organic, can be found in European cities such as Paris and Prague, where it is sometimes known as the Liberty style. But it is quite easy to find examples of it in historic cemeteries, since its popularity was in the heyday of the golden age of the mausoleum. At the time, American funerary architects classified almost anything that had a natural look to it as Art Nouveau. The most extreme examples look like a tomb made of rough-cut stone.

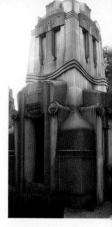

Cimitero Monumentale, Milan, Italy

The Pinardi mausoleum is a fabulous example of Art Nouveau, known in Italy as Liberty style. The softening of the corners, the undulating forms, and the sense that all of the elements flow together are hallmarks of the style.

Modern Classicism Architecture

Just as Art Nouveau was gaining a foothold, influential architects advocated a return to Classical architecture. Various forms of Classical Revival architecture exist to this day. Some types almost exactly mirror their two-millennium-old cousins, but most are sleeker, more stripped down. In the cemetery, look for buildings that appear to be scaled-back versions of Classical architecture. There is an absence or a spartan use of ornament. Columns are modestly scaled or engaged (attached to the structure).

Art Deco Architecture

The *Exposition Internationale des Arts Decoratifs et Industriels Modernes,* held in Paris in 1925 as a showcase for "new inspiration and real originality," formally introduced a new architectural and decorative style called Art Deco. This style would soon permeate designs in fabrics, automobiles, appliances, office buildings, and even mausoleums. Architects used a combination of Art Deco and International Style for many mausoleums built in the 1930s.

One of the best places to see intact Art Deco buildings is in Miami Beach, Florida. Art Deco was also wildly popular in Chicago, where

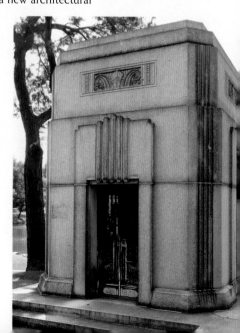

examples can be seen in some of the city's ceme-
teries. Look for mausoleums that have a stream-
lined look, not the severe lines we associate with
modern architecture, but the softer lines we think
of when we think of an appliance, such as a
toaster in a 1930s kitchen.

Modern Architecture

With the modern age has come a lack of orna-
ment and hard, clean lines. By now, the age of
ornament has passed (although, from time to
time, a few adventurous architects advocate its
return). The range of modern architecture extends
from tilt-up concrete buildings, to massive glass,
steel, and stone structures that look like they
belong on a *Star Wars* set. In the cemetery some

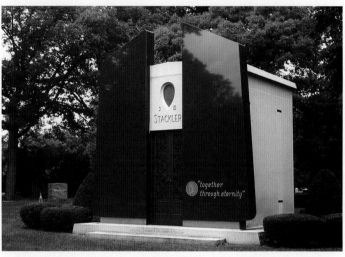

of these structures are very utilitarian looking
while others seem to be ready to blast off from
Earth. Modern manufacturing techniques have
made it fairly easy to build mausoleums that are
just about any shape, enabling architects to
design some pretty far-out-looking structures.
With the assistance of lasers, elaborate designs
can be etched into the surfaces, but there is usu-
ally an absence of external ornament since there
are few craftspeople today who can execute such
fine work.

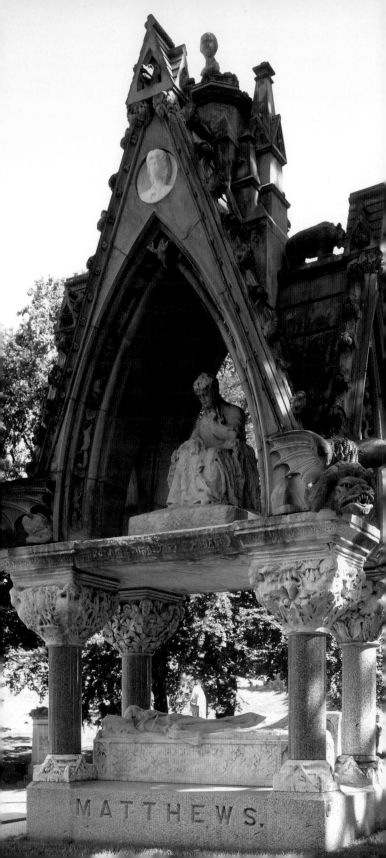

TOMBS SCULPTURES MEMORIALS

Despite the fact that noted art critic Effie Brower found it "depraved," the Matthews monument won an award for mortuary art in 1870. It's in the form of a catafalque, or *castra doloris*, a type of tomb usually reserved for royalty. Catafalques are generally quite elaborate, full of symbolism and depictions of events of the departed's life.

John Matthews (1808–1870) was known as the "soda fountain king" for his popularization of the soda fountain. By the time he died, he owned over 500 soda fountains. On his catafalque are the faces of his daughters (in the gables) and his wife (seated above him). Prostrate and almost melting into his sarcophagus, Matthews looks up at reliefs carved into the column capitals that depict events in his life—leaving England for America, pondering the idea of soda water, and finally being crowned for his achievements.

CEMETERY architecture isn't limited to mausoleums, chapels, and offices. Some of the finest work of renowned American artists and architects can be seen in the form of cemetery tombs, sculptures, and memorials.

THE SARCOPHAGUS

Besides mausoleums, the most abundant forms of architecture in the cemetery are the various interpretations of one of the oldest funerary monuments—the sarcophagus. The word *sarcophagus* is derived from combining the Greek words *sarco* (flesh) and *phagus* (eater), literally "a flesh-eater," since the earliest types of these burial vessels, according to ancient scholars Pliny and Theophrastus, were made out of Assius stone from Assos in Asia Minor. Because of its caustic properties, this stone reduced the body to bone in a matter of weeks. In reality, most ancient sarcophagi were used to preserve bodies rather than dissolve them, but the term stuck.

The purest forms of the sarcophagus actually contain bodies. They can be found in many of the church entombments in European cathedrals. The earthly remains of many a king or queen rest in an elegantly carved marble sarcophagus. Often, it is part of a larger tomb known as a catafalque. The centerpiece of the catafalque is the sarcophagus of the departed royal. On top of the sarcophagus are often sculptural representations of the occupant in his or her death throes. On a platform crowning the catafalque are romantic representations of the person after having risen to the heavens. Other surfaces of the catafalque are often emblazoned with scenes of the person's life.

Because of the relatively small size of a sarcophagus (as compared to monuments and mausoleums)

it is quite easy to place it in locations other than the cemetery. One of the most famous modern sarcophagi is Napoleon's, which resides in the Hotel des Invalides in Paris.

Napoleon Bonaparte died on May 5, 1821, on the island of St. Helena, exiled from his native France. According to his last testament, "I desire that my ashes should rest on the banks of the Seine, amid the French people whom I have so loved." Alas, Napoleon was buried in a grave covered with an unmarked slab in a secluded spot on St. Helena.

But twenty years later, after the political winds had changed, Napoleon's remains were disinterred and brought back to France. Architect Louis Tullius Joachim Visconti's design was chosen for a crypt to be constructed beneath the dome of the Invalides in Paris. The sarcophagus, designed by M. de Montferrand and modeled on the ancient Roman sarcophagus of Scipio that resides in the Vatican, was placed at the center of the crypt. The sarcophagus was a gift from a Russian czar. The 36-foot-diameter crypt is ringed by statues

Albany Rural Cemetery, Menands, New York

The sarcophagus of President Chester A. Arthur was modeled after Napoleon's sarcophagus.

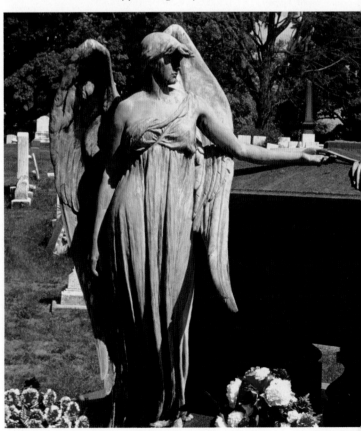

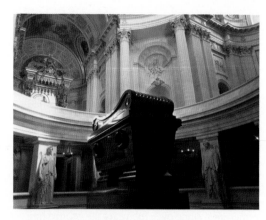

Les Invalides, Paris, France

Napoleon's body rests in six coffins inside each other, all enclosed in a sarcophagus made of red Finland porphyry, modeled on the ancient Roman sarcophagus of Scipio.

and contains two bas-reliefs of the Prince de Joinville, who helped negotiate the return of Napoleon's remains to France: in one, he is observing the exhumation of Napoleon's coffin in St. Helena; and in the other, he is entrusting Napoleon's coffin to Louis-Philippe. The floor of the crypt contains mosaic pavement inscribed with Napoleon's greatest battles.

Napoleon's body spent the next twenty years in the St. Jerome Chapel as work on the crypt progressed. The sarcophagus, made of red Finland porphyry, rests on a pedestal of green Vosges granite. The only decorations on the sarcophagus are four engaged wreath handles and large volutes at the ends of the lid. On April 2, 1861, Napoleon's remains were placed inside the sarcophagus. Curiously, Napoleon rests inside six coffins placed inside each other. The first coffin is tin plate, the next mahogany, then two of lead, one of ebony, and, finally, one of oak. The whole pedestal and sarcophagus assembly is $14\frac{1}{2}$ feet high, 13 feet long, and $6\frac{1}{2}$ feet wide, and weighs sixty-seven tons.

The Meyer memorial, a scaled-down replica of Napoleon's sarcophagus, can be seen in Albany Rural Cemetery, Menands, New York. Also at the same cemetery is President Chester A. Arthur's memorial, which is an adaptation of Napoleon's sarcophagus.

THE SARCOPHAGUS IN CEMETERIES

In its simplest and most utilitarian form, the sarcophagus is a container for the body, but unlike a coffin or casket, it is designed to (more or less) last for eternity. It is rare to find a sarcophagus in a cemetery that actually contains a body, because most are ornamental; the body is usually buried in a vault beneath the sarcophagus. Whether the sarcophagus contains a body or not, it looks like it could contain a body.

One of the most popular styles of the sarcophagus is made out of bronze and looks like a heavily decorated claw-foot bathtub with a cover. This particular style of sarcophagus is easy to spot in cemeteries, since over the years the bronze has developed a streaky green-and-black patina that contrasts with the granite and marble tombs in the rest of the cemetery. Just as mausoleum manufacturers have a few basic models for mausoleums, manufacturers of the bronze sarcophagus had a basic model that could be customized to suit the buyer's wishes. In addition to the occupant's name, all manner of symbols, including flora, fauna, and decorative flourishes, could be applied to the surface of the sarcophagus.

Most sarcophagi in cemeteries are made of stone, and stone carvers have adapted the sarcophagus as a ready canvas to showcase their talent. Indeed, aside from its need to look like it could house a body, the sarcophagus is really a piece of sculpture. Much of what is included in the broad description of sarcophagi has actually evolved into other forms, and sometimes it's hard to say where the line is between a sarcophagus and an ornamental tomb. Nevertheless, we are including a fairly broad sweep of what a sarcophagus-like tomb is.

Sarcophagus Tomb

If you didn't know better, you'd think this type of tomb contains a body. The key to this tomb is that it usually has legs or representations of legs. If it doesn't have legs, it might have a rounded or tapered base.

Facing, upper:
North Laurel Grove Cemetery, Savannah, Georgia

The tomb of Louisa Frederica Gilmer is made of classic white marble with claw-foot legs. Louisa's husband was Major General Jeremy Francis Gilmer, Chief of the Engineer Corps of the Confederate States of America.

Facing, middle:
Mount Auburn Cemetery, Cambridge, Massachusetts

Docents at this cemetery say that the tomb of Paran Stevens resembles an elegant soup tureen. Stevens was involved in merchandising, manufacturing, and stock speculation. Eventually he took charge of the Revere House Hotel in Boston. So adept was Stevens at the hotel business that one writer commented, "He made hotel-keeping a science."

Vatican Museums, Vatican City, Italy

The tomb of Consul Lucius Cornelius Scipio, son of Barbatus, dates from 300 B.C.

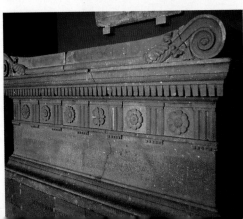

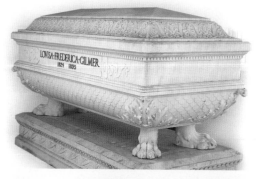

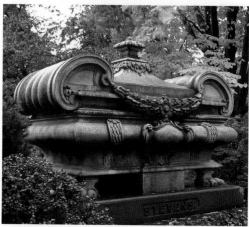

The Warner monument, centerpiece of the Warner plot in the Laurel Hill Cemetery, is one of the most curious pieces of funerary sculpture in the United States. It was carved by Alexander Milne Calder, who also did the carving on Philadelphia's city hall. Calder carved a depiction of a slightly larger-than-life-size female lifting the lid from the sarcophagus/coffin of William Warner (1780–1855) so his soul could be released to the heavens.

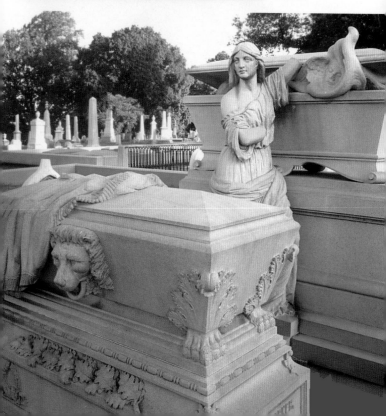

Chest Tomb

A chest tomb is the most unencumbered type of sarcophagus-like tomb. It looks like a large trunk or shipping container. The ornament on the tomb looks like it is worked into the tomb rather than applied to it.

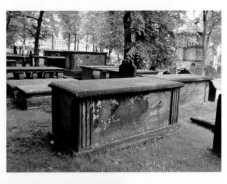

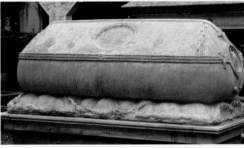

Above:
Chest Tomb,
*St. Paul's Cemetery,
Halifax, Nova Scotia,
Canada*

Left:
*Altar Tomb,
modified,
English Cemetery,
Florence, Italy*

Altar Tomb

When a chest tomb becomes more ornate and looks like ornament is applied to it, especially on the top, it becomes an altar tomb.

Below:
*Altar Tomb,
Brompton Cemetery,
London, England*

Barrel Tomb

These tombs are rounded on the top. The curved top sometimes extends all the way to the ground.

Bale Tomb

A hybrid marriage between a barrel tomb and a chest tomb, this tomb looks like a chest tomb with a rounded top. Some say the rounded top, usually carved with diagonal grooves, is called a bale because it resembles a bale of wool, while others

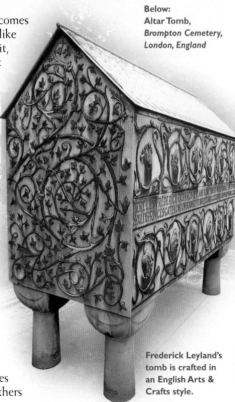

Frederick Leyland's tomb is crafted in an English Arts & Crafts style.

say that the texture of the grooves is meant to resemble the rumpled cloth of a woolen shroud. (In seventeenth-century England, an act was passed dictating that everyone who died was to be wrapped in a woolen shroud.)

Hip Tomb

This tomb takes on the form of a miniature low-slung house. At its simplest, a hip tomb is a rectangular box with a two- or four-sided hip roof applied to the top. Sometimes only the hipped roof is used and the tomb looks like a house with the sides removed.

Hip Tomb,
English Cemetery,
Florence, Italy

Table Tomb

These tombs look like stone tables, usually a stone tablet inscribed with the departed's name, typically supported by six legs. If the stone top is thin, it often becomes bowed, warped, or broken over time. Sometimes a sarcophagus is placed under the table top and a number of legs are added to produce a cage-like effect.

Below:
Table Tomb,
Truro Cemetery,
Truro, Nova Scotia,
Canada

Because the flat top takes a beating from the weather, inscriptions on these tombs are often very difficult to read.

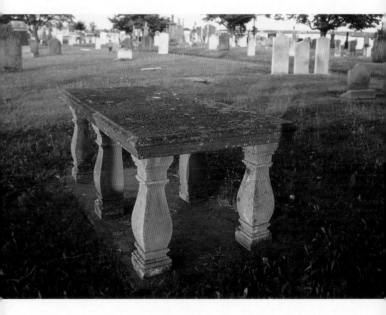

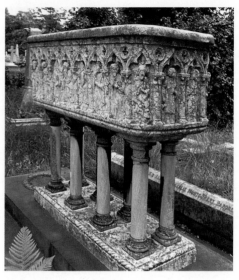

Left:
Pedestal Tomb,
*Brompton Cemetery,
London, England*

The tomb adorning
the graves of
Florence and
Valentine Prinsep
is actually a planter
box with eight legs.
Decorating the tomb
is a fifteenth-century
font depicting the
apostles that
Valentine brought
from Siena, Italy, to
decorate the grave.

Pedestal Tomb

To give sarcophagus-like tombs a more imposing
look, designers place them on pedestals. The
pedestal tomb also may sport an array of attach-
ments such as urns, draped urns, crosses, and
obelisks. Angels and female figures, often depict-
ing one of the virtues, can be found leaning or
standing around the tomb.

Body Stone

Rare in America, but occasionally seen in Europe,
the body tomb looks like a stone mummy resting
directly on the ground.

Coffin Tomb

This tomb is the same as a body stone, but is in
the form of a diamond-shaped coffin.

Hogback Tomb

Also a low-slung tomb, it looks like a long two-
sided roof, raised a bit in the center (spine). It is
frequently adorned with carvings to resemble
ropes or braids.

Mort Safe

Most folks think that the term *body snatcher* has
more to do with folklore than any large-scale
phenomenon. The truth is, in the 1700s, a new
profession was emerging: surgery. And these
new professionals needed something to practice
on: bodies. Unfortunately, laws at the time rele-
gated very few bodies to the schools, far less than

Facing:
Pedestal Tomb,
*Kensal Green
Cemetery,
London, England*

William Holland, who
died in 1856 at the
age of seventy-seven,
was interred in a
tomb supported by
eight griffins in
England's first garden
cemetery. All manner
of flora, fauna, and
decorations embel-
lish the sarcophagus,
including angels,
inverted torches,
an alpha/omega
sign, and acroteria
(the shield-like
protrusions at the
corners).

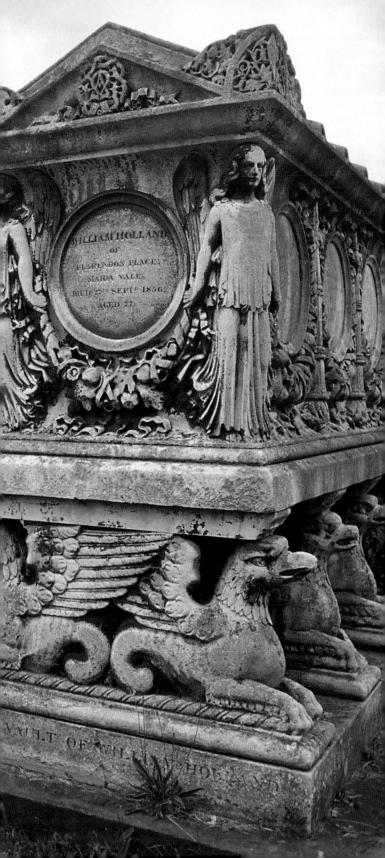

WILLIAM HOLLAND
OF
CLARENDON PLACE
MAIDA VALE
DIED 27TH SEPTR 1856
AGED 77.

VAULT OF WILLIAM HOLLAND

were needed. Enter another new profession: body snatcher; or as they were known at the time: resurrectionists. These scalawags roamed the cemeteries at night in search of fresh bodies, which they sold to medical students and professors. In fact, the phrase "skeleton in the closet"

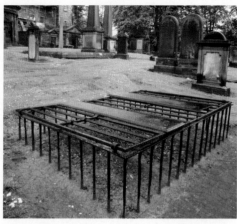

refers to professors hiding disected bodies. To ward off the resurrectionists, all manner of devices were employed, from mausoleums to "mort lairs or cages" (devices that looked like a jail cell), to "mort safe" (a series of iron bars placed over the grave), to "the torpedo coffin" (which exploded if tampered with).

Mort Safe, Greyfriars Churchyard, Edinburgh, Scotland

Exedra

Another often seen cemetery monument is the exedra. These monuments are usually shaped like a curved or rectangular bench, but there are also many examples where the bench is straight. The ancient Greeks constructed public shelters known as stoa. In their simplest form, these structures consisted of a colonnade, walled on one side and roofed. At intervals along these shelters were recesses with seats carved into them. The seating areas were known as *exedrae*, the Greek word for "out of a seat." These structures were frequently used in gymnasiums and public squares. Curved exedrae in public squares were favorite gathering spots for philosophers and teachers since their students could gather around the conveniently placed seats. In private homes and gardens, exedrae were also used for entertaining and seating guests.

Exedrae soon found their way into Greek burial grounds that lined the highways into the city. Greek law expressly forbade burial within the city, so the highways leading into the city became important places for Greek families to erect highly visible monuments to proclaim the stature of the family and celebrate and honor their dead. The traditional Greek burial custom dictated that when a person died, a large mound was formed over the grave. Soon after, an earth or rock wall

Exedra,
Near Pompeii, Italy

The exedra tomb of the Priestess Mamia, situated on the road to Pompeii, dates from before A.D. 79, when the city was destroyed during an eruption of Mount Vesuvius. Behind the exedra is the Istacii family tomb.

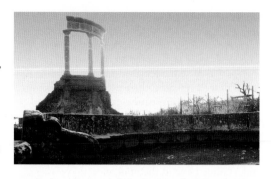

Exedra,
Hollywood Cemetery, Richmond, Virginia

The Walker tomb, which presents itself as a bench, is still classified as an Exedra since its bench is extended by wraparound ends.

was built to better define the burial plot; when enough resources were available, a more permanent stone grave marker was erected.

Graveside services were not a one-time affair for the ancient Greeks; thus, from time to time, the friends and family of the deceased would gather again at the grave. These services were accompanied with wine, food, and offerings that, for convenience, were placed on top of the burial mound. When the family had enough money to erect a suitable monument, they usually picked a table tomb so they would have a place to put the libations and gifts. The next logical progression

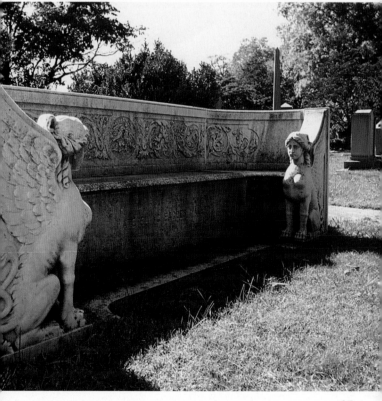

would be to erect a structure that would enable guests to sit and converse, which led to the introduction of the exedra in Greek burial grounds. The exedra was well suited to this setting: its three-sided or semicircular form helped define the burial plot (it replaced the earth or rock retaining wall) and its built-in seating enabled all of the mourners to talk to each other while focusing on the tomb that, conveniently, was heaped with food and wine. This arrangement is not unlike a contemporary living room with a conversation pit and a coffee table in the middle.

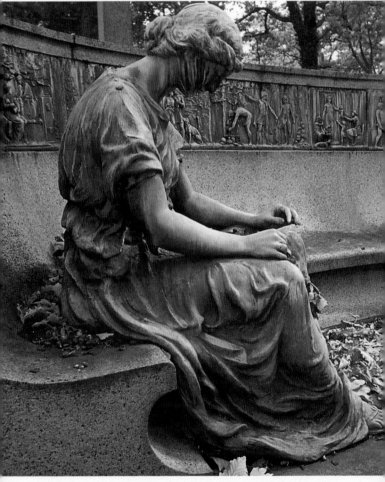

Exedra,
Rock Creek Cemetery, Washington, D.C.

The Kauffmann memorial is an exedra with a female figure representing a mourner. Bronze relief panels on the back of the seat depict the stages of life from birth to marriage to death. Interestingly, a dog that appears in many of the panels does not appear to age very much, while the human figures do. Lucky dog.

When designing exedrae for American cemeteries, architects used semicircular, rectangular, and straight forms. Typically, a statue or architectural feature with the family name is at the center of the exedra and bench seats are on either side, although there are some examples that are simply a bench. The heyday of the exedra was from the late nineteenth century until the 1920s. They are still popular today, but are usually used in public areas rather than as monuments for individuals or families.

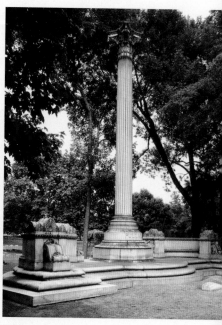

Exedra,
Graceland Cemetery, Chicago, Illinois

The corpse of George Pullman, inventor of the sleeping car, rests securely beneath an exedra-like monument. Pullman's is the most securely buried body in all of Chicago, with the possible exception of some of Al Capone's enemies, who call the bottom of Lake Michigan home. It seems that George Pullman died not long after a bitter strike by Pullman workers—the workers were irritated when Pullman cut their wages but did not cut their rents at the Pullman-owned housing. Fearing desecration of Pullman's corpse, his relatives had his coffin covered in tar paper and asphalt. The asphalt-encrusted coffin was sunk in a block of concrete the size of a small room; then the whole mass was lowered into the ground and topped with railroad ties and more concrete—an entombment to thwart even the most aggressive body snatcher.

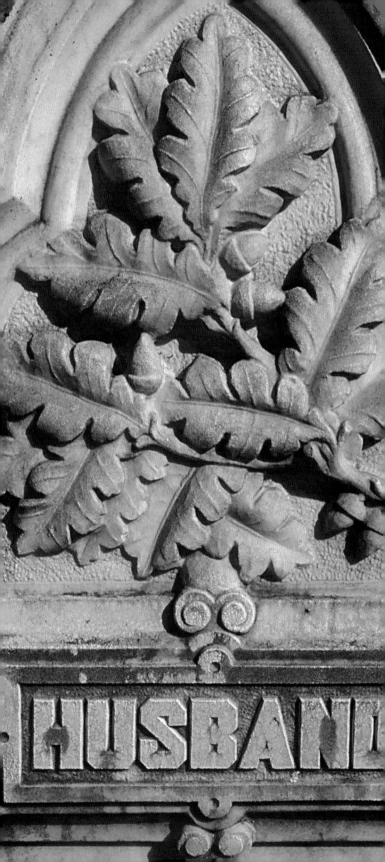

HUSBAND

FLora

PLANTS AND FLOWERS

P LANTS, especially flowers, remind us of the beauty and the brevity of life. They have served as symbols of remembrance ever since we began memorializing our dead. The Egyptians were the first culture to use flowers in a widespread way in funerary rites. They believed that the subtle scent of flowers contained a key to divine powers. Indeed, when the Romans under the command of Julius Caesar invaded and conquered Egypt, the scribes who recorded the events described the overwhelming scent of flowers along the banks of the Nile.

As early as the fourth century B.C., Greek philosopher Aristotle declared that plants had a soul, albeit a special type of soul since they had no ability to move. The heyday of flower symbolism occurred during Victorian times, which conveniently coincided with the rise of the garden cemetery. The Victorians took great pains to give flowers special attributes, adapting many of the ancient myths to Christian symbolism. Lovers passed flowers to each other to convey a special message, and in the cemetery, specific flowers were assigned proper funereal attributes.

Acanthus

The acanthus is one of the most popular architectural flowers, mostly because it adorns the capitals of Corinthian columns. The first recorded use of acanthus leaves in funerary architecture was in the fifth century B.C., when sculptor Callimachus, after seeing the acanthus leaves on the grave of a young girl, was inspired to use them to decorate a column capital. The use of the acanthus in funerary architecture derives from the fact that the leaves are thorny and have often been used as a symbol of the prickly journey of life to death and, ultimately, the final triumph of eternal life.

Page 40:
*Oak Hill Cemetery,
Red Bluff, California*

Left:
*Holy Cross Cemetery,
Colma, California*

Acanthus leaves decorate hearses, tombstones, and funerary garments as well as column capitals. It is said that whoever wears the leaves or has them adorning their tomb has overcome the biblical curse in Genesis 3:

17 And unto Adam he said, Because thou hast hearkened unto the voice of thy wife, and hast eaten of the tree, of which I commanded thee, saying, Thou shalt not eat of it: cursed is the ground for thy sake; in sorrow shalt thou eat of it all the days of thy life; 18 Thorns also and thistles shall it bring forth to thee; and thou shalt eat the herb of the field; . . .

Anthurium

*Oahu Cemetery,
Honolulu, Hawaii*

Although there is not a lot of symbolism attached to the anthurium, it is often used to decorate graves in Hawaii. The anthurium is native to South America, the most famous of which is the *Anthurium andreanum Linden* of Ecuador and Columbia. Anthuriums were imported to Hawaii, where they are a significant part of the cut-flower trade. The flowers of the anthurium are actually contained in the large spike-like "spathe" in the center of the leaf. A gift of an anthurium from a man to a woman is supposed to signify his enormous attraction to her, for reasons that do not need to be explained.

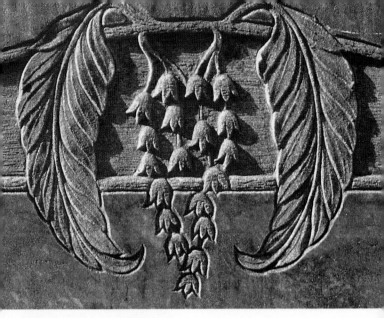

Bellflower

Campanula, the Latin word for "small bell," is a genus of about 300 annuals, biennials, and perennials. Because of its obvious bell-like shape, the bellflower is accorded the same symbolism as all types of religious bells. In the symbolism of flowers, the bellflower is given the attributes of constancy and gratitude. It is the national flower of Chile.

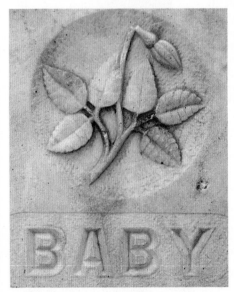

Buds and Seedpods

Seedpods and small buds serve to remind us of the fragile beginnings of life, all too often cut tragically short. Buds, especially those that are broken, almost

Chico Cemetery,
Chico, California

always decorate the grave of a child. The buds can be almost any flower, but rosebuds are the most commonly used.

The use of rosebuds to symbolize the passing of time is aptly illustrated by the proverb, "Gather ye rosebuds while ye may." The proverb comes from a poem by seventeenth-century English poet Robert Herrick (1591–1674):

TO VIRGINS,
TO MAKE MUCH OF TIME

Gather ye Rose-buds while ye may,
Old Time is still a-flying;
And this same flower that smiles today,
To-morrow will be dying.

The glorious Lamp of Heaven, the Sun,
The higher he's a-getting;
The sooner will his Race be run,
And nearer he's to Setting.

That Age is best, which is the first,
When Youth and Blood are warmer;
But being spent, the worse, and worst
Times, still succeed the former.

Then be not coy, but use your time,
And while ye may, goe marry;
For having lost but once your prime,
You may for ever tarry.

Oak Hill Cemetery,
Red Bluff, California

Calla Lily

With its broad leaves and huge vase-like flowers, the calla lily is one of the most stunning flowers. On tombstones it symbolizes majestic beauty and marriage. The South African calla lily was introduced in the United States during the second half of the nineteenth century, which coincided with the beginning of the golden age of the American cemetery. Soon after it was imported, it started to appear in mainstream American art as well as funerary art, and is well known as one of the flowers adopted by artist Georgia O'Keeffe.

Cimitero
Monumentale,
Milan, Italy

Chrysanthemum

The chrysanthemum symbolizes longevity, immortality, fullness, and completeness, chiefly because its dense blooms last into the winter. It is also known as the solar flower and the autumn flower. A chrysanthemum with sixteen petals is the emblem of the Japanese imperial family and it is also an important flower in other Far East cultures.

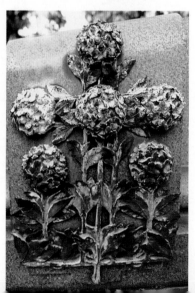

Clover

Because its three leaves form a trefoil, clover is an obvious symbol of the Trinity. An Irish legend says that St. Patrick brought it to Ireland to be an enduring symbol of the Trinity; hence the clover, renamed the shamrock, has become the symbol of Ireland. Even before the arrival of Christianity, pagan Celts used clover as a symbol of vitality because of its abundant growth. The four-leaf clover is rare and has long been a symbol of good luck. Other varieties with more than four leaves have been indicative of bad omens and, for reasons unknown, a sign of a good marriage.

The Protestant Cemetery, Rome, Italy

Cyclamen

The cyclamen is a genus of plants that includes twenty species, many of which have a small reddish-magenta spot at the base of the flower, causing its adoption by early Christians as a symbol of the bleeding sorrow in Mary's heart. The cyclamen is also known as the bleeding nun.

Cimitero Monumentale, Milan, Italy

Like many plants, the cyclamen has been used for a variety of medical treatments. According to a treatise published in the sixteenth century, the cyclamen could be used as a medicinal by pregnant women to speed up delivery, as an antidote for any poison, as an alcohol enhancer, as a treatment for soothing a sunburned face, as a cure for eye weakness, and as an aphrodisiac.

Daffodil (Narcissus)

The daffodil is another funerarily schizophrenic flower. Depending on its use, it can have the positive attributes of rebirth and resurrection or the negative attributes of vanity and self-love. It is the flower of the underworld and of paradise.

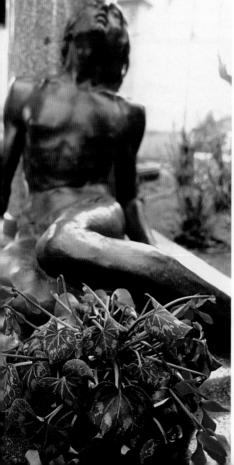

Its narcissistic symbolism comes from the Greek legend of the youth Narcissus, who spurned the beautiful nymph, Echo. While gazing at and admiring his own image in a pool of water, he fell in and drowned; at the spot where Narcissus fell into the pool, a beautiful flower emerged. Christians cleverly turned the Narcissus story around (why waste a beautiful flower?) and gave it the attributes of the triumph of divine love and sacrifice over vanity, selfishness, and death.

Daisy

In the cemetery, daisies and lambs often indicate the graves of children. Because of the unassuming simplicity of the daisy, fifteenth-century artists began using the daisy in scenes of the Adoration to symbolize the innocence of the Christ child. Soon thereafter, wishful lovers started plucking the daisy's petals in the now-familiar refrain, "s/he loves me, s/he love me not."

The daisy is also a symbol of the Virgin Mary: like Mary's love, it can grow almost anywhere. The name "daisy" comes from a corruption of the name the flower was called in England: the *e'e of the daie*, or day's eye. And, lest we forget, a popular term to describe the dead: "pushing up daisies."

Evening Primrose

Also known as the Desert Primrose, Birdcage Evening Primrose, Devil's Lantern, Lion-in-a-Cage, and Basket Evening Primrose, these flowers open in the early evening and close in mid-morning.

On a tombstone, the evening primrose represents eternal love, memory, youth, hope, and sadness. Its pharmacological uses are encyclopedic. It has been used topically as an ingredient in anti-wrinkle cream, and as an anti-inflammatory to treat conditions such as eczema and psoriasis. Its seeds have been ground and their oil extracted to make potions to treat migraines, asthma, and arthritis. The Swiss believed that primroses relieved vertigo, and mountaineers carried them during their ascents.

Mountain View Cemetery, Oakland, California

Fern

Ferns are generally found deep in the forest, only by those who have honestly searched. They symbolize humility, frankness, and sincerity.

Hibiscus

Oahu Cemetery, Honolulu, Hawaii

The delicate hibiscus can be seen decorating the graves and tombstones of people inhabiting the Pacific islands. The large blooms are open for a very short period each day, which suggests the brevity of our time in this realm. In some places the hibiscus has been called the "flower-of-an-hour."

Although the hibiscus originated in Africa, Hawaii has adopted it as its state flower. Hawaiian customs say that a red hibiscus worn behind a girl's right ear indicates that she has a lover; if worn behind the left ear, she desires a lover; if she has a red hibiscus behind both ears, it means, "I have a lover and I desire a lover."

Iris

In Christian symbolism the iris is sometimes referred to as the rival of the lily since it occasionally appears with or replaces the lily in paintings of the Virgin Mary. The iris is also known as the sword lily, and it is the reference to the sword that makes the iris a symbol of the sorrow of the Virgin in scenes of the Passion of Christ.

In ancient mythology, Iris was a messenger of the gods. She carried their messages over a rainbow that connected heaven and earth. Iris also guides the souls of girls and women into the otherworld. That legend continues to live on in modern-day Greece, where it is a custom to place the iris on women's graves. The *iris fiorentina* is the emblem of the Italian city of Florence.

Above:
Seaview Cemetery, Pictou, Nova Scotia, Canada

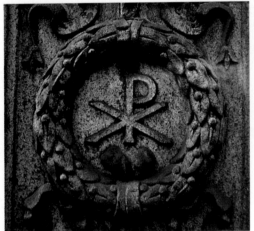

Cimitero Monumentale, Milan, Italy

Laurel

Laurel, usually in the form of a wreath, can represent victory, eternity, immortality, and chastity in funeral art. Its association with eternity and immortality comes from its leaves, which do not wilt or fade. Its link with victory comes from ancient contests where the triumphant winner was crowned with a laurel wreath, which was supposed to bestow immortality. In the Roman world, the laurel wreath was a symbol of military as well as intellectual glory and was also thought to cleanse the soul of any guilt it had over the slaying of enemies. It is also a symbol of chastity because it was consecrated to the Vestal Virgins.

The Chinese also saw the symbolism of immortality in this evergreen shrub. One legend says that while underneath a laurel bush, the Moon Hare distills a drug of immortality made of herbs.

Lily of the Valley

All lilies, and in particular the lily of the valley, are found in funerary art. They are symbols of innocence, purity, and virginity. They symbolize the surrender to God's will and grace, as in Matthew 6:28—*"Consider the lilies of the field, how they grow; they toil not, neither do they spin: . . ."*

Mount Hope Cemetery, Hiawatha, Kansas

The lily of the valley has particular significance in funerary art, since it is one of the first flowers to bloom in the spring, thus symbolizing renewal and resurrection.

It is native to northern Europe and thus has no direct link to early biblical tales. However, the monks liked the delicate beauty of the plant and its medicinal properties so much that they named it lily of the valley in reference to the passage in the Song of Solomon 2:1–2: *"I am the rose of Sharon, and the lily of the valleys. / As the lily among thorns, so is my love among the daughters."*

Lotus

The lotus is as powerful a symbol to Eastern and Egyptian cultures as the rose and the lily are to Western cultures. In Egyptian mythology the lotus is one of the elements of the creation. It arose from the primordial ooze, perfectly clean and pure. The lotus opens its flowers with the sunrise and closes them at sunset, thus becoming linked with the sun god, creation, intelligence, rebirth, immortality, and royal power. Almost all funerary art in Egypt depicts the lotus, from column capitals to ponds of lotus flowers where the dead float in boats made of rushes.

Oak Hill Cemetery, Red Bluff, California

The Chinese see the lotus as a symbol of purity, perfection, spiritual grace, and feminine genius. Buddhists view the lotus stem as the world axis, which holds up the lotus flower throne. The Lord Buddha is often depicted sitting at the center of a lotus flower.

Madonna Lily (Easter Lily)

The Madonna lily is a symbol of purity. It can also be used as a symbol of chastity. As a symbol of purity, its symbolism can be extended to mean casting off earthly things and attaining heavenly/spiritual qualities. This may be because the plant has rather plain foliage but strikingly beautiful flowers. As a practical matter, lilies were frequently used for funerals because of their strong scent, which aided in covering up any bothersome odors.

According to Greek mythology, white lilies were created from droplets of the milk of Hera (Juno), the mother of all gods, after she created the Milky Way. Renaissance painters started using the lily by putting it in the hands of the archangel Gabriel in scenes of the Annunciation. But, since the lily was supposed to be a symbol of purity and chastity, the painters usually did not show the lily's pistils, an all-too-obvious phallic symbol.

Facing:
Corning Cemetery,
Corning, California

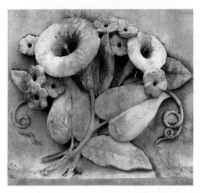

Above:
Chico Cemetery,
Chico, California

Morning Glory

Morning glories are a symbol of the Resurrection, since they close at night and open in the morning sun. There are more than a thousand species of the morning glory, including the humble sweet potato. They play an important part in a number of mythologies, such as the Hawaiian myth of Kawela and Hiku, where the koali (morning glory) vine is used as a swing to transport them to the underworld.

In the cemetery, the morning glory (*Ipomoea*) is a symbol for the Resurrection, morning, youth, and the bonds of love. The morning glory blooms in the early morning but wilts in the afternoon, which plant physiologists say invites us to learn more about two of life's grand themes: reproduction and death. Its ephemeral nature asks us to reflect more deeply on the splendor and brevity of all life, including our own. This thought is reflected in Walt Whitman's "Song of Myself": ". . . a morning-glory at my window satisfies me more than the metaphysics of books."

Adding to its otherworldly mystique, folks who are in charge of naming plant varieties have attached monikers like "Heavenly Blue," "Pearly Gates," and "Flying Saucers" to the creeping vines. In the 1960s, proponents of spiritualism through

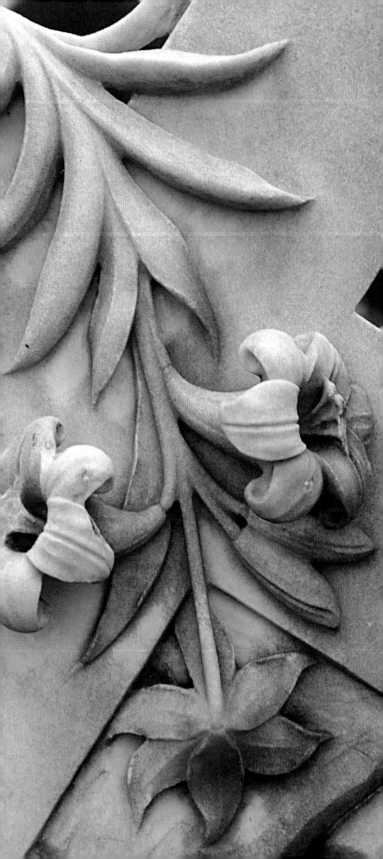

chemistry discovered that morning glory seeds contained lysergic acid (LSD), and there was a concurrent rise in sales of seed packets of morning glory seeds by urban dwellers. Unfortunately, commercially grown morning glory seeds also contain pesticides, and in addition to their strong hallucinatory effects, the seeds can cause liver and neurological damage.

The English Cemetery, Florence, Italy

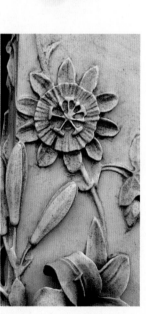

Pansy

The pansy, also called heartsease because of its heart shape, is a symbol of remembrance and specifically hearing the thoughts of a loved one. Indeed, the name "pansy" comes from the French word *pensée* (thought). It's said that attending to the plucked blossom enables one to hear a beloved's thoughts. Pansies are also called johnny-jump-ups, and were first widely cultivated during the nineteenth century, the golden age of the cemetery.

Passionflower

Understandably this flower symbolizes Christ's Passion, Redemption, and Crucifixion. Spaniards who discovered the flowers in the tropical rainforests of South America named the passionflower. Through an interesting bit of convoluted thinking, the Spaniards saw the passionflower as a divine message that it was okay to massacre the Incas and destroy the Inca culture. The flowers were brought back to Rome in 1568, where they became an extremely popular flower, so much so that a noted botanist of the time, the Jesuit Giovanni Battista Ferrari, described the flower in what can only be described as purple prose: "This flower is a miracle for all time, for in it, God's own hand has portrayed the suffering of Christ. The corona ends in thorns reminiscent of Christ's crown of thorns; the Savior's innocence is reflected in the flower's white colour; the ragged nectary is reminiscent of his torn clothes; the styles represent the nails that were driven through his hands and feet; the five stamens represent his five wounds; the tendrils represent the whips."

The English Cemetery, Florence, Italy

The passionflower is also known as a maypop because, modern folklore says, it pops out in May or its fruits make a popping sound when stepped on. In reality the word *maypop* is a corruption of the Algonquian word for the flower, *maycock* or *maracock*. Passionflower is also the dominant flavor in the sugary tropical drink Hawaiian Punch.

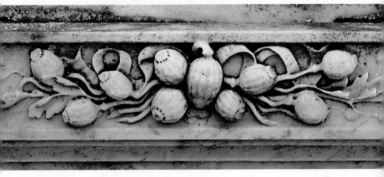

Poppy

Because of the narcotic properties of the opium poppy (*Papaver somniferum*), it is most commonly associated with sleep and death and with Morpheus (the god of sleep and dreams), Hyphos (another god of sleep), and, because of its large seedpod, Demeter (the goddess of fertility and agriculture). It has also been used to symbolize extravagance and ignorance.

Sometimes the poppy is used as an attribute of Christ's Passion because the bright red color of some of its flowers is used to symbolize blood and death. In the Middle Ages, Christians gave the poppy some of the same attributes as ripe ears of corn, in a sort of symbolism by association since the red corn poppy grows in the same fields. In November, the British and the American Legion sell paper poppies to raise money for veterans, as a remembrance of the soldiers who died in World War I, especially in the poppy fields of Flanders, immortalized in the poem by John McCrae (1872–1918).

IN FLANDERS FIELDS

In Flanders fields the poppies blow
Between the crosses, row on row
That mark our place; and in the sky
The larks, still bravely singing, fly
Scarce heard amid the guns below.

We are the Dead. Short days ago
We lived, felt dawn, saw sunset glow,
Loved and were loved, and now we lie
In Flanders fields.

Take up our quarrel with the foe:
To you from failing hands we throw
The torch; be yours to hold it high.
If ye break faith with us who die
We shall not sleep, though poppies grow
In Flanders fields.

Rose

The rose has become the queen of flowers because of its fragrance, longevity, and beauty. It has inspired lovers, dreamers, and poets for countless generations. Venus, the goddess of love, claimed the rose as her own. Cleopatra stuffed pillows full of rose petals. Nero arranged for rose petals to rain down upon his guests. But, the early Christians were reluctant to use the rose as one of their symbols because of its association with decadence. However people's love of the rose was strong and long-lived, so the Christians made some tactical adjustments and adopted the rose as one of their own symbols.

In Christian symbolism, the red rose became a symbol of martyrdom, while the white rose symbolized purity. In Christian mythology the rose in Paradise did not have thorns, but acquired them on Earth to remind man of his fall from grace; however, the rose's fragrance and beauty remained to suggest to him what Paradise is like. Sometimes the Virgin Mary is called the "rose without thorns" because of the belief that she was exempt from original sin. In Victorian-era cemeteries, the rose frequently adorns the graves of women.

Mount Hope Cemetery, Hiawatha, Kansas

Cimitero Monumentale, Milan, Italy

Sunflower

It's quite rare to see a sunflower on a tombstone, and if they are to be found, it's most likely they will appear in Catholic cemeteries, for they signify devotion to the Catholic Church. In Catholic iconography the sun represents the divine light of God and the sunflower represents the devout striving toward God.

The sunflower is a native of North America. It arrived in Spain in 1569, and soon, large expanses of the Spanish countryside were ablaze with the sunflower's dazzling blooms.

When a sunflower is young, it exhibits heliotropism (growing toward the sun), but when it matures, the flowers permanently face east. This quality was readily adopted by Christian iconographers, since most Christian graves are configured so the deceased faces east toward the rising sun.

Seaview Cemetery, Pictou, Nova Scotia, Canada

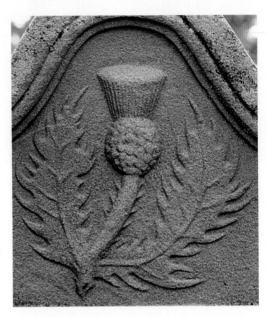

Thistle

God says to Adam in Genesis 3:

> 17 Because thou hast hearkened unto the voice of thy wife, and hast eaten of the tree, of which I commanded thee, saying, Thou shalt not eat of it: cursed is the ground for thy sake; in sorrow shalt thou eat of it all the days of thy life;
> 18 Thorns also and thistles shall it bring forth to thee; and thou shalt eat the herb of the field; . . .

This curse associates the thistle with earthly sorrow and is appropriate in funerary use. Since the thistle is a thorny plant it is also connected with the crown of thorns and the Passion of Christ.

FRUITS, GRAINS, AND VINES

Apple

According to Christian lore, life here on earth would be very different if it weren't for that pesky apple. The crux of the tale is found in Genesis 3:

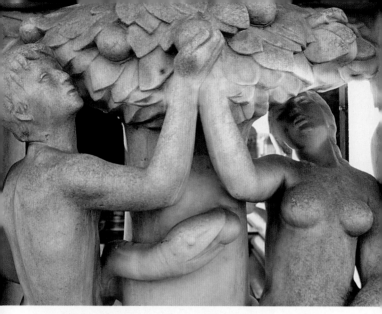

*2 And the woman said unto the serpent, We may eat
of the fruit of the trees of the garden:
3 But of the fruit of the tree which is in the midst of
the garden, God hath said, Ye shall not eat of it,
neither shall ye touch it, lest ye die.
4 And the serpent said unto the woman, Ye shall not
surely die:
5 For God doth know that in the day ye eat thereof,
then your eyes shall be opened, and ye shall be as
gods, knowing good and evil.*

Interestingly, apples are never mentioned in
Genesis. In other books of the Bible, apples are
only mentioned in rather benign ways, like "apple
of thine eye" (Proverbs 7:2) or "the smell of thy
nose like apples" (Song of Solomon 7:8) or "I
raised thee up under the apple tree" (Song of
Solomon 8:5). Truth is, the reason the poor apple
got attached to Eve's world-changing deed is that
the Latin words for "apple" and for "evil" are the
same—*malum*.

Despite Eve's transgressions, the apple
redeemed itself. In the New Testament, Christ
symbolically becomes the new Adam and the
Virgin Mary symbolically is believed to be the
new Eve. Thus, artists are allowed to put an apple
in the hands of Mary as an allusion to salvation.

Corn

Not surprisingly, the most likely place to find
corn on a tombstone is in America's heartland.
Corn is one of the oldest harvested plants and has
long been used as a symbol of fertility and rebirth
and as a funerary symbol in Mediterranean as well

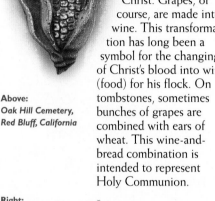

as Central American and Eastern cultures. In American Indian culture the seeds of an ear of corn (maize) represent all the people as well as all the things in the universe. The Aztecs had a number of corn gods, and in Peru a woman made of maize stalks represented fertility.

Grape Clusters

Grapes and grape clusters represent the Eucharistic wine, which is a symbol of the blood of Christ. Grapes, of course, are made into wine. This transformation has long been a symbol for the changing of Christ's blood into wine (food) for his flock. On tombstones, sometimes bunches of grapes are combined with ears of wheat. This wine-and-bread combination is intended to represent Holy Communion.

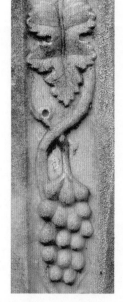

Above:
Oak Hill Cemetery,
Red Bluff, California

Right:
Oak Hill Cemetery,
Red Bluff, California

Ivy

Because ivy is eternally green even in harsh conditions, it is associated with immortality and fidelity. Ivy clings to a support, which makes it a symbol of attachment, friendship, and undying affection. Its three-pointed leaves make it a symbol of the Trinity.

Below:
Holy Cross Cemetery,
Colma, California

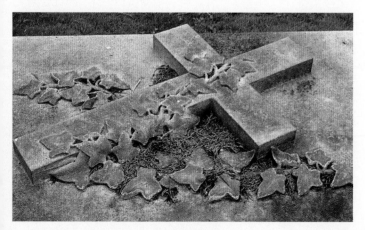

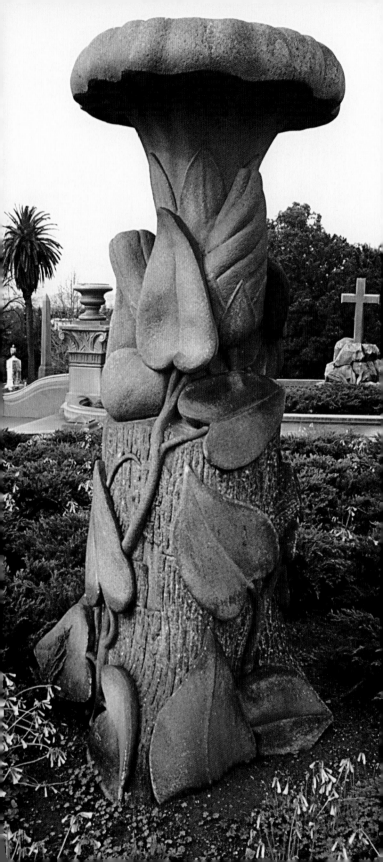

Philodendron

When seen in funerary art, the philodendron is probably used more as a decorative element than to evoke any great symbolic qualities. The philodendron is a climbing vine that is native to South America and, because of its adaptability to indoor climates, has become a popular houseplant all over the world. For more information on vines, see below.

Facing:
Mountain View
Cemetery,
Oakland, California

Pomegranate

In pagan mythology, the pomegranate was attributed to the goddess Persephone (Proserpina), who represented the return of spring and rejuvenation. Christians later adapted the rejuvenation aspect of the pomegranate in their art to symbolize the hope of immortality and resurrection, while the hundreds of seeds of the pomegranate found in one fruit were identified with unity and the pomegranate itself with holiness, love, and hope. On a more earthly plain the many seeds of the pomegranate symbolize fertility, regeneration, passion, and sensuous love.

San Michele
Cemetery,
Venice, Italy

The pomegranate was particularly revered in Judea, where it was permitted to decorate the Ark of the Covenant. Also known as the "holy apple," a representative of God's commandments, the pomegranate was depicted on priests' clothing.

San Michele
Cemetery,
Venice, Italy

Vine

The vine is one of the more powerful symbols of the relationship between God and man. The evangelist John recounts Christ's words in John 15:

1 I am the true vine, and my Father is the husbandman.
2 Every branch in me that beareth not fruit he taketh away: and every branch that beareth fruit, he purgeth it, that it may bring forth more fruit.
3 Now ye are clean through the word which I have spoken unto you.
4 Abide in me, and I in you. As the branch cannot bear fruit of itself, except it abide in the vine; no more can ye, except ye abide in me.

5 I am the vine, ye are the branches: He that abideth in me, and I in him, the same bringeth forth much fruit: for without me ye can do nothing.

Wheat

A sheaf of wheat on a tombstone is often used to denote someone who has lived a long and fruitful life of more than seventy years. It is one of the most basic foodstuffs and is thought of as a gift from God, particularly because its origins were unknown. It denotes immortality and resurrection because of its use as a harvested grain. This association with immortality may explain why priests in ancient Greece and Rome sprinkled wheat or flour on their victims' heads prior to sacrificing them. A sheaf of wheat is a popular Masonic symbol as well.

Seaview Cemetery, Pictou, Nova Scotia, Canada

TREES AND BUSHES
Cypress Tree

The cypress, sometimes referred to as the Tree of Life, has been associated with death and immortality since pagan times. The dark evergreen leaves symbolize solemnity, longevity, resurrection, and immortality; its sticky resin symbolizes incorruptibility; when cut down, it will never again spring up from its roots, symbolizing the finality of death; its elongated form gives the tree the look of fingers pointing toward heaven; and from a strictly utilitarian point of view, it is fairly easy to maintain and doesn't take up a lot of space that could otherwise be used for tombstones and mausoleums. In European cemeteries, the yew tree is often used either with or instead of the cypress.

The cypress can be found in pagan and Christian cemeteries. In Roman and Greek societies it was linked with Hades (Pluto), god of the underworld, and was planted in cemeteries. In ancient China, it was believed

Bisbee Cemetery, Bisbee, Arizona

that eating cypress seeds would promote longevity because the seeds were rich in yang substances, and gold and jade could be found by the light of a burning cypress resin torch because gold and jade were yin substances symbolizing immortality. Cypress wood is used to build temples for Shinto worship in Japan, and temples for secret societies in China because of the wood's association with incorruptibility and immortality.

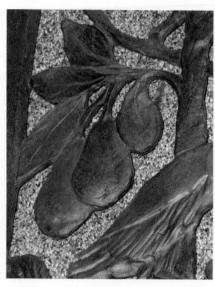

Fig Tree

The fig was one of the first plants mentioned in the Bible in Genesis 3:7—*"And the eyes of them both were opened, and they knew that they were naked; and they sewed fig leaves together, and made themselves aprons."*

In many scenes of the Fall of Man, the Tree of Knowledge is depicted as a fig tree rather than an apple tree. Thus, the fig is seen as a symbol of lust and its many seeds as a symbol of fertility.

Holly Tree (Ilex)

Because of its evergreen quality the holly tree is associated with immortality. It is one of the trees whose wood was said to be used to build the cross on which Christ was crucified. One Christian legend says that when the trees heard that Christ was to be crucified, they agreed amongst themselves that they would not allow themselves to be used for that purpose. If an ax touched them they would disintegrate into thousands of pieces—all except the holly tree, that is. Thus, the holly tree's wood was used to make the cross and it became a symbol of the Passion.

Oak Tree, Acorn

Like the egg, the acorn symbolizes prosperity and fruitfulness and thus is found gracing many coats of arms and column capitals. As a religious symbol it can be seen at the end of the red cords of a cardinal's hat, where it represents the power of spiritual growth from a kernel of truth.

Two acorns paired together can represent male

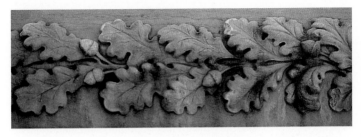

sexuality, or (on a more spiritual plane) the twin acorns can represent truth and the power of the spirit that is obtained by two sources: the natural world and the world that waits to be revealed.

Oak Tree, Leaves

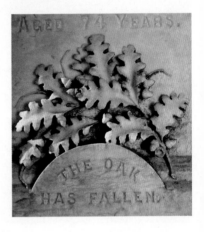

Just as the lion is the King of Beasts, the oak is the King of Trees. Oak leaves can symbolize many things, including strength, endurance, eternity, honor, liberty, hospitality, faith, and virtue. All of these elements combined make the oak a symbol of the power of the Christian faith even in times of adversity. The oak, along with the aspen and the holly, is one of the trees that lays claim to being the tree that was made into Christ's cross.

Oroville Cemetery, Oroville, California

But, long before the Christians adopted the oak, Celtic Druids used the oak in many of their rituals. Indeed the Druid name may have been derived from the Welsh word for "oak," *derw*. The oak was also a sacred tree to the Romans, Greeks, Norse, and Teutonic peoples.

San Michele Cemetery, Venice, Italy

Olive Tree, Branch

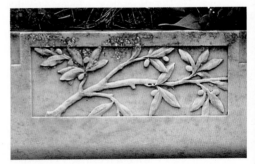

The olive tree is certainly the most referenced tree in the Bible. In the cemetery a depiction of a dove with an olive branch in its beak symbolizes that the soul of the deceased has departed in the peace of God. This is a reference to the peace that God made with man after the great flood, as recounted in Genesis 8:

10 And he stayed yet other seven days; and again he sent forth the dove out of the ark;

11 And the dove came in to him in the evening; and, lo, in her mouth was an olive leaf pluckt off: so Noah knew that the waters were abated from off the earth.

The peaceful symbolism of the olive branch was also used by Sienese school painters when, in scenes of the Annunciation, they depicted the archangel Gabriel handing an olive branch to the Virgin Mary. Most paintings of the Annunciation depict Gabriel with a lily, but the lily was the emblem of Florence, the avowed enemy of Siena.

In addition to its peaceful symbolism, the olive tree also signifies fruitfulness, purification, strength, and victory. In Islamic tradition the olive is the central tree on the world axis and is also associated with light since its oil was used as a lamp fuel.

Palm Tree

Romans used palm fronds as a symbol of victory. Christians adapted them to symbolize a martyr's triumph over death and, by extension, any believer's triumph over death.

A staff made out of a palm tree is an attribute of St. Christopher. In Christian mythology, he carried Christ across the river, then thrust his palm tree staff into the ground, where it grew and bore fruit.

Pine Tree, Cone or Apple

The kinds of pineapples we eat are symbols of hospitality, because they were often presented as gifts from seafarers after they returned from South America. Bronze plaques in the shape of a pine-apple are often used on a home's front door.

The apple of the pine tree, the pinecone, is used as a decoration for homes and in funerary art as a symbol of immortality and incorruptibility. The evergreen tree it comes from represents

immortality, and its sticky resin, which resists dilution or removal (just ask any parent who has tried to remove it from their child's hair), represents incorruptibility. Romans associated the pinecone with Aphrodite (Venus) and fertility.

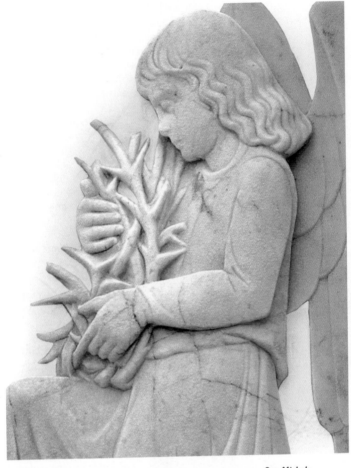

San Michele Cemetery, Venice, Italy

Thorns

Thorn branches and thorns symbolize grief, difficulties, and sin. Roman soldiers put a crown of thorns on Christ's head as a satire of the Roman emperor's festal crown of roses. St. Thomas Aquinas taught that thornbushes represented minor sins while brambles represented major sins. Despite their prickly appearance, Christians have found a way to put thorns in a more positive light by depicting rays of light emanating from Christ's thorny crown. Some Christian iconography even goes so far as stating that Christ's crown of thorns celebrates the marriage of heaven and the virgin earth with a wedding ring (the crown of thorns).

Tree of Life

Every culture has some kind of symbolism connected to the tree, and almost all cultures have a Tree of Life. Ultimately the tree can be used as a symbol for the three basic elements of the cosmos. Its roots represent the underworld, its lower branches and trunk represent earthly matters, and its upper branches reach for and represent the heavens.

In Christian cemetery symbolism, the tree most often depicted is the Tree of Life. It makes its first biblical appearance in Genesis 2:9—*"And out of the ground made the LORD God to grow every tree that is pleasant to the sight, and good for food; the tree of life also in the midst of the garden, and the tree of knowledge of good and evil."*

In other biblical writings the Tree of Life reappears frequently, most notably as the Tree of the Cross, also known as the Tree of the New Covenant.

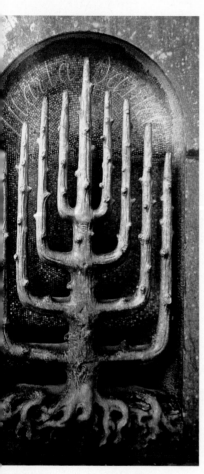

Cimitero Monumentale, Milan, Italy

Treestones

Treestones, or tree stumps, are some of the most curious varieties of funerary art. They were derived from the Victorian rusticity movement, the most common example of which is cast-iron lawn furniture that looks like it's made of twigs. As folklorist Susanne Ridlen tells it, any decorative art that was popular outside the cemetery in Victorian times eventually made it inside the cemetery. The heyday of treestone monuments was a quarter-century span from the 1880s to around 1905. Where one treestone is seen, often many will be found, suggesting that their popularity may have been tied to a particularly aggressive monument dealer in the area or a ready local supply of limestone, which was the carving material of choice. Treestones could also be ordered from Sears and Roebuck, which may explain why they seem to be more popular in the Midwest where more people read the catalog and became

*Wyuka Cemetery,
Nebraska City,
Nebraska*

acquainted with the style. Treestones provide a
ready canvas for symbols because so much sym-
bolism is closely tied to nature.

 This particular example above marks the
Morton family plot in Wyuka Cemetery,
Nebraska City, Nebraska. It was erected for
Caroline Morton, the wife of J. Sterling Morton,
founder of the national tree-planting holiday,
Arbor Day. This twenty-foot-tall treestone is
bursting with symbolism. The tie between trees,
the Morton family, and Arbor Day is obvious.
But further inspection reveals that the top of the
tree is broken, referring to Mrs. Morton's life cut
short (she died in 1881 at age forty-seven after
wasting away from "acute rheumatism"). At the
base of the tree are an artist's palette, pencils,
and brushes, which refer to Mrs. Morton's
passion for the arts and painting. Beside the

palette are embroidery items representing another of her interests. Around a bit further is a sheet of music engraved with "Rock of Ages." Around still further are carved ferns, which are generally found deep in the forest only by those who have honestly searched. They symbolize humility, frankness, and sincerity. Near the ferns is a tipped-over vase of lilies, another symbol for the end of life. High on the treestone is an open knot serving as a bird's nest, which contains three young birds, their mother, and a fourth small bird tucked under her wing. This tableau refers to Mrs. Morton's four sons. Treestones are a popular funerary motif for members of the Woodmen of the World (see page 188).

Weeping Willow Tree

Although the form of the weeping willow certainly suggests grief and sorrow, in many religions it suggests immortality. In Christianity it is associ-

ated with the gospel of Christ because the tree will flourish and remain whole no matter how many branches are cut off. The willow and urn motif was one of the most popular gravestone decorations of the late eighteenth and early nineteenth centuries. The willow is also frequently paired with other cemetery symbols such as lambs and crosses.

Wyuka Cemetery, Nebraska City, Nebraska

The center of some lodges in the Far East is know as the "City of Willows," which is an abode of immortality. In Taoist folklore, graves of mythological figures are dug beneath willow trees.

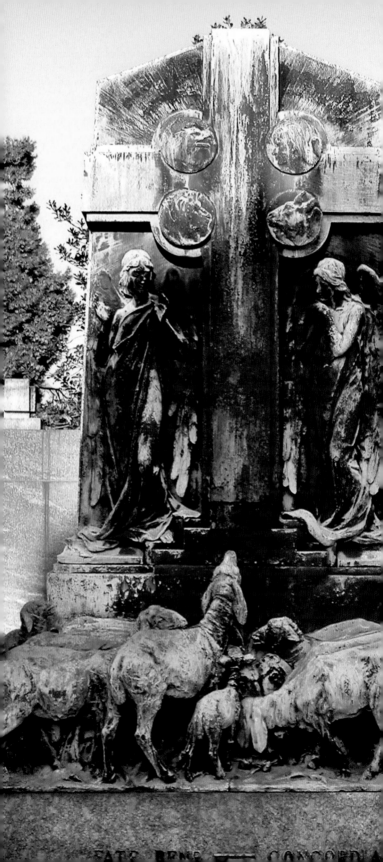

Fauna

ANIMALS

O

F ALL THE VARIETIES of symbols, it is animals that have the most powerful connection with human beings. After all, like us, they are born, live and breathe, then die. More importantly, many animals have attributes that we wish we possessed. Who wouldn't want to be as strong as a bull, as respected as a lion, or as beautiful as a peacock? For thousands of years we gazed toward the sky wondering what we would see and how we would feel if we could soar like a bird, or pondered what it would it be like to live our lives like a bear or an elephant, fearing nothing except our own kind.

Whether it slithers or crawls, trudges or gallops, soars or hovers, animals are an important part of the symbolism of the cemetery. Some animals are well-known religious symbols, like the lamb and the fish. Others fall into the realm of symbols of immortality, like the snake eating its tail (eternity and rebirth) or the butterfly (transformation and resurrection). Still others are mythological figures, like Pegasus and the Phoenix. As you wander through the cemetery, it's hard not to wonder if the deceased is sending us a Walter Mittyish message of what attributes they wished they had or what qualities they hope they will possess in the next realm.

According to the Bible, the enormous task of naming all of the animals fell upon Adam, as recounted in Genesis 2:

> 19 And out of the ground the LORD God formed every beast of the field, and every fowl of the air; and brought them unto Adam to see what he would call them: and whatsoever Adam called every living creature, that was the name thereof.
> 20 And Adam gave names to all cattle, and to the fowl of the air, and to every beast of the field; but for Adam there was not found an help meet for him.

From the beginning of time, animals were associated with specific attributes. As early as the seventh century B.C., hundreds of animal tales known as Aesop's Fables were compiled by Aesop, a Greek. A list of the attributes of real and imagined animals, known as a "bestiary," was compiled in England in the twelfth century. Bestiaries detailed the symbolic meanings of animals and were especially popular in the Catholic Church. In a time when few people could read and write, the bestiaries were used as a way to communicate ideas and morality tales in a visual rather than written language, not unlike comic books of today. During the same era, there were narratives known as "beast fables." One of the best known is Geoffrey Chaucer's "The Nun's Priest's Tale" from *The Canterbury Tales*, where the regal rooster, Chaunticleer, meets his flattering enemy, Daun Russel the fox, in a delightful morality romp.

Page 68:
Cimitero Monumentale, Milan, Italy

Above:
Cimitero Monumentale, Milan, Italy

Ass

In Christian lore, because Christ chose an ass for his entry into Jerusalem, it is a symbol of humility, patience, and poverty. The ass is an essential element in depictions of the nativity, where it symbolizes the most humble of creatures was present at Jesus' birth.

In other cultures, the ass has often been relegated to comical, or even sinister, roles: Midas was given an ass's ears to signify his spiritual shortcomings; the ass's ears are part of a jester's hat; and in Shakespeare's *A Midsummer Night's Dream*, the character Bottom wears the head of an ass as a satire of love. The ass takes on a darker role in ancient Egyptian legends, where the red ass is one of the most dangerous beasts that the soul encounters on its voyage to the otherworld.

Bear

Bears, when used as symbols, are very much the way they are in real life: a mixed blessing. In Christianity, bears symbolize reforming and regenerating the heathens because bear cubs were believed to have been born shapeless and then molded into form by the mother bear.

According to a Christian legend, St. Euphemia was thrown into the arena to be mauled by the animals, but she was worshipped rather than eaten by the bear. Whether or not a bear worshipped her will never be known. What is true is that her life was abbreviated when she was

St. Peter's, The Vatican Crypts, Vatican City, Italy

burned at the stake in A.D. 308 during the persecutions of Diocletian.

In the Old Testament a bear represented the Kingdom of Persia, which was ultimately destroyed by God. And in 2 Kings 2:24 bears are said to have mauled forty-two youths who mocked the prophet Elisha because of his baldness.

Pet's Rest Cemetery, Colma, California

Cat

If you see an image of a cat on a tombstone you are probably in a pet cemetery or at the tombstone of a cat lover. In Christian iconography, the cat is a symbol of laziness, lust, darkness, and Satan. Sometimes Christ is portrayed with cats rather than snakes at his feet. Although the cat is generally considered a negative creature, sometimes it is seen in paintings of the Nativity with a litter of kittens. This *gatta della Madonna* is depicted with a cross-shaped marking on its back.

The cat doesn't fare particularly well in other cultures either. In Japan, cats are regarded as beasts of ill omen; a Buddhist legend says that only cats and snakes were unmoved by the death of Buddha; and the Chinese see the cat as a yin animal with nocturnal powers of evil. In Cambodia a cat is a symbol of drought; thus, a cat is carried in a cage from location to location where it is repeatedly doused with water. Its howls are supposed to awaken the rain goddess Indra. Defenders of the furry feline point out that the cat is merely misunderstood and its supposedly negative attributes of trickery and laziness are actually remarkable powers of cunning and stealth.

Dog

Nowadays when one sees a carved dog in a cemetery it is probably homage to a beloved pet. But the virtues or fidelity, loyalty, vigilance, and watchfulness have long been symbolized by man's best friend.

The dog has often been associated with funerary art and the afterlife: the three-headed dog Cerberus is a guardian of the portals of Hades, the underworld. Ancient Mexicans buried dogs with the dead to serve as guides to the afterlife, and dogs brought the dead across the "Ninefold River" to the underworld; Anubis, Egyptian god of the dead, is depicted with the head of a dog; and in the Middle Ages

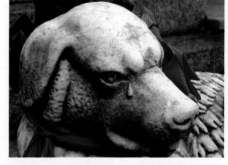

Metairie Cemetery, New Orleans, Louisiana

dogs were often carved on tombstones to represent feudal loyalty or marital fidelity. Dogs play an important part in the life of St. Dominic and the Dominican Order. It's said that while St. Dominic's mother was pregnant with him she dreamed that she gave birth to a dog carrying a torch. This image has become a symbol of the Dominicans and is an integral part of their coat of arms. Interestingly, the Latin word *Dominicanus* (after substituting an "i" for the "u") can be bisected into the words *Domini* (of the Lord) and *Canis* (dog); thus, oftentimes Dominicans are referred to as "Dogs of the Lord."

Although dogs are usually portrayed in a positive light they can also be fierce beasts, such as when they are depicted as Satan's soul-hunting hellhounds. Black dogs, just like black cats, are often portrayed as demonic companions of witches and necromancers.

Elephant

It's unusual to see an elephant gracing a tomb, but the diligent cemetery sleuth can find them now and then. They are most frequently seen on the tombs of explorers and adventurers as testament to their exploits. Although their use as a symbol is mostly in Eastern cultures where they are revered as symbols of strength, longevity, prosperity, and happiness, they are occasionally used in Christian symbolism as well. Elephants are shown trampling snakes, which is a reference to Christ overcoming

death and evil, and have also been used as a symbol for chastity because of the ancient belief that the male refrained from sex during the two-year gestation period of his mate.

Cementiri del Sud-Est, Barcelona, Spain

Hog (Swine)

Although hogs are not often seen decorating tombstones, they can be found. Often they have a somewhat human form, perhaps suggesting that certain humans are prone to hog-like behavior. Not surprisingly, the hog is a symbol of gluttony, greed, and sensuality. Buddhists see the hog as a symbol of ignorance and greed; the Chinese see untamed nature and dirt; and the Hebrew and Islamic cultures see the hog as unclean and as a forbidden food. Hogs do have their advocates. At various times, Hindus, Tibetan Buddhists, Greeks, Celts, and Romans have bestowed fertility and motherly attributes upon the porcine mammal.

Cimitero Monumentale, Milan, Italy

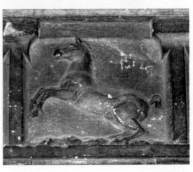

Horse

The horse is one of the most powerful and varied animal symbols. Virtually all cultures bestow magical powers on the horse, and because horses can exist as both wild and domesticated animals, their symbolic meanings can be opposites of each other: white horses represent good; black horses represent evil. In the ancient world, horses brought in death as well as life, fire as well as water, and light as well as darkness. In the Bible, horses are usually equated with lust, as in Jeremiah 5:8—*"They were as fed horses in the morning: every one neighed after his neighbour's wife."*

San Michele Cemetery, Venice, Italy

Lamb

In funerary art, lambs usually mark the graves of children and particularly infants, symbolizing innocence. The lamb is one of the most frequently used symbols of Christ in all periods of Christian art. Christ is often depicted as a shepherd, but he is also referred to as the Lamb of God, as in John 1:29—*"Behold the Lamb of God, which taketh away the sin of the world."*

Christian, Jewish, and Muslim cultures all have their sacrificial lambs tied to vernal (springtime) rites of renewal: Jewish Passover, Christian Easter, and Muslim Ramadan.

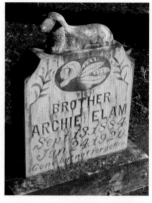

Marysville Cemetery, Marysville, California

Lion

The lion, when seen as a cemetery sculpture, has its usual earthly association with the traits of courage, majesty, and strength. It is frequently seen guarding the portals of tombs and mausoleums. On a more spiritual plain, lions symbol-

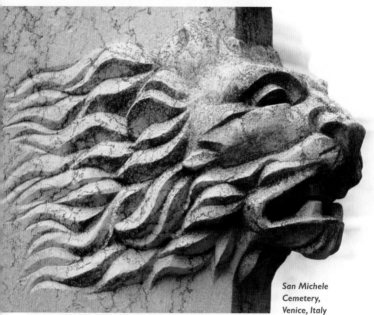

San Michele Cemetery, Venice, Italy

ize the Resurrection because of the ancient belief that lion cubs were born dead but came to life after three days (conveniently the same time Christ spent in his tomb) when they were breathed on by the male lion. The winged lion is also a symbol of St. Mark (see page 97).

Ox

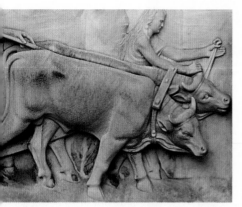

In Christian art, the ox is most often portrayed in Nativity scenes. As a symbol the ox sometimes refers to those who humbly bear the yoke of life and quietly work for the good of others. By extension, the ox also symbolizes patience, strength, and submissiveness. The winged ox is also a symbol of St. Luke (see page 98).

Cimitero Monumentale, Milan, Italy

Unfortunately for the ox, it has often been used as a sacrificial animal, especially by the Jews, and in Renaissance painting an ox was often used to portray the Jewish nation. In the classical world, white oxen were sacrificed to Zeus (Jupiter) and black oxen were sacrificed to Hades (Pluto). Perhaps the ultimate sacrifice of oxen was an ancient Greek ritual called a *hecatomb,* where a hundred oxen were sacrificed.

Squirrel

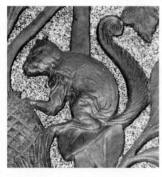

Except for birds, the squirrel may be the most frequently seen live animal in the cemetery, but it's found infrequently on tombstones. This furry, scampering, elusive creature is usually seen in conjunction with other symbols, particularly in tableaus of biblical scenes. Look for it lurking in the corner, for the squirrel (in particular the red squirrel) is one of Satan's animals. Its association with Satan

Cimitero Monumentale, Milan, Italy

comes from its red color and its ability to live and operate at many different levels. In Norse legends, the rat-tooth squirrel runs up and down the world tree (Yggdrasill), causing strife and confusion.

Stag (Deer, Hart)

Psalm 42:1 reads, *"As the hart [deer] panteth after the water brooks, so panteth my soul after thee, O God."* Thus the deer, or hart, symbolizes piety and religious aspiration. The deer, and particularly, the stag, symbolizes solitude and contemplation because of the belief that it leads a primarily solitary life. Because of the form of the stag's antlers, they are often said to represent the Tree of Life.

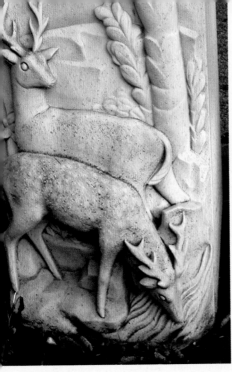

*Cimitero
Monumentale,
Milan, Italy*

The Legend of St. Eustace

In the cemetery and in Christian religious works the stag is usually portrayed with a cross attached to its antlers. This refers to the tale of St. Eustace (Placidus before he converted to Christianity), who supposedly lived in the second century. The story goes that Placidus was a wealthy Roman general who, like most Romans, practiced a type of idol worship. Placidus was also a big-hearted man, giving generously to the poor. One day while hunting in the woods he encountered a beautiful white stag with a glowing crucifix enmeshed in its antlers. The figure of the crucifix spoke to Placidus, complimenting him on his kind deeds. The figure said, "I am Christ whom you serve without knowing it. Because of your generosity to the poor, I am hunting you."

Placidus hurried home and was baptized along with his wife and two sons, who had received a similar visit. After the baptism he changed his name to Eustace. The next day he encountered the stag again and the figure said, "Your faith must be tested. Satan will fight furiously to regain your soul. You will be like a new Job. But, when you have proven yourself, I will restore everything to you. Do you want the test now or at the end of your life?"

Eustace chose to be tested at once. Within a few days, his servants and horses were killed by plague and robbers ransacked their house. Somewhat disillusioned, he decided to flee to Egypt with his family, but, alas, on the way, sailors kidnapped his wife and wild beasts carried off his sons. For fifteen years Eustace lived in isolation and poverty. His luck changed when soldiers from Rome found him, and restored him to his former rank. Soon thereafter he won a notable battle for the Emperor and found his wife and sons alive and unharmed.

Unfortunately Eustace's life took another downward and ultimately fatal turn. When he returned to Rome to be honored at a victory celebration, Eustace and his family, being good Christians, refused to offer sacrifices to the idols. As punish-

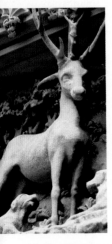

*Woodlawn Cemetery,
Bronx, New York*

ment, they were roasted alive inside a bronze bull. Therefore, a stag with a crucifix in its antlers symbolizes piety and devotion. Sometimes the stag is painted or plated bronze, a reference to St. Eustace's unfortunate demise.

The stag with a crucifix is also a symbol of St. Hughbert (Hubert) and a similar story is told. Unfortunately there is no conclusive documentation that either one of the saints ever existed. But whether fact or fiction, both of them have become the patron saints of hunters.

FOWLS AND INSECTS

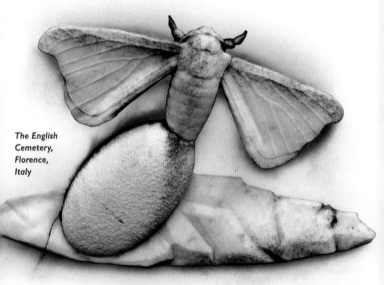

The English Cemetery, Florence, Italy

Butterfly

The butterfly is one of the more literal funerary symbols. The three stages of its life—caterpillar, chrysalis, and butterfly—are easily recognizable as symbols of life, death, and resurrection. The emergence of the butterfly from the chrysalis is likened to the soul discarding the flesh.

The Japanese associate the butterfly with feminine aspects. Butterflies are also seen as wandering spirits. Seeing them can be a sign that a visitor will soon arrive or that death will soon pay a visit to the house. In classical antiquity, Psyche was often portrayed as a young woman with the wings of a butterfly. Some primitive cultures have taken the caterpillar/chrysalis/butterfly transformation one step farther by adding reincarnation, which occurs when the butterfly lays eggs that will produce a caterpillar, thus completing the cycle.

Bee

Because of their myriad well-documented habits, bees have been used as symbols by a variety of cultures for thousands of years. When the followers of Christ started looking for symbols to illustrate their faith, the bee was one of the first to be incorporated as a Christian symbol. In Christian iconography the bee may represent parishioners working fervently for the Church (hive); its hibernation can represent resurrection and its production of honey has made it a symbol of Christ. The bee is an attribute of the Virgin Mary because of an ancient belief that bees do not procreate in the usual way; rather they gather their young from the buds of flowers. The bee's sting is also a symbol of the Last Judgment.

Cementiri del Sud-Est, Barcelona, Spain

Some ancient European cultures equate dreaming of bees with death: the soul is "buzzing off." Germanic cultures see the seemingly erratic flight of bees as a symbol of wandering souls. In all cultures, the bee's activity illustrates the idea that small actions of an individual contribute to the benefit of the whole.

Crane

In the cemetery look for sculptures of cranes perched high atop mausoleums and monuments, for the crane is a symbol of vigilance as well as loyalty and good works. Their loyalty is attributed by the ancient legend that, at night, all of the birds gather around their leader/king in a great circle. The attribute of vigilance is derived from the belief that when they stand on one leg, the claw of the other leg holds a small stone; should the crane start to doze off, the stone would be released and hit the other leg, wakening the crane. The crane's migratory flight is a symbol of renewal and was adopted by Christians as a symbol of the Resurrection.

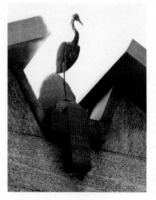

Cimitero Monumentale, Milan, Italy

In China, the crane is a symbol of longevity. It is often depicted perched on a pine tree, also a symbol of longevity and immortality. The Japanese believed that cranes lived for thousands

of years, and Japanese elders were given pictures of cranes on festive occasions.

Dove

The dove is the most frequently seen animal symbol in the cemetery. It is portrayed in a number of poses, but most frequently it is seen holding an olive branch, a reference to the dove sent out by Noah to search for land, as explained in Genesis 8:

> 10 And he stayed yet other seven days; and again he sent forth the dove out of the ark;
> 11 And the dove came in to him in the evening; and, lo, in her mouth was an olive leaf pluckt off: so Noah knew that the waters were abated from off the earth.

The dove then became a symbol of purity and peace because God had made peace with man. It also became a powerful symbol of the Holy Ghost, as illustrated in John 1:

> 31 And I knew him not: but that he should be made manifest to Israel, therefore am I come baptizing with water.
> 32 And John bare record, saying, I saw the Spirit descending from heaven like a dove, and it abode upon him.
> 33 And I knew him not: but he that sent me to baptize with water, the same said unto me, Upon whom thou shalt see the Spirit descending, and remaining on him, the same is he which baptizeth with the Holy Ghost.

Oak Hill Cemetery, Red Bluff, California

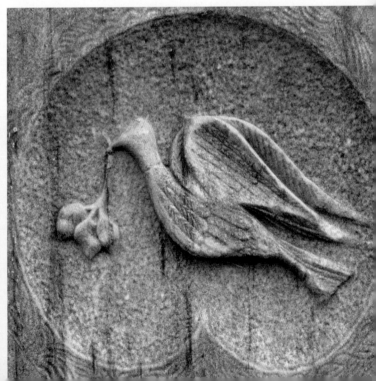

The dove is present in depictions of the Trinity, the Baptism, and the Annunciation of Mary. Seven doves are also used to represent the Seven Spirits of God, and it is the attribute of several saints, including St. Benedict and St. Gregory.

Dragonfly

The dragonfly shares some of the same symbolism as the butterfly—immortality and regeneration—but has the added elements of lightness, elegance, and speed. It is one of nature's most beneficial and long-lived creatures, having existed for millions of years. It consumes great quantities of bugs and mosquitoes and does not sting or destroy crops. But in many cultures, dragonflies have been objects of superstition and are often linked to the Devil.

Cementiri del Sud-Est, Barcelona, Spain

Some German folktales have different names for dragonflies, including *Teufelsnadel* ("Devil's Needle"), *Wasserhexe* ("Water Witch"), *Hollenross* ("Goddess' Horse"), *Teufelspferd* ("Devil's Horse"), and *Schlangentöter* ("Snake Killer"). In England they have been called the "Devil's Darning Needle" and the "Horse Stinger." Folks in Denmark call the dragonfly *Fandens ridehest* ("Devil's Riding Horse") and *Guldsmed* ("Goldsmith"). The Spanish call them *Caballito del Diablo* ("Devil's Horse") and the French *l'aiguille du diable* ("Devil's Needle"). Swedes called the dragonfly *Blindsticka* ("Blind Stinger") because they believed a dragonfly could pick out a person's eyes, while others thought that dragonflies were capable of sewing people's eyelids together. The dragonfly is a national emblem of the Japanese island of Honshu (the Dragonfly Island).

Metairie Cemetery, New Orleans, Louisiana

Eagle

Without a doubt, the eagle is one of the most powerful bird symbols. It is also the quintessential symbol of America. In funerary art it usually symbolizes the Resurrection and rebirth, since it was once thought that from time to time, the eagle flew toward the sun where its feathers were burned off, then it plunged into water and was rejuvenated. This legend is alluded to in Psalm 103:

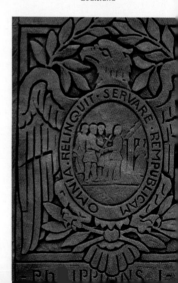

4 Who redeemeth thy life from destruction; who crowneth thee with lovingkindness and tender mercies; 5 Who satisfieth thy mouth with good things; so that thy youth is renewed like the eagle's.

The eagle's watery renewal can also be compared to a baptism. Sometimes it represents generosity because another old belief declared that no matter how great the bird's hunger, it always left half its prey for other creatures.

The power of the eagle symbol is certainly not limited to Christians and Americans. The eagle was sacred to the Norse god Odin, the Greek god Zeus; the Roman god Jupiter, and it was the most sacred of all animals to Native Americans. St. John is frequently portrayed as the eagle (see page 99).

Eagle, Two-Headed

The eagle has always been associated with power and respect. Eagles with twin heads are intended to amplify the point. The two-headed eagle has had a long history as a symbol. In fact, it is one of humankind's oldest emblematic symbols. Originally it was a Hittite symbol, and then it was given a new life when the Seljuk Turks in the Middle Ages adopted it. Europeans embraced it during the Crusades, and finally it was incorporated into the coats of arms of imperial Russia and Austria. Somewhere in the middle of all this borrowing, the Freemasons added it to their vast repertoire of symbols. Besides being a symbol of power, the two-headed eagle ultimately represents the dual nature of unity, which is especially appropriate because of its journey from Eastern to Western culture.

This particular example, the double-headed eagle of Lagash, is on the tombstone of a 33rd Degree Mason. The eagle sports a Prussian crown and is perched on a sword on which is draped a banner emblazoned with the Masonic slogan *Deus Meumque Jus* ("God and my right").

Wyuka Cemetery, Nebraska City, Nebraska

Falcon or Hawk

The falcon is another creature with symbolically schizophrenic meanings because falcons can exist in the wild as well as be domesticated. In the wild, they can represent evil thoughts and actions. In Renaissance paintings they are often seen hovering over meat markets, a suggestion that some people think with their stomachs and not their hearts. Nowadays the hawk is associated with warlike actions while the dove is associated with peaceful behavior.

The Protestant Cemetery, Rome, Italy

In a positive sense, the domesticated falcon represents the pagan converted to Christianity. It is often seen in religious paintings on the arm of a page in the company of the Magi (the three wise men).

Hummingbird

Hummingbirds on tombstones are usually a purely decorative item, no doubt a reference to the deceased's fondness for the delicate bird. But they do have symbolic meaning in some cultures. The Aztecs believed that the souls of warriors returned to Earth as hummingbirds, and a tribe of Colombian Indians believes that hummingbirds procreate with flowers and are thus a powerful symbol of male virility.

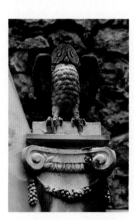

Chico Cemetery, Chico, California

Owl

The owl is another animal that has mixed symbolic messages. In funerary art it's most likely that an owl symbolizes watchfulness, wisdom, or contemplative solitude. Although owls are not mentioned specifically in the New Testament, the owl has become an attribute of Christ, and depictions of the Crucifixion often contain an owl, which refers to Christ's ability to guide those who are in darkness. The owl-like powers of Christ are described in Luke 1:79—*"To give light to them that sit in darkness and in the shadow of death, to guide our feet into the way of peace."*

In another context, the owl symbolizes Satan, the Prince of Darkness, because it

Cementiri del Sud-Est, Barcelona, Spain

was said that the owl fears light and lives and hides in darkness. Like Satan, the owl is also seen as a trickster. Satan deceives mankind while the owl deceives other animals. The owl is an omen of death in many European folktales. In ancient China, the owl was believed to have a hyper-abundance of yang energy. Children born on the Day of the Owl (the solstice) were believed to be predisposed to violent behavior.

Partridge

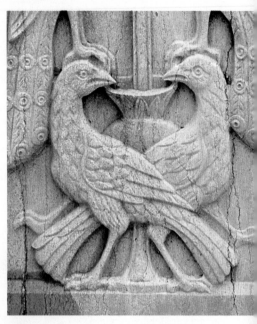

San Michele Cemetery, Venice, Italy

The symbolic meaning of a partridge depends on where it is depicted. A partridge drinking from a chalice may be a symbol of the Church and of truth, but the chalice itself can represent good as well as evil, as when Christ asked God to take the chalice (cup) from him because he knew of the pain and suffering it represented (a foretelling of the Crucifixion). In ancient Chinese as well as European folklore, the partridge was regarded as a neutralizer of poison. But, in most Christian lore the partridge represents an incarnation of the Devil and symbolizes temptation and damnation.

In Greek mythology, Deadalus ordered one of his nephews cast off the Acropolis; Athene took pity on the airborne youth and turned him into a partridge as he fell. Then the bird appears in the story of the funeral of Deadalus' son as an obviously delighted spectator.

In reality, when seen in the cemetery, the partridge may serve more as a decorative device than having any great meaning.

Peacock

Although not a widely used symbol in American cemeteries, the peacock is often seen decorating tombs in European cemeteries. The peacock symbolizes immortality because of the legendary belief that its flesh does not decay. The multitude of "eyes" of the peacock's plumage can represent the all-seeing church or an all-seeing God.

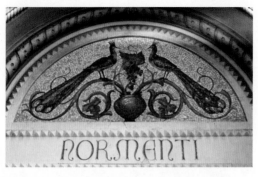

NORMANTI

Sometimes two peacocks are seen drinking from
the Eucharistic chalice or on either side of the
Tree of Life, symbolizing the twofold nature of the
human psyche and the incorruptibility of the soul.

Peacocks are also common in Eastern culture
and religions. Its many eyes can symbolize the
universe, the moon, the sun, or a starry sky. One
legend tells of the peacock's ability to kill serpents
and transmute the poison into the beautiful colors
of its feathers. One Chinese legend refers to the
peacock as "the pimp," since one glance from the
bird supposedly will make a woman pregnant.

Pelican

After the dove, the pelican is
the most common bird seen
in Christian funerary sym-
bolism. An early observer
of pelicans thought they
saw pelicans feeding their
young from a self-
inflicted gash in their
flesh. In reality, the peli-
can was feeding its young
from its pouch. Never-
theless, the errant observa-
tion became the grist for a
legend that says a female
pelican either killed her chil-
dren or they were killed by a ser-
pent, and after three days the pelican
opened a gash in her breast and resuscitated her
young with her own blood. Thus, the pelican rep-
resents self-sacrifice, the greatest love of a parent
for its children.

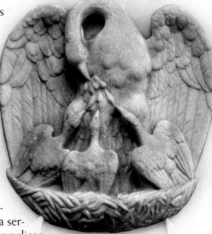

*The English Cemetery,
Florence, Italy*

Christians adopted the pelican's self-sacrificial
feeding of its young from its own blood as a sym-
bol of Christ's sacrifice on the cross because of his
love for humankind. In a cemetery, look for sculp-
tures and carvings of pelicans, as well as pelicans
perched atop crosses.

Rooster

Roosters are symbols of watchfulness, vigilance, and courage because of their early morning vocalizations. In paintings St. Peter is often depicted with a rooster at his feet, which refers to Christ's oft-quoted biblical passage in John 13:38, where he says to Peter, *"Wilt thou lay down thy life for my sake? Verily, verily, I say unto thee, The cock shall not crow, till thou hast denied me thrice."*

Roosters are often used on weather-vanes atop churches to watch for evil, even in the darkest hours.

Unfortunately for the rooster, it has often been used as a sacrificial animal. Sometimes its blood is used to fertilize the soil and other times its entrails have been "read" to foretell the future. In some Chinese initiation rituals, a white rooster is sacrificed to signify the death of an old life and the birth of a new one. Not so long ago, in rural Eastern European countries such as Transylvania, a rooster was buried up to its neck and then decapitated with a sickle after the last sheaf of wheat was harvested, thus ensuring a bountiful harvest the next year.

San Michele Cemetery, Venice, Italy

Woodpecker

The pesky hammering of the woodpecker makes it a symbol of Satan, undermining belief and human nature. The woodpecker is also said to have prophetic powers and is particularly adept at foretelling storms. In cemetery sculpture it is usually part of large tableaus, pestering another animal or person or quietly laying in wait.

The woodpecker figures prominently in Roman lore because it was the bird that brought food to Romulus and Remus, the mythological founders of Rome. Many Native American tribes also saw the woodpecker as a predictor of storms, and its feathers were used in ceremonies to ward off approaching storms and natural disasters. There is a legend in France that says the woodpecker was the only bird that would not help God when he needed trenches made for lakes and rivers, so God condemned the woodpecker to a life of beating its head against trees and drinking only water.

Cimitero Monumentale, Milan, Italy

FISHES AND MOLLUSKS

Dolphin

Besides the generic Christian fish symbol, the dolphin is the most frequently portrayed marine animal in Christian art and symbolism. On funerary monuments, dolphins are often intertwined with an anchor, which was an early disguise for a cross. Dolphins symbolize salvation (in mythology they are often portrayed as rescuing sailors), transformation (Bacchus was said to have turned drunken sailors into dolphins), and love (they are widely thought of as friendly and playful marine mammals). Since early artists rarely saw real whales, their depictions of the biblical fable of Jonah and the Whale usually portrayed a dolphin swallowing Jonah.

San Michele Cemetery, Venice, Italy

Fish

The fish is one of the most common Christian symbols. It can be seen everywhere from tombstones to bumper stickers. The symbols of sacramental fish, with wine and a basket of bread, represent the Eucharist and the Last Supper in Christian art. The fish symbol developed as a Christian icon for a number of reasons. It was often used as a part of a secret code during times of persecution by the Roman government.

The most frequent use of the fish symbol nowadays is when it incorporates the Greek letters ICHTHUS, (IXΘYE), spelled Iota CHi THeta Upsilon Sigma, which are the Greek uppercase letters for the first letters of the phrase "Jesus Christ, of God, the Son, the Savior":

Cimitero Monumentale, Milan, Italy

I =	*Iota*	*Iesous*	*Jesus*
X =	*CHi*	*Christos*	*Christ*
Θ =	*THeta*	*Theou*	*of God*
Y =	*Upsilon*	*Uios*	*the Son*
Σ =	*Sigma*	*Soter*	*the Savior*

Numerous drawings of the fish sign (without the Greek letters) can be seen in the catacombs under the streets of Rome. Followers of this early Christian sect were called *pisciculi* ("little fish").

Another reference to the adoption of the fish as a Christian symbol comes from the oft-quoted passage in Mark 1:

> 16 Now as he walked by the sea of Galilee, he saw Simon and Andrew his brother casting a net into the sea: for they were fishers.
> 17 And Jesus said unto them, Come ye after me, and I will make you to become fishers of men.
> 18 And straightway they forsook their nets, and followed him.

Thus, the Apostles were often referred to as "fishers of men."

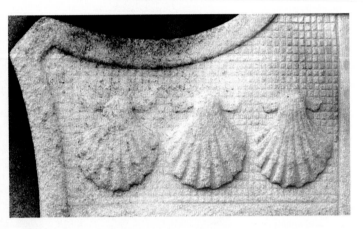

The English Cemetery, Florence, Italy

Shell

When seen on a tombstone, the cockleshell, or the scallop shell, symbolizes a journey or a pilgrimage. The scallop shell is also a symbol of baptism, specifically the Baptism of Christ. Even today some baptismals have shells incorporated into their design, and the baptismal water is sometimes sprinkled from a shell.

The shell's association with water and the sea is an integral part of many myths, and it is a female/goddess attribute in many cultures. Perhaps the best-known depiction of the shell and a female is Botticelli's famous painting *The Birth of Venus*. Because the shell may also contain a pearl, it is associated with good luck and prosperity in a number of cultures.

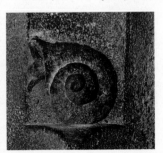

Cementiri del Sud-Est, Barcelona, Spain

Snail

When snails are depicted on tombs they probably are used as decorations rather than having any strong symbolic qualities. The most likely place to find one is at the bottom or the corner of a mausoleum or tomb.

Nevertheless, snails do play an important part in funerary art. It

was believed that snails materialized out of the mud and fed on it, never really needing to seek food since there was plenty at hand. Therefore, the snail is a symbol of laziness and sin. But, as with many negative symbols, snails do have their positive attributes: the spirals of its shell are a symbol for harmony; since it carries its "home" along with it, the snail is a symbol for self-sufficiency; and since a snail seals itself within its shell and reemerges after the winter, it is a symbol for Christ's Resurrection.

Whale

The biblical tale of Jonah and the Whale has an analogous story in most religions. Being swallowed by a whale means entering a time of darkness, the time within the belly of the whale represents an initiation rite, and being disgorged by the whale symbolizes resurrection and transformation. In the biblical story, Jonah emerges from the whale after three days; the same time that Christ was in his sepulchre before his resurrection. This is recounted in Matthew 12:40—*"For as Jonas was three days and three nights in the whale's belly; so shall the Son of man be three days and three nights in the heart of the earth."*

San Michele Cemetery, Venice, Italy

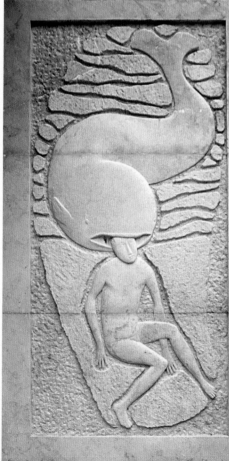

Nun, one of the letters of the Arabic alphabet, is a symbol for the word "fish" and, more specifically, "whale." The letter nun, which looks like a crescent with a dot in the middle, is said to symbolize Noah's Ark. Additionally, the crescent shape symbolizes the jaws of the whale.

Due to the whale's enormous size and its long migratory path, it appears in tales of cultures from Alaska to Polynesia and from Scandinavia to Africa. Interestingly, despite the whale's wide-ranging influence, Renaissance artists were unfamiliar with

its actual form, so their depictions of the story of Jonah and the whale portrayed the Whale as a dolphin or a large hairy fish.

REPTILES AND AMPHIBIANS

Frog

Don't expect to see this creature front and center on a tombstone. But frogs can be found on tombstones as elements in primordial tableaus. Exodus 8:1–8 pretty much sums up the role of frogs in a biblical sense:

> 1 And the LORD spake unto Moses, Go unto Pharaoh, and say unto him, Thus saith the LORD, Let my people go, that they may serve me.
> 2 And if thou refuse to let them go, behold, I will smite all thy borders with frogs:
> 3 And the river shall bring forth frogs abundantly, which shall go up and come into thine house, and into thy bedchamber, and upon thy bed, and into the house of thy servants, and upon thy people, and into thine ovens, and into thy kneadingtroughs:
> 4 And the frogs shall come up both on thee, and upon thy people, and upon all thy servants.
> 5 And the LORD spake unto Moses, Say unto Aaron, Stretch forth thine hand with thy rod over the streams, over the rivers, and over the ponds, and cause frogs to come up upon the land of Egypt.
> 6 And Aaron stretched out his hand over the waters of Egypt; and the frogs came up, and covered the land of Egypt.
> 7 And the magicians did so with their enchantments, and brought up frogs upon the land of Egypt.
> 8 Then Pharaoh called for Moses and Aaron, and said, Intreat the LORD, that he may take away the frogs from me, and from my people; and I will let the people go, that they may do sacrifice unto the LORD.

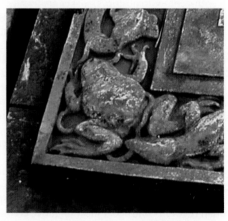

The Protestant Cemetery, Rome, Italy

Then as added punctuation, frogs reappear in Revelation 16:13—"And I saw three unclean spirits like frogs come out of the mouth of the dragon, and out of the mouth of the beast, and out of the mouth of the false prophet."

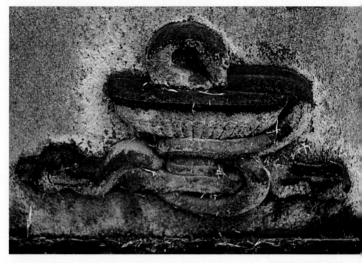

Snake (Serpent)

Glasgow Necropolis,
Glasgow, Scotland

Despite its reptilian ways, snakes are well repre-
sented on tombstones although their presence fell
off substantially by the twentieth century. On nine-
teenth-century tombstones, snakes are usually
depicted biting their tail (see Ouroboros on page
91) as a symbol of immortality. On earlier tomb-
stones they are often seen slithering on a corner of
a tombstone or winding their way through a skull,
for during those times, these cold-blooded crea-
tures were most often used as mortality symbols.
Psychologists tell us that snakes are repellent to
humans primarily because they are almost com-
pletely our antithesis. We walk on two feet, high
above the ground; snakes slither at ground level.
We are warm-blooded; they are cold-blooded. We
have hair; they are hairless. Taking it one step far-
ther, psychologists say that perhaps we are also
afraid because we still retain part of the reptilian
brain that can control our most primitive emotions.

The Bible establishes the snake's evil ways right
away in the Fall of Man as explained in Genesis 3:

*1 Now the serpent was more subtil than any beast of
the field which the LORD God had made. And he
said unto the woman, Yea, hath God said, Ye shall
not eat of every tree of the garden?*
*2 And the woman said unto the serpent, We may eat
of the fruit of the trees of the garden:*
*3 But of the fruit of the tree which is in the midst of
the garden, God hath said, Ye shall not eat of it,
neither shall ye touch it, lest ye die.*
*4 And the serpent said unto the woman, Ye shall not
surely die: . . .*

The snake's fate is finally sealed:

> 13 And the LORD God said unto the woman,
> What is this that thou hast done? And the woman
> said, The serpent beguiled me, and I did eat.
> 14 And the LORD God said unto the serpent,
> Because thou hast done this, thou art cursed above all
> cattle, and above every beast of the field; upon thy
> belly shalt thou go, and dust shalt thou eat all the
> days of thy life:
> 15 And I will put enmity between thee and the
> woman, and between thy seed and her seed; it shall
> bruise thy head, and thou shalt bruise his heel.

Snake or Ouroboros (Uroborus)

In the cemetery, a snake biting or
eating its tail is a symbol of
immortality, rejuvenation,
and eternity. It is seldom
used in funerary art
nowadays, but it was a
very popular symbol in
nineteenth-century
cemeteries. Images of
the ouroboros can be
found in the art of
ancient Egypt (where
it symbolized the daily
cycle of the sun), China
(where it was among the
myriad yin and yang symbols), the
Roman Empire (where it was associated with
Saturn, the god of time), as well as in European
and American funerary art.

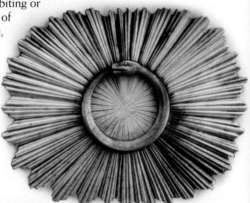

*The English Cemetery,
Florence, Italy*

Beyond symbolizing immortality the ouroboros
suggests that for every ending there is a new
beginning. In alchemy the ouroboros symbolizes
a closed cyclical process (heating, evap-
oration, cooling, condensation), which
refines or purifies substances.

Turtle or Tortoise

In funerary art the turtle is usually used
as a purely decorative element. Never-
theless, depending on the eye of the
viewer, the turtle can have a positive
or sometimes a negative meaning. It
can represent the virtues of longevity,
patience, durability, and strength, as well as the
negative traits of sloth and secrecy. It's not unusual
to find a tortoise supporting the corner of a tomb
or mausoleum. And in some cultures, depictions
of the tortoise show it supporting the entire world.

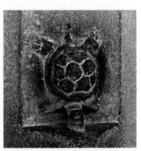

*Cementiri del Sud-Est,
Barcelona, Spain*

Ultimately the turtle is seen as a benign and somewhat comical creature, perhaps summed up by the emblem of Cosimo de' Medici, a wealthy Florentine banker and art patron— a turtle with a sail on its back ("steady as she goes").

MYTHICAL CREATURES

Dogs
or Shih Tzu of Fo

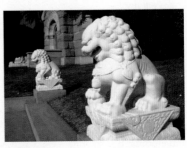

These mythological animals, special guardians of the Lord Buddha, teach patience and the subjugation of the ego and its passions. The male, seen here with a ball under its paw, is always located on the east. The ball is hollow, a symbol of the "emptiness" of the mind in Buddhist spiritual beliefs. The female dog-lion, on the west, has a baby under her paw. These paired creatures also represent the opposing forces of yin (female) and yang (male).

*Cypress Lawn
Memorial Park,
Colma, California*

The dog-lions and the positioning of other elements and statuary are part of the feng shui of the site, an art based on the belief that a harmonious relationship between our environment and nature's forces affects our disposition and luck.

Dragon

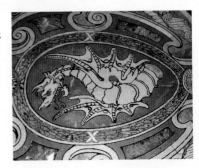

In Christian lore, the dragon is usually depicted as a winged serpent, symbolizing the Devil. In the cemetery it may be found lurking in the corners of mausoleums and tombs. In the Vatican a dragon is integral to many pieces of sculpture and artwork. The reference to the dragon as an avowed enemy of God is quite clear. The most vivid account is in Revelation 12:

*St. Peter's,
Vatican City, Italy*

> 7 And there was war in heaven: Michael and his angels fought against the dragon; and the dragon fought and his angels,
> 8 And prevailed not; neither was their place found any more in heaven.
> 9 And the great dragon was cast out, that old serpent, called the Devil, and Satan, which deceiveth the whole world: he was cast out into the earth, and his angels were cast out with him.

In a more positive light, the dragon is a national symbol for Wales and can be seen decorating Welsh-ethnic gravestones. Dragons also play a major role in other cultures, particularly in China and Japan. The Chinese see the dragon as a ferocious beast, but, more importantly, it represents the highest spiritual power, strength, and supernatural wisdom. In Japan, the three-clawed dragon represents the Mikado (imperial and spiritual power).

Griffin

Griffins have been portrayed in works of art for more than three thousand years. This fantastic beast has the body of a lion and the wings and claws of an eagle, which gives it dominion over

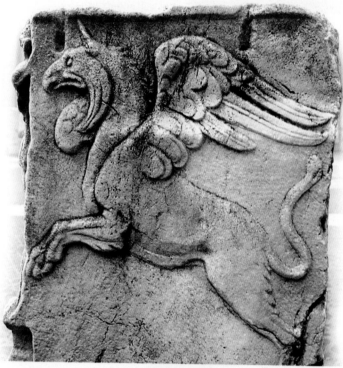

The Vatican Museums, Vatican City, Italy

the earth and the skies. It was first seen in western Asia and has been adopted by a number of cultures, from Persians to Assyrians to Indians. Originally in Christian iconography it was a demonic symbol of those who persecuted and oppressed Christians. Then in the fourteenth century the creature did a symbolic about-face; from then on, Christian artists used the griffin to portray the dual nature of Christ—human and divine—because of its mastery of the earth and the heavens.

Pegasus

The winged horse Pegasus is often seen as a symbol of intellectual and poetic creativity. In Greek mythology, there were three ugly sisters (Euryale, Stheno, and Medusa) whose hair was composed of snakes. Looking upon them turned the viewer to stone. When Perseus decapitated Medusa, Pegasus sprang from her severed head. Another part of the legend of Pegasus states that the sacred spring Hippocrene arose from the marks left by its hooves. When seen in a cemetery, Pegasus may symbolize resurrection, renewal, and rebirth.

Cimitero Monumentale, Milan, Italy

Phoenix

In the cemetery the phoenix represents rebirth, resurrection, and transformation. Christians began using the phoenix on their graves as early as the first century A.D., when St. Clement related the legend of the phoenix in his first Epistle to the Corinthians. In Christian symbolism it is associated with the Resurrection of Christ and appears in scenes of the Crucifixion.

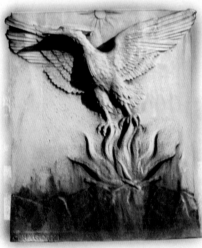

But the roots of the phoenix are much older. In Egyptian legends the benu bird (*phoenix* in Greek) builds itself a nest of myrrh, sets the nest on fire, then throws itself on the flames. After the fire has consumed the phoenix, a newborn bird arises from the ashes to begin another life. Depending on the storyteller, this fowl conflagration happens once every 100 to 500 years and is repeated over and over again for eternity.

Cimitero Monumentale, Milan, Italy

The legend of the phoenix migrated to China where the phoenix acquired a sexual identity. The male phoenix was associated with happiness, while the female was an emblem of the empress. Male and female phoenixes together are symbols of a happy marriage, and one Chinese legend depicts the birds leading happy couples to the Paradise of the Immortals.

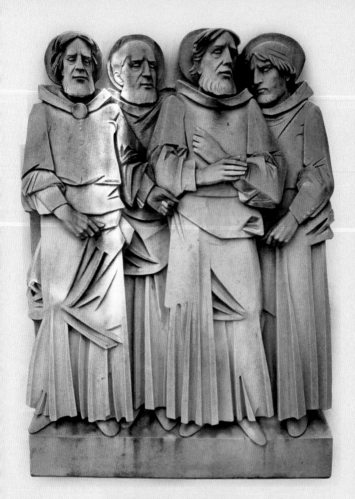

THE EVANGELISTS

The four evangelists who wrote the respective Gospels—Matthew, Mark, Luke, and John—all have winged attributes. When you see a depiction of a flying cow or an aeronautical lion in the cemetery, it's not the musings of a whimsical artist but the symbol of a saint. Usually all four of the fluttering creatures appear together: an ox, a lion, an eagle, and an angel.

The attributes of the Evangelists are referred to in Ezekiel 1:

> *4 And I looked, and, behold, a whirlwind came out of the north, a great cloud, and a fire infolding itself, and a brightness was about it, and out of the midst thereof as the colour of amber, out of the midst of the fire.*
> *5 Also out of the midst thereof came the likeness of four living creatures. And this was their appearance; they had the likeness of a man.*

6 *And every one had four faces, and every one had four wings.*

7 *And their feet were straight feet; and the sole of their feet was like the sole of a calf's foot: and they sparkled like the colour of burnished brass.*

8 *And they had the hands of a man under their wings on their four sides; and they four had their faces and their wings.*

9 *Their wings were joined one to another; they turned not when they went; they went every one straight forward.*

10 *As for the likeness of their faces, they four had the face of a man, and the face of a lion on the right side; and they four had the face of an ox on the left side; they four also had the face of an eagle.*

They are also referred to in Revelation 4:7— "*And the first beast was like a lion, and the second beast like a calf, and the third beast had a face as a man, and the fourth beast was like a flying eagle.*"

This "tetramorph" is, no doubt, influenced by the notion of four guardians supporting the heavens from the four corners of the earth. The four guardians are also said to represent four signs of the zodiac—Aquarius, Scorpio, Taurus, and Leo—in what is known as the "fixed cross" or "grand cross."

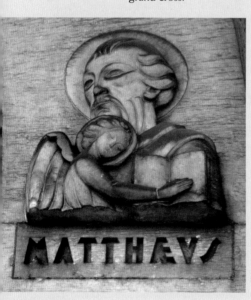

San Michele Cemetery, Venice, Italy

St. Matthew

Before he became one of Christ's disciples, Matthew was a tax collector, at which time he may have had the name Levi. As a scribe, he is said to have written a detailed account of the incarnation of Christ in Judea, then went to Ethiopia where he preached and eventually died. Of all the evangelists, Matthew's life after Christ's death is the most obscure. In art, he is most often portrayed as a man with wings, an angel, because his gospel begins with the human incarnation of Christ.

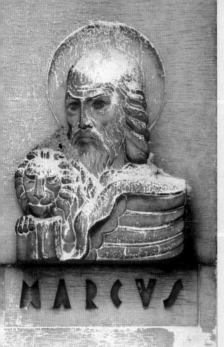

St. Mark

Scholars agree that Mark's Gospel was the earliest written. Tradition says that the Gospel was dictated to Mark when he served as Peter's secretary. There is a legend that while he was traveling in the Adriatic he was caught in a great storm, during which he was cast onto an area of lagoons and islands, where an angel appeared and said that a great city would rise in his honor. Four hundred years later people fleeing Attila the Hun founded the city of Venice on that site.

San Michele Cemetery, Venice, Italy

Another four hundred years would pass before relics of St. Mark were transported from Alexandria to the Cathedral of San Marcos in Venice, where they remain to this day. St. Mark is the patron saint of Venice.

St. Mark's most frequently portrayed attribute is the winged lion because his writings emphasize the dignity of Christ, "the Lion of Judah," and because his Gospel begins with a voice crying in the wilderness, a reference to John the Baptist. St. Mark is often portrayed with a pen in his hand, a reference to being Peter's secretary.

San Michele Cemetery, Venice, Italy

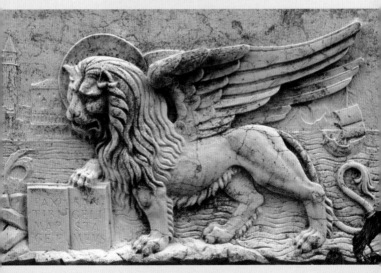

St. Luke

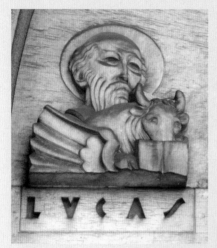

Luke was a Greek, probably born in Syria. He was a physician by trade and was also said to be a great painter. At one time there were paintings of Christ and the Virgin Mary that were attributed to Luke, but upon further investigation, the paintings were found to have been executed centuries after his death. Nevertheless, Luke's words became the inspiration for many great paintings. He is best known for the Gospel of St. Luke, but he is also well known for writing the Acts of the Apostles. Luke became the constant companion of the apostle Paul and wrote a detailed account of Paul's life. Luke never married and is said to have died peacefully at the age of eighty-four.

San Michele Cemetery, Venice, Italy

In works of art he is frequently portrayed with a paintbrush and is the patron saint of painters as well as physicians. His most frequently portrayed attribute, and the way he is symbolized in the cemetery, is that of a winged ox. The angelic ox refers to Luke's emphasis of the priesthood of Christ, since the ox has long been a symbol of sacrifice.

Cementiri del Sud-Est, Barcelona, Spain

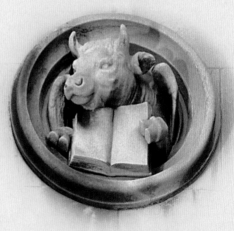

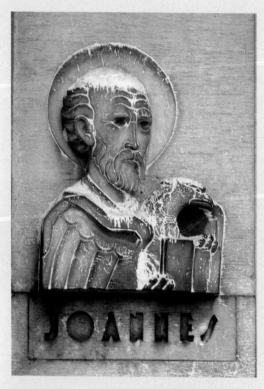

St. John

John was the youngest of all the apostles. In
depictions of the Last Supper, he is the one
leaning on Christ's chest. John was present at
the Crucifixion, where Christ essentially
appointed him to take his place as Mary's son.
This is recorded in John 19:

> 26 *When Jesus therefore saw his mother, and the
> disciple standing by, whom he loved, he saith unto
> his mother, Woman, behold thy son!*
> 27 *Then saith he to the disciple, Behold thy mother!
> And from that hour that disciple took her unto his
> own home.*

In the cemetery and in works of art, John's most
frequently portrayed attribute is that of an eagle,
the symbol of highest aspiration, because his
gospel contains the most vivid account of ascend-
ing to heavenly heights. As a human, John is
sometimes depicted with a cauldron of boiling
oil or with a chalice containing a snake (see page
90), both of which refer to legendary attempts by
the Roman Emperor Domitian to assassinate him.

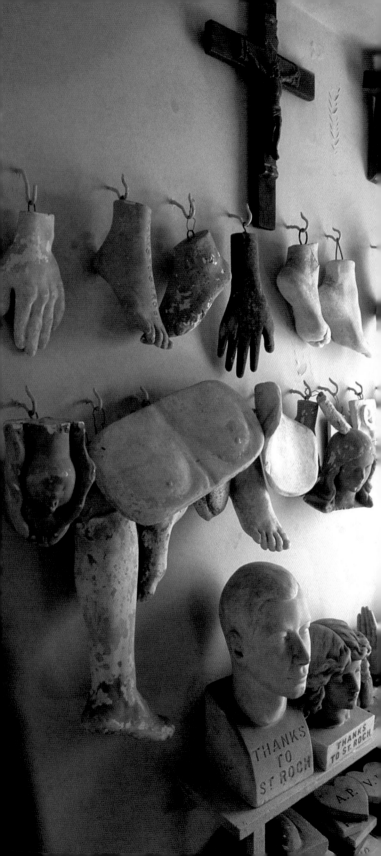

JOSEPH
ODDO

THE
Human
CONDITION

I N A SMALL ROOM in back of the chapel
in St. Roch Cemetery in New Orleans is a
display of exvotos: crutches, prosthetics, false
teeth, eyes, and sculpted representations of a
part of the body that was healed by praying
to St. Roch.

The human body is most often portrayed in the
cemetery in the form of strongly emotional sculp-
tures. Some of the world's greatest sculptors have
been commissioned to create magnificent works
of funerary art. Unlike museums, where the
viewer is often separated from the sculpture by
tidy red velvet ropes, these beautiful works in the
cemetery are available for close inspection. In
addition to large full-body sculptures, tombstones
also contain images of the human body. The most
commonly seen parts of the body are various con-
figurations of hands, some with fingers pointing
up, others with open palms coming down, and
still others with hands clasped. Also common is
the ever-watchful all-seeing eye that is found on
tombstones of Freemasons and Odd Fellows.

Catholic religious art, when it includes depic-
tions of their seemingly endless array of saints,
has a particular fondness for body parts since so
many saints acquired their martyrdom by torture
of their bodies and forcible removal of various
body parts. A head on a platter is an attribute of
John the Baptist, a reference to his demise at the
request of Salome. Breasts on a platter are an
attribute of St. Agatha, who had her breasts torn
by pincers. The ear is a symbol of the Passion
because of a reference in John 18:10: *"Then Simon
Peter, who had a sword, drew it and struck the high priest's
servant, cutting off his right ear."*

Even human hair has particular symbolic quali-
ties, depending on how it is depicted. Flowing

✿ 101

hair symbolizes a virgin saint because unmarried women in ancient times wore their hair loose and long. Very long hair is a symbol of penance, an allusion to the story in Luke where a sinning woman cleansed Jesus' feet with her tears and wiped them dry with her long hair (see Luke 7:37–38).

THE SEVEN VIRTUES

The most common gatherings of sculpted human forms in the cemetery are groupings of the Virtues. There are seven Virtues, usually divided into two groups. There are three theological virtues: Faith, Hope, and Charity; and four cardinal, or moral, virtues: Temperance, Prudence, Fortitude, and Justice. Sometimes Prudence is put into a separate category as an intellectual virtue. Usually four of the Virtues are seen together and almost always, three of the four are Faith, Hope, and Charity. The other four seem to be always vying for the fourth spot. The biblical idea of Virtues is best illustrated in 2 Peter 1, where Simon Peter admonishes the faithful to be aware of the gifts they have been given by God:

3 According as his divine power hath given unto us all things that pertain unto life and godliness, through the knowledge of him that hath called us to glory and virtue:
4 Whereby are given unto us exceeding great and precious promises: that by these ye might be partakers of the divine nature, having escaped the corruption that is in the world through lust.
5 And beside this, giving all diligence, add to your faith virtue; and to virtue knowledge;
6 And to knowledge temperance; and to temperance patience; and to patience godliness;
7 And to godliness brotherly kindness; and to brotherly kindness charity.
8 For if these things be in you, and abound, they make you that ye shall neither be barren nor unfruitful in the knowledge of our Lord Jesus Christ.
9 But he that lacketh these things is blind, and cannot see afar off, and hath forgotten that he was purged from his old sins.
10 Wherefore the rather, brethren, give diligence to make your calling and election sure: for if ye do these things, ye shall never fall:
11 For so an entrance shall be ministered unto you abundantly into the everlasting kingdom of our Lord and Saviour Jesus Christ.

Forest Lawn Cemetery, Buffalo, New York

Page 100:
St. Roch Cemetery, New Orleans, Louisiana

And further, in Philippians 4:

> 8 *"Finally, brethren, whatsoever things are true, whatsoever things are honest, whatsoever things are just, whatsoever things are pure, whatsoever things are lovely, whatsoever things are of good report; if there be any virtue, and if there be any praise, think on these things."*

In the cemetery, most depictions of the Virtues have the name of the virtue as part of the sculpture. Sometimes single sculptures do not name the virtue, but they all have unique sculptural attributes and are easy to identify.

Faith

Faith is depicted as a woman with a cross or sometimes with a chalice or candle. She can be seen at a baptismal font or holding an oil-burning lamp. In art her symbols are the color blue, the emerald, and a child. Sometimes St. Peter is at her feet.

Hope

In art, Hope is often seen with wings. In funerary art, she seldom has wings, which probably upset the balance of groupings of Virtues. But she is almost always seen with an anchor, an ancient symbol of hope. Artistic depictions of her may show her with a ship on her head, an allusion to a hopeful voyage to the next realm, or with a basket of flowers.

Right and below:
Forest Lawn Cemetery, Buffalo, New York

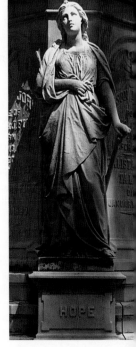

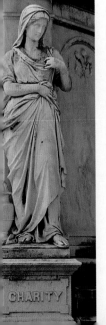

Charity

In art, Charity is almost always portrayed nursing an infant. But in the properly chaste Victorian era, cemetery sculptures of Charity show her in the process of revealing one breast. More or less cleavage is revealed depending on the taste of the sculptor or client. She may also be depicted with a flame, torch, or candle, or with food for the hungry or clothes for the needy.

Temperance

Temperance crops up in cemetery sculptures on the tombs of prohibitionists and teetotalers. She is usually seen with some sort of water pitcher, extolling the virtues of clean living, and sometimes also with a torch. Other attributes of Temperance are a bridle and bit (control) and a sheathed sword (restraint).

Prudence

Sculptures of Prudence are not often seen in the cemetery, since, in art, she has two heads and may be portrayed with a snake or dragon, which doesn't fit well with the other Virtues. Other times she is simply seen with a mirror. The two heads and the mirror

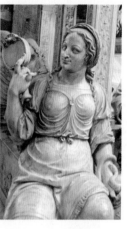

are not symbols of vanity; rather, they are used to symbolize the wisdom of the quest for self-knowledge. The sculpture of Prudence in this picture, found on the corner of the catafalque of Louis XII and Anne of Brittany in St. Denis Chapel near Paris, has a mirror in her right hand and a snake wrapped around her left hand.

Above:
Mountain View Cemetery, Oakland, California

Left:
The Abbey Church of St. Denis, Paris, France

Below:
Forest Lawn Cemetery, Buffalo, New York

Fortitude

Fortitude is depicted as a female warrior. In art, she is often seen with a club and wearing little more than a helmet and a shield. In the cemetery, sculptors portray her in a confident stance (hand on hip) with a large stick, club, or sword at her side. She may also be seen with a column at her side, an allusion to Samson's destruction of the Philistine temple.

Justice

Sculptures of Justice are more likely to be seen hovering over the entrance to courthouses than in the cemetery. Justice is one of the easier virtues to identify, since she is always shown holding scales. An angel with scales is the Archangel

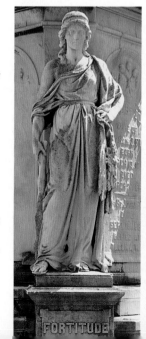

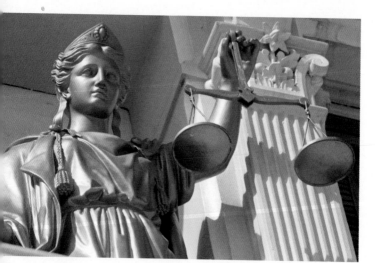

Michael. Popular mythology says that depictions of Justice always show her blindfolded, suggesting that Justice is not influenced by outside appearances. In fact, Baroque artists added the blindfold; many depictions of Justice show her with a straightforward stare.

HUMAN BODY PARTS

Breasts

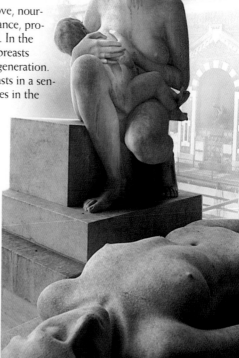

Breasts are a symbol of love, nourishment, comfort, abundance, protection, and motherhood. In the context of motherhood, breasts symbolize rebirth and regeneration. Biblical lore refers to breasts in a sensual way a number of times in the Old Testament, most graphically in Ezekiel 23:21—*"Thus thou calledst to remembrance the lewdness of thy youth, in bruising thy teats by the Egyptians for the paps of thy youth."*

In funereal symbolism, the word *breast* is discarded for the more chaste *bosom*. Funeral liturgies often speak of the souls of the righteous taking their rest in Abraham's bosom, where they await the resurrection.

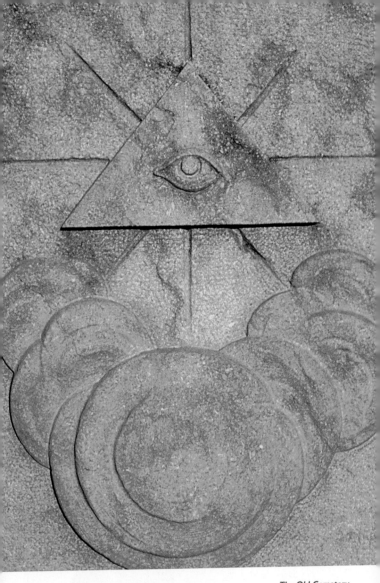

Eye

The all-seeing eye with rays of light is an ancient symbol for God. Although many cultures have eye symbols, some good and some evil, when seen in a cemetery it usually means that the person was a Mason. This symbol is familiar to us all as one of the mysterious images on the reverse of the dollar bill. Its placement there is largely the result of America's Founding Fathers, among them George Washington, Benjamin Franklin, Alexander Hamilton, Paul Revere, and John Paul Jones, who were Masons. In fact, one scholar describes Washington's Continental Army as a "Masonic convention."

The Old Cemetery,
Barcelona, Spain

Facing:
North Laurel Grove
Cemetery,
Savannah, Georgia

Foot

The human foot symbolizes humility and service since it touches the earth. The washing of feet was a common practice in biblical times. It is referred to in Luke 7:

> 37 And, behold, a woman in the city, which was a sinner, when she knew that Jesus sat at meat in the Pharisee's house, brought an alabaster box of ointment,
> 38 And stood at his feet behind him weeping, and began to wash his feet with tears, and did wipe them with the hairs of her head, and kissed his feet, and anointed them with the ointment.

And at length in John 13:

> 1 Now before the feast of the passover, when Jesus knew that his hour was come that he should depart out of this world unto the Father, having loved his own which were in the world, he loved them unto the end.
> 2 And supper being ended, the devil having now put into the heart of Judas Iscariot, Simon's son, to betray him;
> 3 Jesus knowing that the Father had given all things into his hands, and that he was come from God, and went to God;
> 4 He riseth from supper, and laid aside his garments; and took a towel, and girded himself.
> 5 After that he poureth water into a bason, and began to wash the disciples' feet, and to wipe them with the towel wherewith he was girded.

> 6 Then cometh he to Simon Peter: and Peter saith unto him, Lord, dost thou wash my feet?
> 7 Jesus answered and said unto him, What I do thou knowest not now; but thou shalt know hereafter.
> 8 Peter saith unto him, Thou shalt never wash my feet. Jesus answered him, If I wash thee not, thou hast no part with me.
> 9 Simon Peter saith unto him, Lord, not my feet only, but also my hands and my head.
> 10 Jesus saith to him, He that is washed needeth not save to wash his feet, but is clean every whit: and ye are clean, but not all.
> 11 For he knew who should betray him; therefore said he, Ye are not all clean.
> 12 So after he had washed their feet, and had taken his garments, and was set down again, he said unto them, Know ye what I have done to you?
> 13 Ye call me Master and Lord: and ye say well; for so I am.
> 14 If I then, your Lord and Master, have washed your feet; ye also ought to wash one another's feet.
> 15 For I have given you an example, that ye should do as I have done to you.
> 16 Verily, verily, I say unto you, The servant is not greater than his lord; neither he that is sent greater than he that sent him.
> 17 If ye know these things, happy are ye if ye do them.

Hand Coming Down

In early Christian art, it was forbidden to depict the countenance of God. This was largely due to an interpretation of the fourth commandment, found in Exodus 20:4—*"You shall not make for yourself an idol, or any likeness of what is in heaven above or on earth beneath or in the water under the earth."*

But the Bible is packed with references to the hand or arm of God, so the presence of God was permitted. Thus, the presence of the Almighty was often depicted as a hand emerging from the clouds, sometimes with three fingers pointing down representing the Trinity, other times holding a flower and sometimes holding a broken chain.

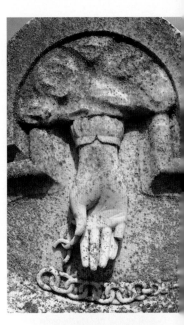

Hands Pointing Up

A hand pointing up is usually an indication that the soul has risen to the heavens. If the first two fingers are together and the deceased is a member of the clergy, the hand represents the hand of God *(Manus Dei)*. In this context, the hand is a symbol of the Trinity and is usually enclosed in a circle or has rays of light emanating from it. A less common upright hand is the Greek form of the Manus Dei, where the first two fingers and the fourth finger are upright and the third finger is bent down. This configuration simulates the letters IC XC, which are contractions of the name Jesus Christ in Greek (see page 86).

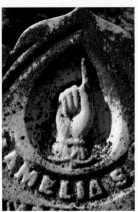

Hollywood Cemetery, Richmond, Virginia

Hands Together

Hands that appear to be shaking are usually a symbol of matrimony. Look carefully at the sleeves. One should appear feminine and the other masculine. If the sleeves appear to be gender neutral, the hands can represent a heavenly welcome or an earthly farewell.

Oak Hill Cemetery, Red Bluff, California

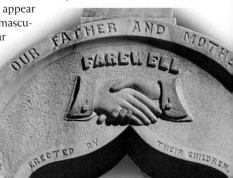

Heart

The human heart is the symbol for the deepest heartfelt emotions, including love (Valentine's Day); courage (the cowardly lion's desire in the Wizard of Oz); sorrow (a broken heart); and joy ("my heart soars like an eagle," a Native American phrase now used in New Age spiritualism). The deep religious symbolism of the heart is aptly illuminated in 1 Samuel 16:

> 7 But the LORD said unto Samuel, Look not on his countenance, or on the height of his stature; because I have refused him: for the LORD seeth not as man seeth; for man looketh on the outward appearance, but the LORD looketh on the heart.

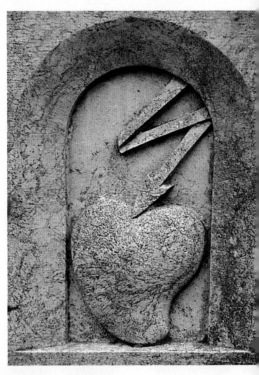

Facing, upper:
Hills of Eternity Memorial Park, Colma, California

Below:
San Michele Cemetery, Venice, Italy

In religious and cemetery symbolism, a flaming heart symbolizes religious fervor, a pierced heart indicates repentance and devotion, and a heart wrapped in thorns is associated with the Great Promise of the Immaculate Heart of Mary. The heart surrounded by thorns is especially appropriate in the cemetery because it refers to a promise made at the hour of one's death that was revealed to Lucy of Fatima in 1925, when she saw a vision of the Virgin Mary holding a heart surrounded by thorns. The following is a part of Catholic doctrine:

> I promise to assist at the hour of death, with the graces necessary for salvation, all those who, on the first Saturday of five consecutive months, shall confess, receive Holy Communion, recite five decades of the Rosary, and keep me company for fifteen minutes, while meditating on the fifteen mysteries of the Rosary, with the intention of making reparation to me.

Modern tombstones often use hearts to symbolize matrimony.

Nudity

Christian teachings classify nudity in four different ways: *nuditas naturalis* is the condition that all of us were born in, *nuditas temporalis* refers to a lack of worldly goods, *nuditas virtualis* represents the qualities of virtue and innocence, and *nuditas criminalis* is the absence of virtue and refers to the traits of vanity and lust. Nudity in funereal art, while at times certainly sensual and provocative, usually would come under the heading of *nuditas virtualis*.

WORLDLY SYMBOLS

Much of the world we live in is composed of things we have manufactured and built. In the world of symbolism, common items like doors, tents, ladders, lamps, and anchors are not always what they seem.

When we see depictions of the natural world in funerary art, their meaning can be taken more literally: rocks are for permanence, water is fleeting and temporary, stars speak of wonder, and the moon hints of mystery.

THE CONSTRUCTED WORLD

Balls

Stone balls in the cemetery are almost always purely decorative. Cannonballs often ring veterans' gravesites. But if they occur in a group of three they could be a reference to gifts or money, like the three balls seen hovering over a pawnbroker's shop. The use of three balls to symbolize money comes from the legend of St. Nicholas of Myrna, who threw three sacks of money into the window of a poor man's house to allow him to provide dowries for his three daughters. St. Nicholas is also said to be a purveyor of secret gifts for children. In this context he is better known as Santa Claus.

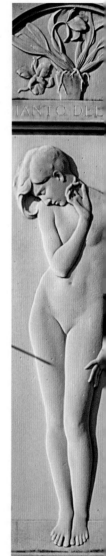

Above:
*Cimitero
Monumentale,
Milan, Italy*

Left:
*Forest Lawn
Cemetery,
Buffalo, New York*

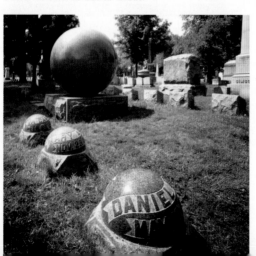

Coins (Money)

One of the most frequently misquoted passages in the Bible is, "Money is the root of all evil." In fact, the actual passage is in 1 Timothy 6:10—*"For the love of money is the root of all evil: which while some coveted after, they have erred from the faith, and pierced themselves through with many sorrows."*

Indeed, money in symbolism can be likened to charity as much as it can to greed. It is all a matter of context.

Anchor

The anchor is a symbol of hope. The reason for this symbolic meaning comes from the passage in the Epistle to the Hebrews 6:

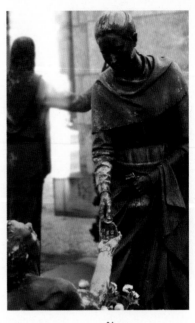

19 Which hope we have as an anchor of the soul, both sure and stedfast, and which entereth into that within the veil; 20 Whither the fore-runner is for us entered, even Jesus, made an high priest for ever after the order of Melchisedec.

Statues of the Virtue of Hope have her leaning on an anchor.

Above:
Cimitero Monumentale, Milan, Italy

Left:
Mount Hope Cemetery, Hiawatha, Kansas

Below:
The English Cemetery, Florence, Italy

Anchor Cross

Known as the *crux dissimulata*, this anchor is actually a cross in disguise (the bottom open curve represents receptivity to spiritual matters). When Christians first started practicing their religion, they had to do it under a veil of secrecy lest they be persecuted for their beliefs. The anchor cross was one way Christians could broadcast their religion to other followers without being discovered. It is, understandably, a more popular symbol in cemeteries in coastal cities, but it does not always have a link to the seafaring life.

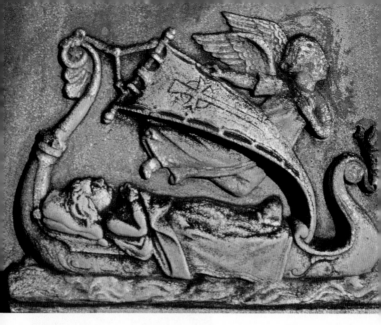

Boat

Virtually all civilizations use an image of a boat
with the body of the deceased to represent a voy-
age or the crossing over to the "other world." The
boat also suggests a return to the cradle or the
womb. A pilot-less boat implies that God guides
the soul's journey.

Ship

Ships have religious and nonre-
ligious meanings in the ceme-
tery. Usually ships are used to
mark the grave of one who led
a seafaring life, often in refer-
ence to one who went down
with the ship. Ships are used in
landlocked ways as in the "ship
of state." In biblical symbolism
the earliest reference to a large
seagoing vessel is Noah's ark,

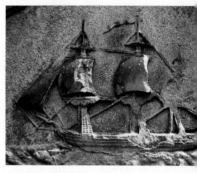

*The Howff,
Dundee, Scotland*

which has become a symbol of the Church since
it weathered the storm against overwhelming odds,
protecting and saving all that were on it. In the
writings of St. Ambrose, he equates the ship as
the Church and the mast as the cross.

*Oroville Cemetery,
Oroville, California*

Book, Closed

In the cemetery a closed book usually represents a
completed life; the last chapter in this realm ends
in the cemetery. It may also represent virginity,
secrecy, and mystery. Any book can also represent
the Bible.

Book, Open

An open book is a favorite device for registering the name of the deceased. In its purest form an open book can be compared to the human heart, its thoughts and feelings open to the world and to God.

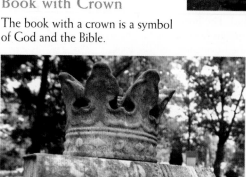

Book with Crown

The book with a crown is a symbol of God and the Bible.

Above:
Albany Rural Cemetery, Menands, New York

Left:
Rock Creek Cemetery, Washington, D.C.

Below:
Serbian Cemetery, Colma, California

Crown

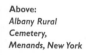

From the earliest times, the crown has been a symbol of victory, leadership, and distinction. Eventually it became a symbol of royalty. The Pope wears a triple crown (tiara), a symbol of his triple royalty and of the Trinity. Crowns are often used as attributes of a variety of saints to denote that they were either a martyr or of royal blood. The most often depicted crown in Christian symbolism is Christ's crown of thorns.

Cross with Crown

The cross with a crown is a Christian symbol of the sovereignty of the Lord. When the crown is combined with a cross, the crown means victory and the cross means Christianity. The cross with a crown also denotes a member of the York Rite Masons. As with all types of crowns used by the Masons, it symbolizes the power and authority to lead or command. (*See also* Knights Templar on page 193.)

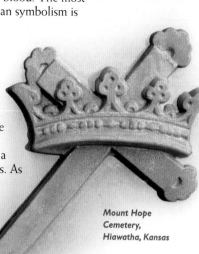

Mount Hope Cemetery, Hiawatha, Kansas

Anvil

The anvil symbolizes the primordial forging of the universe. It is an attribute of the storm and thunder gods Vulcan (Roman) and Thor (Norse). In Christian symbolism, the anvil is an attribute of St. Eligius (Eloy), the patron saint of blacksmiths. The story goes that around the year 610, St. Eligius brought a horse to his forge to be shod. The horse kicked furiously, causing everyone to flee except St. Eligius, who calmly cut off the horse's leg, put the foot on his anvil, affixed a new shoe, and rejoined the severed limb to the horse.

Chico Cemetery, Chico, California

Candelabra

Candles and candelabras symbolize light during the dark times of life and also light the way to the next world. Candles are a common funerary device in Eastern and Western funeral rites. Two candles on either side of a cross represent the dual nature of Christ. Three candles represent the Trinity. In Qabalism, three candles represent wisdom, strength, and beauty. Four candles represent the four evangelists. Five candles

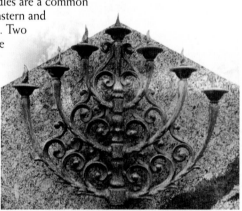

are symbolic of the wounds of Christ. Six candles is the number of creation and perfection, signifying the six days God took to create the earth, less the seventh day of rest. Seven candles can also represent the seven days of creation; the seven deadly sins; the sevenfold gifts of the Holy Spirit; the sun, moon, and five principal planets; and the seven joys and seven sorrows of the Virgin.

Cimitero Monumentale, Milan, Italy

Odd Fellows Cemetery, Virginia City, Nevada

Crook (Crosier)

In the cemetery, shepherds crooks, or crosiers, are often associated with fallen Odd Fellows. The end of the crook, which is shaped like a semicircular hook, symbolizes the opening of the earth to the powers of heaven. The crook was an ancient emblem of rulership in

Egypt, Assyria, and Babylonia, and was an attribute of the Egyptian god Osiris. In Christian symbolism the crook is an emblem of the Apostles and is associated with Christ in his role as the Good Shepherd.

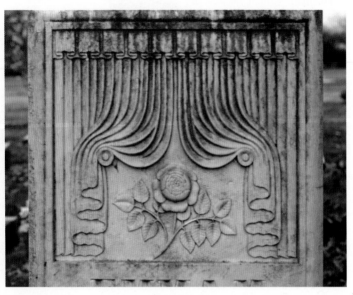

*Oak Hill Cemetery,
Red Bluff, California*

Curtain (Veil)

The veil, which in funerary art usually looks more like a curtain, is a symbol of the passage from one type of existence to another. Veils are meant to protect as well as conceal. The veil that covered the Ark of the Covenant was meant to protect mere mortals from its radiance. Christians had a new interpretation of the Ark of the Covenant, which they called the Glory of the New Covenant. It is explained in 2 Corinthians 3:

> *13 And not as Moses, which put a vail over his face, that the children of Israel could not stedfastly look to the end of that which is abolished:*
> *14 But their minds were blinded: for until this day remaineth the same vail untaken away in the reading of the old testament; which vail is done away in Christ.*
> *15 But even unto this day, when Moses is read, the vail is upon their heart.*
> *16 Nevertheless when it shall turn to the Lord, the vail shall be taken away.*
> *17 Now the Lord is that Spirit: and where the Spirit of the Lord is, there is liberty.*
> *18 But we all, with open face beholding as in a glass the glory of the Lord, are changed into the same image from glory to glory, even as by the Spirit of the Lord.*

Door

The door is an obvious partition symbolizing the transition from one realm to the next. Unlike gates, which, because of their porous nature, provide us with a ready view into the world beyond, there is always a certain amount of mystery attached to the partially opened door. The mysterious aspect aside, doors are ultimately viewed as a sign of hope and opportunity in all cultures. Cathedrals often have three doors symbolizing Faith, Hope, and Charity. In Christian teachings, Christ is often referred to as the "door to heaven."

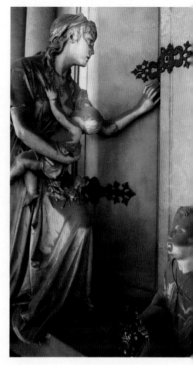

Fountain

In Christian symbolism, the fountain is an attribute of the Virgin Mary, who is widely regarded as the fountain of living waters. This symbolism is an adaptation of a passage in the Song of Solomon 4:15—*"A fountain of gardens, a well of living waters, and streams from Lebanon."*

And also in Psalm 36:

> 8 *They shall be abundantly satisfied with the fatness of thy house; and thou shalt make them drink of the river of thy pleasures.*
> 9 *For with thee is the fountain of life: in thy light shall we see light.*

Gate

In Christian funerary symbolism, gates represent the passage from one realm to the next. In scenes of the Last Judgment, gates are always central in the picture. Often Christ is seen breaking through these dividing barriers between the damned and the righteous.

Upper and above:
Cimitero Monumentale, Milan, Italy

Left:
Wyuka Cemetery, Lincoln, Nebraska

Ladder

This illustration depicts a ladder on the tomb-stone of a Freemason. The letters C, H, and F are abbreviations for Charity, Hope, and Faith. When the ladder is seen ascending toward the clouds (heavens), it is known as Jacob's ladder, a symbol of the pathway between heaven and earth, in reference to the vision of Jacob as described in Genesis 28:

> 10 And Jacob went out from Beersheba, and went toward Haran.
> 11 And he lighted upon a certain place, and tarried there all night, because the sun was set; and he took of the stones of that place, and put them for his pillows, and lay down in that place to sleep.
> 12 And he dreamed, and behold a ladder set up on the earth, and the top of it reached to heaven: and behold the angels of God ascending and descending on it.

St. Paul's Cemetery, Halifax, Nova Scotia, Canada

The ladder is also one of the symbols of the Passion since it was used to take Christ down from the cross.

The most interesting aspect of the ladder as a transport mechanism between heaven and earth is that the ladder is comprised of rungs, and each rung must be negotiated before another one is attempted. Ladders are used in many different religions, including Buddhism, Islam, Polynesian, Native American, and in ancient mythology. Oftentimes these ladders have seven rungs, which correspond to the Seven Heavens.

Lamp

Because of the light emitted by it, the lamp is a symbol of wisdom, faithfulness, and holiness. In 2 Samuel 22, a lamp is a symbol for God:

> 28 And the afflicted people thou wilt save: but thine eyes are upon the haughty, that thou mayest bring them down.
> 29 For thou art my lamp, O LORD: and the LORD will lighten my darkness.
> 30 For by thee I have run through a troop: by my God have I leaped over a wall.

San Michele Cemetery, Venice, Italy

The most referenced part of the Bible in relation to the symbolism of the lamp is the Parable of the Ten Virgins in Matthew 25:

> 1 Then shall the kingdom of heaven be likened unto ten virgins, which took their lamps, and went forth to meet the bridegroom.

2 *And five of them were wise, and five were foolish.*

3 *They that were foolish took their lamps, and took no oil with them:*

4 *But the wise took oil in their vessels with their lamps.*

5 *While the bridegroom tarried, they all slumbered and slept.*

6 *And at midnight there was a cry made, Behold, the bridegroom cometh; go ye out to meet him.*

7 *Then all those virgins arose, and trimmed their lamps.*

8 *And the foolish said unto the wise, Give us of your oil; for our lamps are gone out.*

9 *But the wise answered, saying, Not so; lest there be not enough for us and you: but go ye rather to them that sell, and buy for yourselves.*

10 *And while they went to buy, the bridegroom came; and they that were ready went in with him to the marriage: and the door was shut.*

11 *Afterward came also the other virgins, saying, Lord, Lord, open to us.*

12 *But he answered and said, Verily I say unto you, I know you not.*

13 *Watch therefore, for ye know neither the day nor the hour wherein the Son of man cometh.*

Flute

Flutes are frequently mentioned in the Bible, usually in terms of entertainment rather than with any special spiritual attributes. Like the lyre, flutes are often seen as instruments of playfulness. In mythology, Pan (Faunus), the god of shepherds, woods, and pastures, is depicted prancing through the woods, playing a flute made of reeds. Pan has the legs, horns, and beard of a goat. This frightful combination is the source for the word *panic*.

Harp

The ethereal tones of the harp have long been associated with heavenly aspirations. Harps are mentioned frequently in the Bible as a musical entertainment and as a source of divine music. David's prowess with the harp is mentioned in 1 Samuel 16:

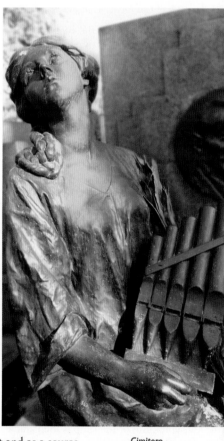

Cimitero Monumentale, Milan, Italy

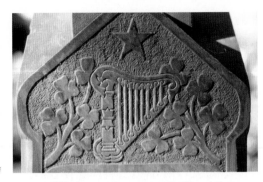

Seamen's Cemetery, Lahaina, Maui, Hawaii

Oak Hill Cemetery, Red Bluff, California

22 And Saul sent to Jesse, saying, Let David, I pray thee, stand before me; for he hath found favour in my sight.

23 And it came to pass, when the evil spirit from God was upon Saul, that David took an harp, and played with his hand: so Saul was refreshed, and was well, and the evil spirit departed from him.

Lyre

A lyre is usually depicted as a more playful instrument than the harp. There is a Chinese legend where P'ao-pa makes the birds and fishes dance while playing a lute, and Chen-wen creates the four seasons by plucking each of the four strings, creating harmony by strumming all of the strings. In Western mythology, the lyre is one of Apollo's attributes. This particular example has a funereally appropriate, artfully rendered broken string.

San Michele Cemetery, Venice, Italy

Music

Musical notes or a musical score on a tombstone almost always symbolize a favorite song of the deceased, or sometimes the music is a hymn like "Rock of Ages." The Greek philosopher Pythagoras is credited with inventing the monochord to determine musical scale. Almost all cultures equate the structure and rhythm of music with unity in the cosmos.

Music has often been associated with reverence, as depicted in Daniel 3:7— *"Therefore at that time, when all the people heard the sound of the cornet, flute, harp, sackbut, psaltery, and all kinds of musick, all the people, the nations, and the languages, fell down and worshipped the golden image that Nebuchadnezzar the king had set up."*

Castle

Castles are fortresses and strongholds. In the cemetery they are usually shown as a single tower, much like a "castle keep," where royal families retreated in times of siege. Usually the castle will have three windows or openings, a reference to the Trinity. God as a fortress is described in Psalm 59:

> 16 But I will sing of thy power; yea, I will sing aloud of thy mercy in the morning: for thou hast been my defence and refuge in the day of my trouble.
> 17 Unto thee, O my strength, will I sing: for God is my defence, and the God of my mercy.

A castle with two towers, one on either side of the entry, is the insignia of the U.S. Army Corps of Engineers, which traces its history to 1775 when the Continental Congress authorized the first Chief Engineer to build fortifications at Bunker Hill.

City Mansions

In the King James Version of the Bible is the oft-quoted phrase in John 14:2: *"In my Father's house are many mansions: if it were not so, I would have told you. I go to prepare a place for you."*

In that quote, "house" really means "city," and the quote is the source for depictions of cities with glorious mansions in Christian art as well as tombstones. Interestingly, in subsequent versions of the Bible, God's abode has been downsized to a simple house with many rooms:

The New International Version (© 1973) of the Bible reads, *"In my Father's house are many rooms; if it were not so, I would have told you. I am going there to prepare a place for you."*

Cimitero Monumentale, Milan, Italy

Paia Cemetery, Paia, Maui, Hawaii

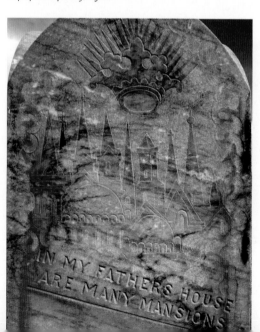

The New American Bible (© 1986) changes "rooms" to "dwelling places" and makes the quote a question: *"In my Father's house there are many dwelling places. If there were not, would I have told you that I am going to prepare a place for you?"*

The Message (© 1993) version of the Bible changes the passage even more: *"There is plenty of room for you in my Father's home. If that weren't so, would I have told you that I'm on my way to get a room ready for you?"*

Nevertheless, the spirit of the quote is that there is room for everybody, provided they follow the necessary dictates prescribed in the Bible.

Temple

Rather severe-looking modern churches on relatively new tombstones are often depictions of the temples of The Church of Jesus Christ of Latter-day Saints, whose members are better known as LDS or Mormons. Understandably, more of these are found worldwide where the LDS Church has a substantial following. The most depicted Mormon temple is the Salt Lake Temple, located in Salt Lake City, Utah. Other LDS temples often portrayed include those located in Ogden, Utah; Boise, Idaho; and Oakland, California, to name a few.

Oakland Temple
Chico Cemetery,
Chico, California

Tent

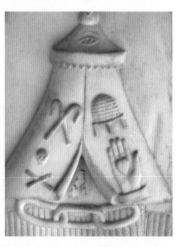

Despite its diminutive size, the tent is jam-packed with symbolism. According to Exodus, Moses was given instructions for a portable tent-like sanctuary that was to be the center of Israel's worship. This sanctuary is called the "Tabernacle" and the "Tent of Meeting." It measured 45 feet long and 15 feet wide, and was divided into two parts. The forecourt contained a lampstand, an incense altar, and a table with twelve loaves of bread. The inner court housed the Ark of the Covenant, which contained the tablets on which the Ten Commandments were written. The Israelites took the Tent of Meeting with them as they traveled through the wilderness from Mount Sinai to Canaan. After Solomon built the first temple in Jerusalem, the tabernacle was no longer used.

Masonic Cemetery,
Virginia City, Nevada

Societies all over the world associate the tent as a place to summon the powers of God. Secret societies frequently use tents or tent-like structures in their initiation rights. The Freemasons put an initiate in a "Chamber of Reflection," which contains a candle that illuminates a human skull, some bones, a piece of bread, a glass of water, an hourglass, and two saucers (one containing salt and the other containing sulphur). On the wall is a scythe, a picture of a rooster, and the initials V. I. T. R. I. O. L., which is the ancient Latin phrase *visita interiora terrae, rectificando invenies occultam lapidem* ("visit the center of the earth, and by rectifying you shall find the hidden stone"). After a proper time of contemplation, the initiate writes down his thoughts and emerges from the *tent*, ready to begin his journey in Freemasonry.

Helmet

The helmet represents power, protection, and sometimes, thought. In mythology, Perseus used a winged helmet to allow him to escape after he slew Medusa, the Gorgon. In funerary art, the virtue Faith is usually shown with a helmet. A biblical reference to the use of a helmet as protection can be found in Psalm 60:7—"*Gilead is mine, and Manasseh is mine; Ephraim also is the strength of mine head; Judah is my lawgiver; . . .*"

San Michele Cemetery, Venice, Italy

THE NATURAL WORLD

Feather

Wyuka Cemetery, Lincoln, Nebraska

Because of their lightness and their association with wings, feathers can be a symbol of the ascent to the heavens. A feather can also represent the authority to administer justice because, even though the feather is very light, it is enough to tip the scales. For this reason it is associated with the Pope's authority to rule. Plumes are often seen at the corners of awnings that cover the platform where the Pope sits. Nowadays feathers are often seen decorating the graves of Native Americans.

Flame

In the cemetery, flames usually represent eternal life or eternal vigilance. In Christian religious iconography, flames and fire represent religious fervor and, often, martyrdom because so many saints met their end by various methods of incineration. Until recently, the Catholic Church banned cremation for its members because the Romans, to mock the Christian belief of resurrection, burned Christians at the stake to prevent the resurrection of the body.

Woodlawn Cemetery, Bronx, New York

Rock

In Christian lore, rocks are a powerful symbol of the Lord. The Old Testament is replete with references to water coming from rocks and comparing God to a rock. One example of rocks yielding water is in Exodus 17:

> *5 And the LORD said unto Moses, Go on before the people, and take with thee of the elders of Israel; and thy rod, wherewith thou smotest the river, take in thine hand, and go.*
> *6 Behold, I will stand before thee there upon the rock in Horeb; and thou shalt smite the rock, and there shall come water out of it, that the people may drink. And Moses did so in the sight of the elders of Israel.*

One of the many comparisons of a rock to God is in Psalm 18:2—*"The LORD is my rock, and my fortress, and my deliverer; my God, my strength, in whom I will trust; my buckler, and the horn of my salvation, and my high tower."*

In Matthew 16:18, Christ refers to St. Peter as the rock that is the cornerstone of his Church: *"And I say also unto thee, That thou art Peter, and upon this rock I will build my church; and the gates of hell shall not prevail against it."*

In almost all cultures, rocks represent permanence, stability, reliability, and strength. But they can also represent emotional coldness.

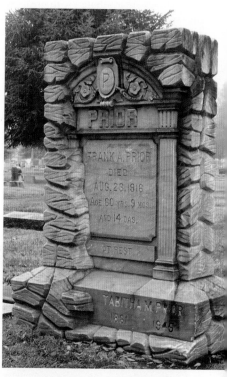

Chico Cemetery, Chico, California

Stone

One large stone next to a tomb refers to the Resurrection. This event is detailed in a number of books in the New Testament, including Luke 24:

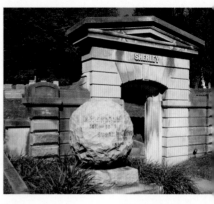

> 1 Now upon the first day of the week, very early in the morning, they came unto the sepulchre, bringing the spices which they had prepared, and certain others with them.
> 2 And they found the stone rolled away from the sepulchre.
> 3 And they entered in, and found not the body of the Lord Jesus.

Cave Hill Cemetery, Louisville, Kentucky

Large stones are attributed with great power and were used to build megalithic shrines like Stonehenge. Perhaps the best-known sacred large stone is the Black Stone of the Kaaba at Mecca. Smaller stones are also associated with power. Scotland has its Stone of Destiny at Scone Palace; the Irish have the Blarney Stone, which they kiss to give them "the gift of gab"; stone chimes are Chinese fertility symbols; and in many cultures, thrown stones are associated with death.

Star

A star or stars lighting the heavens is a symbol of divine guidance. A single star is almost always a symbol of the Star of the East that guided the Magi to Bethlehem. Twelve stars are a symbol of

Cimitero Monumentale, Milan, Italy

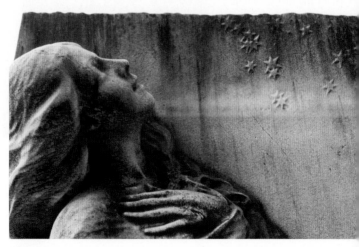

the Twelve Apostles or the Twelve Tribes of Israel. A crown with twelve stars refers to a description of the Queen of Heaven in Revelation 12:1— *"And there appeared a great wonder in heaven; a woman clothed with the sun, and the moon under her feet, and upon her head a crown of twelve stars: . . ."*

Other cultures, of course, abound with star symbology, which is often used to symbolize the highest attainment. The two stars most often referenced are the Pole Star, or North Star, and Venus, which is a planet and not a star. Venus is attributed with warfare and life energy when seen as a morning star and with sexuality and fertility when seen as an evening star. After death, Egyptian Pharaohs were identified with the Pole Star. The Chinese depict spiritual wisdom using a combination of stars, Sun, and Moon. In Greco-Roman mythology, planetary gods are depicted with a star on their forehead. Islamic symbolism depicts a star with a crescent as a sign of divinity and supremacy.

San Michele Cemetery, Venice, Italy

Sun and Moon

In the cemetery, Sun and Moon together are likely to be fairly modern symbols, relating more to the cosmos in general rather than any specific religion. In Christian symbolism, the combination of Sun and Moon are attributes of the Virgin Mary as described in Revelation 12:1 (see Star above). Sun and Moon are also part of the Freemasons' vast repertoire of symbols.

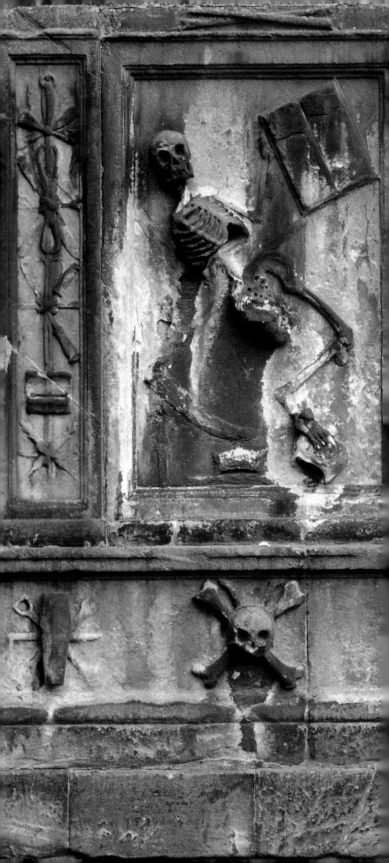

MOrTaLITY SYMBOLS

I T GOES WITHOUT SAYING that the
cemetery is the best place to find mortality
symbols. In fact, many of these symbols can
only be found in the cemetery. Most folks
don't want to be reminded that their time in
this realm is fleeting, especially in the modern age
when professionals handle the business of death.
It was not always so. A couple of hundred years
ago when infant mortality rates were very high
and most folks died at home, the common person
was familiar with the process of dying and death.
The dead were laid out in parlors for all to see—
and to be reminded that death comes to us all.
There were even books that explained the proper
way to die. A whole genre of books called *ars
moriendi* detailed in words and pictures (most
people were illiterate) "the good death." The
leading character, of course, was the dying per-
son, but the proper behavior was explained for
the family, the clergy, and the doctor. Family
excursions to the cemetery were much more
popular a hundred years ago than they are today.
Thus, people were more attuned to their mortal-
ity than they are nowadays.

As a rule, the older the tombstone, the more
literal is its mortality symbolism. It's unlikely that
a cemetery wanderer will find a skull and cross-
bones on a modern tombstone, but they were
commonplace a few hundred years ago. At the
time, these graphic mortality symbols were
grouped under the heading of *Memento Mori* (see
page 132).

Arrows, Lances, Swords

Projectiles such as arrows, lances, swords, and
bladed instruments like the ax and the scythe
can be grouped under the heading "weapons of
death." On this panel of a zinc tombstone they
probably represent a person's association with

the military. Individually these weapons have their own symbolism and attributions. St. Sebastian is often depicted with arrows in him; because he is said to have survived, he became one of the patron saints of victims of the plague. By extension, the arrow is a symbol of the plague. Because it was used to pierce the body of Christ, the lance is a symbol of the Passion. It is also an attribute of St. Thomas because one killed him. The archangel Michael is almost always portrayed with a sword, which is an attribute of a number of saints because so many were beheaded by one.

Above:
Oahu Cemetery,
Honolulu, Hawaii

Chair, Empty or Vacant

Empty chairs are usually depicted with a small pair of shoes, one of them usually on its side, for the vacant chair symbolizes the death of a child. This is aptly illustrated in a poem that appeared in *Godey's Lady's Book* in January 1850.

Page 126:
Greyfriars
Churchyard,
Edinburgh, Scotland

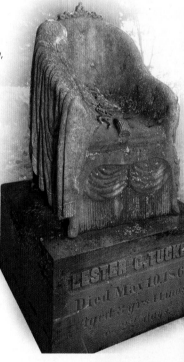

THE VACANT CHAIR
by Richard Coe Jr.

WHEN we gather round our hearth,
Consecrated by the birth
Of our eldest, darling boy,
Only one thing mars our joy:

'Tis the dreary corner, where
Stands, unfilled, the vacant chair!
Little Mary, bright and blest,
Early sought her heavenly rest.
Oft we see her in our dreams—
Then an angel one she seems!
But we oftener see her, where
Stands, unfilled, the vacant chair.

But 'twere sinful to repine;
Much of joy to me and mine
Has the gentle Shepherd given.
Little Mary is in heaven!
Blessed thought! while gazing where
Stands, unfilled, the vacant chair.

Many parents, kind and good,
Lost to them their little brood,
Bless their Maker night and day,
Though he took their all away!
Shall we, therefore, murmur, where
Stands, unfilled, one vacant chair!

Oakwood Cemetery,
Syracuse, New York

Little Mary! angel blest,
From thy blissful place of rest,
Look upon us! angel child,
Fill us with thy spirit mild.
Keep o'er us thy watchful care;
Often fill the vacant chair.

A vacant chair can symbolize the death of young people as well as children. A famous Civil War ballad eulogizes eighteen-year-old John William "Willie" Grout, who was killed at Balls Bluff, Virginia, in October 1861:

THE VACANT CHAIR
Words by H. S. Washburn
Music by George F. Root (1861)

We shall meet but we shall miss him. / There will be one vacant chair.
We shall linger to caress him / While we breathe our ev'ning prayer.
When one year ago we gathered, / Joy was in his mild blue eye.
Now the golden cord is severed, / And our hopes in ruin lie.

Chorus:

We shall meet, but we shall miss him.
There will be one vacant chair.
We shall linger to caress him
While we breathe our ev'ning prayer

**Kensal Green
Cemetery,
London, England**

Column, Broken

The broken column is a symbol for the end of life and more specifically life cut short. It attained favor in the funerary arts around the middle of the nineteenth century and became one of the most popular mortality symbols because of its visual impact.

Deid Bell

Primarily seen on tombstones in the British Isles, the Deid (dead) Bell was rung to announce funerals and rung again during the funeral procession. During the actual funeral, usually

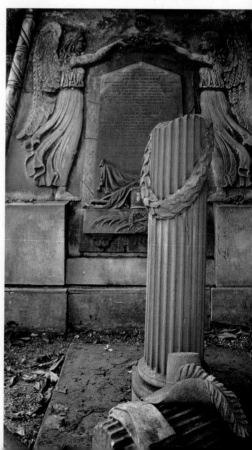

a smaller bell was rung. In almost all cultures bells have been used as a call to worship; the announcement of weddings, good news, and victories; the passing of time; and the warding off of evil. In the Western world, the most well-known funerary bell occurs in John Donne's celebrated essay "Devotions Upon Emergent Occasions," where he states:

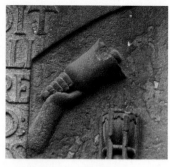

Greyfriars Churchyard, Edinburgh, Scotland

> *No man is an island, entire of itself; every man is a piece of the continent, a part of the main. If a clod be washed away by the sea, Europe is the less, as well as if a promontory were, as well as if a manor of thy friend's or of thine own were: any man's death diminishes me, because I am involved in mankind, and therefore never send to know for whom the bell tolls; it tolls for thee.*

Father Time

Father Time, the figure who drags his way to his inevitable demise on December 31, is usually depicted with a long robe and an hourglass on his head to remind us that time is running out. Occasionally he is seated with an elbow on an hourglass, but usually he is seen in a rather trudging-like pose, patiently stalking death.

St. Andrews Cemetery, St. Andrews, Scotland

Green Man

The Green Man is a popular graveyard motif in Scotland, but his image, which is a sort of hybrid between a man and a woody creature, can be seen gracing tombs and churches all over Europe. In fact, the Green Man probably has its origins in the leaf masks that were worn in Roman times. There are a couple of interpretations of the symbolic nature of the Green Man, but the most popular

Greyfriars Churchyard, Edinburgh, Scotland

belief is that he represents the new life that springs from death. Just as nature dies every winter to be renewed in the spring, so must man die to rise again new and reborn.

Grim Reaper

The Grim Reaper, with his ample scythe, is in the business of harvesting souls. Although this figure symbolically has the same purpose as Father Time and the King of Terrors, there are, arguably, subtle differences. The Grim Reaper almost always is depicted as a rather thin figure (sometimes skeletal) and is essentially ageless, while Father Time is usually portrayed as an older, more portly figure.

The roots of the Grim Reaper may be with the Greek myth of Charon, a rather seedy character who ferried the dead over the River Styx to the underworld. A coin, which was payment for the trip, is depicted in the mouth of the deceased.

Cimitero Monumentale, Milan, Italy

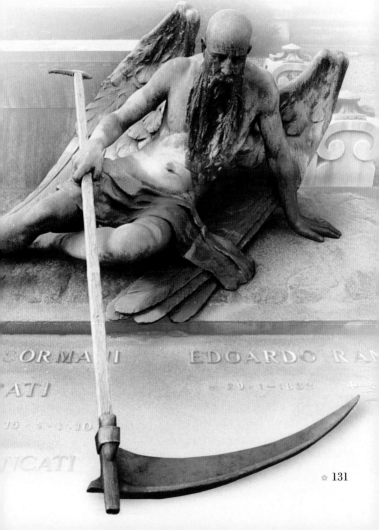

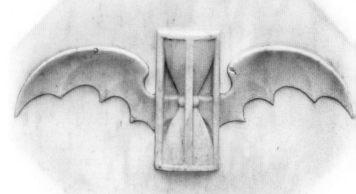

Hourglass (wings optional)

The English Cemetery, Florence, Italy

The symbolism is clear: time is passing rapidly, and every day, one comes closer to the hour of their death. A bolder interpretation of the hourglass suggests that since it can be inverted over and over again, it symbolizes the cyclic nature of life and death, heaven and earth.

Memento Mori

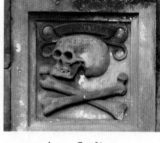

Greyfriars Churchyard, Edinburgh, Scotland

A *memento mori* is an image (drawing, sculpture, or photograph) or an item (hair locket, tear vial) that urged a person to "remember thy death." This tradition was started in Europe in the late Middle Ages, most particularly with the Black Death and the "Dance of Death." Memento mori persisted through the nineteenth century. Its purpose is to remind the viewer that death is an unavoidable part of life, something to be prepared for at all times. Memento mori images are graphic demonstrations that death was not only a more frequent occurrence in medieval Europe but also much more of a part of family and community life than it is today. Memento mori can also be in the form of an epitaph. Some of the most frequent memento mori epitaphs are various versions of this epitaph from a tombstone in the Howff Graveyard in Dundee, Scotland: "Remember Man as you Pass by / As you are now so once was I / As I am now so must you be / Remember man that you must die." This epitaph and its variants are the most common ones found on Colonial New England gravestones.

Sexton's Tools

These are the tools that the sexton uses to ply his trade. Depending on the stone carver and local tradition, various combinations of coffins and

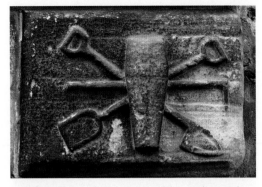

tools are depicted. Common tools are the spade,
the triangularly bladed turf cutter, and the pick.
The job description of the sexton was like a
modern-day church caretaker, except in
addition to the care and maintenance
of the church the sexton was responsi-
ble for all aspects of tending to the
needs of the graveyard. In large grave-
yards and cemeteries the sexton's job
was mostly supervisory, but in small
graveyards the sexton had to pre-
pare the ground, dig the grave,
close the grave, mow the lawn,
and maintain the roads and paths.

Skeleton

The skeleton can appear in a num-
ber of ways, but ultimately it is a
memento mori symbol. A reclining
skeleton represents a passive figure
of death, which sooner or later
(and very patiently) comes to us
all. An upright skeleton usually has
one or more of the "weapons of
death": scythe, darts, arrows, or
spear. When depicted with these
weapons the skeleton is known as
the "King of Terrors."

Skull

It is hard to think of a death symbol
quite as vivid as a skull. Other sym-
bols may suggest death, but the
skull literally is death and it
reminds us that there is no
escape. For those with
a literary bent, there are
few scenes as evocative
as the meditation
between Hamlet

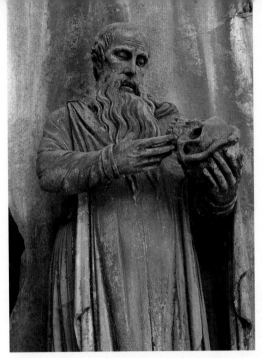

Olsany Cemetery,
Prague,
Czech Republic

and the skull of Yorick. It occurs in Act V, Scene i, in the graveyard as the gravedigger hands the skull of the King's jester to Hamlet, who says:

Evolution of the
death's head—

Both images:
ca. 1750
Valley Cemetery,
Stirling Castle,
Scotland

> *Alas, poor Yorick! I knew him, Horatio; a fellow of infinite jest, of most excellent fancy: he hath borne me on his back a thousand times; and now, how abhorred in my imagination it is! my gorge rises at it. Here hung those lips that I have kissed I know not how oft. Where be your gibes now? your gambols? your songs? your flashes of merriment, that were wont to set the table on a roar? Not one now, to mock your own grinning? quite chap-fallen? Now get you to my lady's chamber, and tell her, let her paint an inch thick, to this favour she must come; make her laugh at that.*

Death's Head

It is said that a picture is worth a thousand words and, by extension, an image is worth a thousand words. That is certainly true when looking at the evolution of a curious funerary symbol called the death's head.

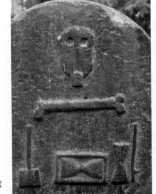

Before the Reformation (early sixteenth century) there were few formal burial grounds for common folk. The rich and powerful were buried inside the church walls, floors, and some-

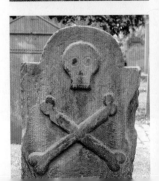

times in specially constructed tombs. But, the most important factor in choosing a final resting place was, as modern-day realtors like to say, location, location, location. The most desirable spots were the closest to the altar (the better to be inched toward the heavens on the parishioners' prayers). Changing social attitudes (many of which were the result of the Reformation), plus the problem of running out of desirable space inside the church (few new churches were being built at the time), forced the dead out of the church and into newly constructed burial grounds outside the church walls, which came to be known as God's Acres. The good news was that there was much more room for artistic expression out of the confines of the church walls. The bad news (at least for the middle class) was that their chance of making it from this realm to the next was no better than they had been before. But the opening of these God's Acres did give the middle class a place to at least erect a tombstone so they had a chance of being remembered.

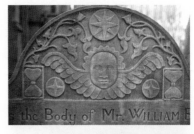

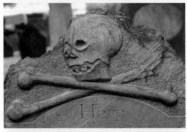

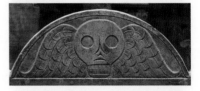

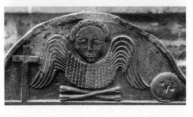

Evolution of the death's head—

1752
Trinity Churchyard, New York, New York

1755
St. Paul's Cemetery, Halifax, Nova Scotia, Canada

1757
St. Paul's Cemetery, Halifax, Nova Scotia, Canada

1784
St. Paul's Cemetery, Halifax, Nova Scotia, Canada

Enter the death's head. At the time, the Puritans had the upper hand when it came to religious thought and practices; alas, the Puritans were a pretty gloomy lot. They preached that only the elect had much of a chance in making it to heaven, while the rest of us were doomed to be born, live, die, then rot. Nowhere is that attitude more aptly illustrated than in the graveyards. In the sixteenth century, those who had the means to have a tombstone carved for their final resting place usually had their name, birth and death dates, and a skull, skull and crossbones, or skull gnawing on a femur. Usually the words *Here Lies the Body of* were placed before the name. The image of the skull plus the word *body* pretty much summed up the attitude of the time: "This person lived for a while and now he's dead . . . end of story."

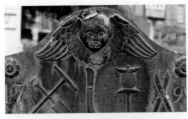

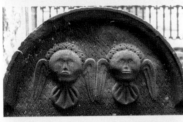

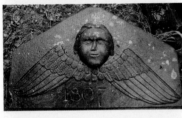

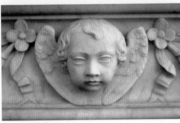

Evolution of the death's head—

1796
*The Howff,
Dundee, Scotland*

1806
*St. Paul's Cemetery,
Halifax, Nova Scotia,
Canada*

1807
*Scone Palace,
Scotland*

ca. 1910
*Cypress Lawn
Memorial Park,
Colma, California*

But somewhere in the seventeenth century the Puritans began to lose their vise-like grip on people's psyche and, ever so slightly, religious attitudes started to change. With that change came the small hope that there was a possibility that when they died they would make it to another realm. What that realm might be (heaven, hell, or purgatory) was unknown, but at least there was hope. We need go no farther than the cemetery to validate that supposition. Along with the skull and crossbones, there were also winged skulls, which gave the gravestone a lighter look and conveyed the message that life was a fleeting thing.

In the next two centuries the death's head and the inscription continued to change. The degree and speed of change varies by locale, but it can be plumbed with astounding accuracy to coincide with the waning influence of the Puritans. The next major change in the death's head (now referred to as a "soul effigy") was swapping the skull for a human face (albeit one with a vacant stare) and subtle changes in the words to phrases like "Here Lies the Mortal Remains of," amplifying the idea of the person having a soul. It wasn't long before a face with very human features and emotions replaced the vacant stare. With the emergence of rural and garden cemeteries in the mid-nineteenth century, the death's head had been replaced by a winged cherub, and any reference to the corruptible body had essentially been eliminated by inscribing the tombstone with flowery phrases such as "Sacred to Memory of" or "Gone But Not Forgotten."

Torch, Inverted

The inverted torch is a purely funerary symbol. It is unlikely that it will be found anywhere but the cemetery. The inverted torch comes in two forms.

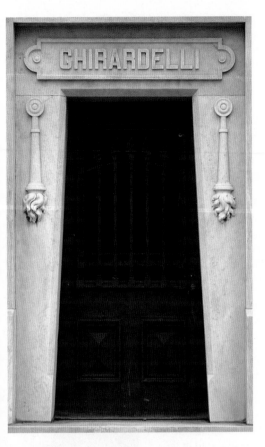

The most common is the inverted torch with flame burning, which while symbolizing death, suggests that the soul (fire) continues to exist in the next realm. The other version is an upside-down torch without a flame, which simply means life extinguished.

Both images:
Mountain View Cemetery, Oakland, California

Urn, Draped

The draped cinerary urn is probably the most common nineteenth-century funerary symbol. Some nineteenth-century cemeteries appear to be a sea of urns. The drape can be seen as either a reverential accessory or as a symbol of the veil between earth and the heavens. The urn is to ashes as the sarcophagus is to the body, which makes the urn a very curious nineteenth-century funerary device, since cremation was seldom practiced. Nowadays the word *ashes* has been replaced by *cremated remains* (abbreviated to *cremains* by the death-care industry).

But in the nineteenth century, urns seldom contained ashes. Rather, they were used as decorative devices, perched on top of columns, sarcophagi, and mausoleums, and carved into tombstones, doors, and walls. The urn and the willow tree were two of the first funerary motifs to replace death's heads and soul effigies when funerary symbolism started to take on a softer air after the Revolutionary War.

Word entomologists tell us that the phrase "gone to pot" may have had its origin as a reference to a cinerary urn.

Weeping Bottle/Tear Vial

Tear containers, whether vials, bottles, or wineskins, have been used for a very long time. The first biblical record of them is in the King James Version of the Bible, Psalm 56:8, when David prays to God, *"Thou tellest my wanderings: put thou my tears into thy bottle: are they not in thy book?"* Other versions of the Bible say that the container was a wineskin.

Tear bottles were common in the first few centuries A.D. Small tear-shaped bottles were placed at the base of tombs as a tribute to the deceased. Sometimes professional weepers were hired to supplement the bereaved family's tears, and extra compensation was awarded to those who cried the most and the loudest. Tear bottles reappeared in the nineteenth century and are strongly associated with Queen Victoria's constant mourning after the death of her beloved Albert. His death coincided with the Civil War, and women quickly adopted the tear vial as part of the mourning vocabulary. Some women used tear vials in the customary way, crying into one upon the death of a loved one, while other women cried into them when their loved one left for the war. Still others cried into the tear vial before their loved one left, then sent the tear vial along with their son or husband who was going off to war. A tear bottle, also known as a tear catcher, tear vial, and lachrymatory, are very collectible items, especially among collectors of Civil War memorabilia.

Albany Rural Cemetery, Menands, New York

One particular tear receptacle (it is large enough to be called a tear bottle) has been the subject of a bit of American folklore. A story ran in an early-twentieth-century pocket magazine, a precursor to our modern-day supermarket tabloids, about poor Sara, who is depicted on her monument as cradling a bottle of booze, a slave to its magic charms. The article went on to say that the monument's inscription, "Sara and her Babe," referred to the bottle as her "babe" and that the memorial was put up by her husband, William, as warning to all to stay away from the demon rum that killed Sara.

The truth is, the inscription refers to Sara Weed, wife of William Weed, who, along with her unborn child, died in childbirth at the age of twenty-seven. The bottle she is holding is a weeping bottle, which she is crying into because of the belief that every tear shed would become a babe in eternity. The monument, erected in Albany Rural Cemetery, Menands, New York, was commissioned by her husband.

Wheel

See Religious Devotion, Christian Symbolism, on page 152.

Catholic Cemetery,
Red Bluff, California

Wheel, Broken

The wheel is a universal symbol that represents eternity, continuation, and progress. A broken wheel can no longer turn, simply stating that this journey is now over.

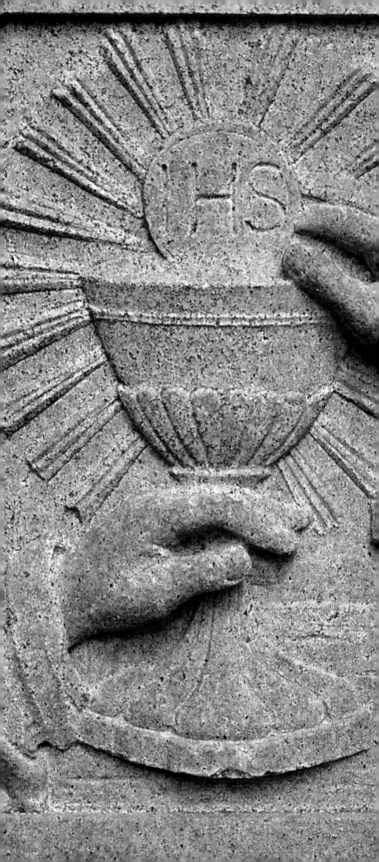

RELIGIOUS DEVOTION

MOST SYMBOLS in a cemetery have some connection with a religion, but many are overwhelmingly religion specific, like the cross for Christians and the Cohanim (or Kohanim) hand sign for Jews. Generally, these symbols are associated with some sort of religious ritual. (Look elsewhere in this book for symbols whose meaning goes beyond or is not specific to a particular religion.)

There is a grouping of Christian symbols known collectively as symbols of the Passion. These symbols depict the events leading up to and immediately following Christ's crucifixion. Some of the most often used symbols of the Passion are 1) the cross surmounting the chalice (agony at Gethsemane), 2) Roman lantern (betrayal), 3) hammer and nails (crucifixion), 4) cross and winding sheet (descent from the cross), and 5) empty cross with nails and INRI monogram (descent from the cross). In religious art, the events of the passion are put together in a sort of comic strip form in the Stations of the Cross, which are fourteen scenes of Christ's journey from the time he is condemned to death until he is laid in his sepulchre. All of these scenes together are frequently seen in churches and individual scenes can be found in funerary art.

CHRISTIAN SYMBOLISM

Adam and Eve

Adam and Eve tombstones are relatively rare because of the amount of carving required. They were most popular during the seventeenth and early eighteenth centuries and are found in cemeteries where death's heads and soul effigies are common. The particular tombstone shown

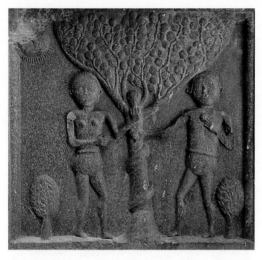

Page 140:
*Holy Cross Cemetery,
Colma, California*

Left:
*St. Paul's Cemetery,
Halifax, Nova Scotia,
Canada*

Facing:
*St. Joseph's Cemetery,
Woodland, California*

Below:
*Holy Cross Cemetery,
Colma, California*

here dates to 1796. If their depictions were bibli-
cally correct, Adam and Eve would be portrayed
naked, but modesty prevailed and they are usu-
ally seen with some sort of garment, although
both are portrayed bare-breasted. A snake is
always part of the tableau, often with an apple
in its mouth. The symbolism is obvious: If it
weren't for Eve's transgression, we'd all be
happy as clams. Alas, we're doomed to spend
our lives toiling away, only to meet our end rot-
ting away in the cemetery—except, of course,
for a lucky few who, upon their death, will rise
above this veil of tears to ascend to boundless
joy in heaven.

Symbols of the Eucharist

The chalice with wafer, grapes,
and wheat combined into a
single scene are collectively
a symbol of the Eucharist. The
use of all of these elements
together is usually restricted to
religious orders. Grapes and
wheat together are also a sym-
bol for the Eucharist and are
usually found on the graves
of common folk.

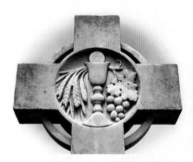

Holy Ghost

A dove, dive-bombing from the heavens, with
an olive branch or a cross in its beak is the sym-
bol for the Holy Ghost. This representation of
a dove comes from John 1:

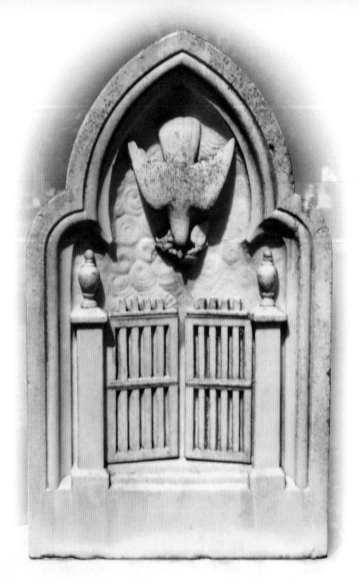

32 And John bare record, saying, I saw the Spirit descending from heaven like a dove, and it abode upon him.

33 And I knew him not: but he that sent me to baptize with water, the same said unto me, Upon whom thou shalt see the Spirit descending, and remaining on him, the same is he which baptizeth with the Holy Ghost.

34 And I saw, and bare record that this is the Son of God.

A similar-looking tableau, but with the dove holding the earth in its beak, is a symbol for the fourth, or highest, degree of a Knight of Columbus, a fraternal organization for Catholics.

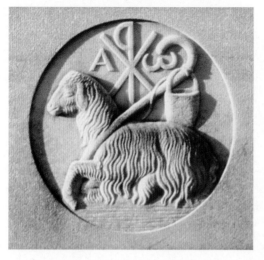

Cimitero Monumentale, Milan, Italy

Agnus Dei—Lamb of God

A lamb with a cross and usually also with a banner and a halo is the symbol for the Lamb of God. Christ is the Lamb of God as referenced in John 1:29—*"The next day John seeth Jesus coming unto him, and saith, Behold the Lamb of God, which taketh away the sin of the world."*

In addition to the cross, banner, and halo, there are a number of other accessories that may be portrayed with the lamb. Among these are shepherds' crooks, Chi-Rho crosses, and alpha/omega symbols. If the lamb is portrayed without any additional items, it is a symbol of innocence and is frequently found on children's graves. Accessorized, the lamb is almost always the Agnus Dei.

Dice

After Christ was crucified, the soldiers were said to have cast dice for possession of his undergarment. John 19 reads:

Oahu Cemetery, Honolulu, Hawaii

> 23 Then the soldiers, when they had crucified Jesus, took his garments, and made four parts, to every soldier a part; and also his coat: now the coat was without seam, woven from the top throughout.
> 24 They said therefore among themselves, Let us not rend it, but cast lots for it, whose it shall be: that the scripture might be fulfilled, which saith, They parted my raiment among them, and for my vesture they did cast lots. These things therefore the soldiers did.

On a tombstone, if the dice are used with other symbols of the Crucifixion, such as nails, the dice

are a symbol of the Passion. If the dice are used alone, they probably represent the deceased's fondness for games of chance.

Nail

Nails are a symbol of the Passion because of their association with the Crucifixion of Christ. Early depictions of the Crucifixion show four nails, one in each of Christ's hands and feet, but probably because the number three is such a powerful number (since it represents the Trinity) for Christians, the use of three nails became the norm. Thus, three nails are used in scenes of the Crucifixion and one nail is used to pierce both of Christ's feet.

Cimitero Monumentale, Milan, Italy

Nails are not restricted to biblical lore: in some parts of Europe, a visitor pounded a nail into a tree to tell others he was there; in Central Africa, nails are driven into human "nail fetishes" as a reminder of one's responsibilities; and there is a Chinese custom of hammering extra nails into a house to ward off demons. This extra nail(s) custom may have inspired an early-twentieth-century California builder known as "One-Nail MacGregor," who always put an extra nail into his homes before he called them finished.

Chalice

In the cemetery, the chalice is seen as the human heart's yearning to be filled with the true spirit of the Lord, as symbolized by wine. It is one of the strongest symbols of Christian faith. Its most vivid biblical reference is in Mark 14:

> 23 And he took the cup, and when he had given thanks, he gave it to them: and they all drank of it.
> 24 And he said unto them, This is my blood of the new testament, which is shed for many.
> 25 Verily I say unto you, I will drink no more of the fruit of the vine, until that day that I drink it new in the kingdom of God.

In paintings, the chalice is often depicted as a vessel used for gathering the blood from the dying Christ on the cross. In this context, the chalice symbolizes the Eucharist and the redemption of mankind. The chalice with a serpent (see page 90) is the attribute of St. Paul. A chalice and a wafer are attributes of St. Barbara. And, of course, the chalice may represent the Holy Grail.

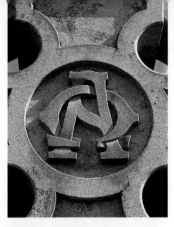

Alpha, Omega, and Mu

Alpha and Omega are the first and last letters of
the Greek alphabet. In Christian iconography the
Alpha and Omega emblem relates to three similar
passages in the book of Revelation. The most
expansive of the three passages, found in
Revelation 21, reads:

> *5 And he that sat upon the throne said, Behold, I
> make all things new. And he said unto me, Write: for
> these words are true and faithful.*
> *6 And he said unto me, It is done. I am Alpha and
> Omega, the beginning and the end. I will give unto
> him that is athirst of the fountain of the water of
> life freely.*
> *7 He that overcometh shall inherit all things; and I
> will be his God, and he shall be my son.*

Sometimes the Alpha and Omega will have the
letter M (Mu) inserted, which expands the mean-
ing to the beginning, the continuation, and the
end of all things.

It is quite common to see the Alpha and
Omega symbols in all sorts of religious art,
especially on books and clothing. As a symbol,
the letters are frequently seen dangling from a
Latin cross or incorporated in a Chi-Rho emblem.

IHS or IHC

This symbol is often seen emblazoned on crosses.
Usually, the letters are overlaid on each other,
which, curiously enough, looks a lot like a dollar
sign. Popular belief says that the IHS (Greek)
or IHC (Roman) is an abbreviation of the Latin
phrase *in hoc signo*, which is a shortened version
of a banner with the words *in hoc signo vinces* ("in
this sign you will conquer"), seen in a vision by
the Emperor Constantine before he went into
battle—a good story, but not the origin of IHS.

Another puts the origin as an abbreviation of the Latin phrase *Iesus Hominum Salvator*, ("Jesus, Savior of Men")—another good story, but also not the origin. In fact, the origin is rather pedestrian. Jesus' name in upper- and lowercase Greek lettering is IHSOYS / Ihsoys or IHSUS / Ihsus;

iota = I / ι
eta = H / η
sigma = Σ / ς
omikron = O / o
upsilon = Y / υ
sigma = Σ / ς

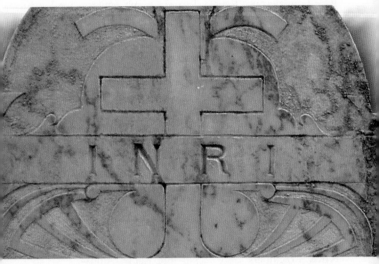

IHS is derived from the first three letters of Jesus' name using the Greek alphabet: Iota, Eta, Sigma.

Another variation in Roman lettering is IHCOYC / Ihcoyc or IHCUC / Ihcuc. IHC is derived from the first three letters of Jesus' name using the Roman alphabet.

Corning Cemetery, Corning, California

Cimitero Monumentale, Milan, Italy

INRI

This symbol is very straightforward. It's the first letters of the Latin words *Iesus Nazarenus Rex Iudaeorum*, meaning "Jesus of Nazareth The King of the Jews." According to John 19:19, after Jesus was crucified, Pilate mockingly wrote these same words on the cross in Hebrew, Greek, and Latin.

Pax

Pax is simply the Latin word for "peace." Despite the short length of the word, it is sometimes abbreviated to PX.

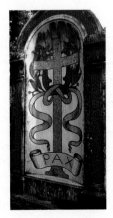

IC XC NIKA

This is an ancient monogram of Greek letters signifying "Jesus Christ Conquers." Usually the letters are broken into four parts and arranged around the center of a cross. The letters IC and XC are the first and last letters of the Greek and Roman spelling of Jesus Christ, as follows:

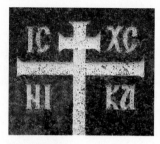

*Serbian Cemetery,
Colma, California*

IC = Jesus (Iesous / Iesus)	Iota, eta, sigma, omikron, upsilon, Sigma
ΙΗΣΟΥΣ	in uppercase Greek symbols
Ιησους	in upper- and lowercase Greek symbols
IHCOYC / IHCUC	in uppercase Roman letters
pronounced	YAY-soos

XC = Christ (Christos)	Chi, rho, iota, sigma, tau, omikron, Sigm
ΧΡΙΣΤΟΣ	in uppercase Greek symbols
Χριστος	in upper- and lowercase Greek symbols
XPICTOC	in uppercase Roman letters
pronounced	CHREES-tos

NIKA = conquers	Nu, Iota, Kappa, Alpha
NIKA	in uppercase Greek symbols
Νικα	in upper- and lowercase Greek symbols
NIKA	in uppercase Roman letters
pronounced	NEE-kuh

For further information on Greek symbols and Roman letters, see Fish on page 86; Alpha, Omega, and Mu on page 146; IHS or IHC on page 146; INRI on page 147; Pax on page 147; and Chi-Rho on page 149.

RIP

The most common letters seen on tombstones in cartoons are RIP. Even schoolchildren are familiar with this abbreviation, and it may be their first experience with cemeteries. RIP is an abbreviation for the Latin words *Requiescat In Pace*, which translates nicely to the English words "Rest in Peace."

*Holy Cross Cemetery,
Colma, California*

Heart

In modern times, the symbolism of the heart has more to do with romantic love than anything else. But in the cemetery, the heart is almost always a Christian symbol. The rise of the heart as a strong Christian symbol began with the mysticism of the late Middle Ages. The heart was given an encyclopedic vocabulary of attributes: a pierced heart means repentance; a flaming heart means religious zeal; a bleeding heart symbolizes Christ's suffering; a heart in hand symbolizes love and piety; a heart surrounded by thorns is an

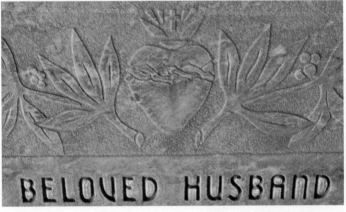

emblem of St. Catherine of Siena; an exposed heart with seven drops of blood symbolizing the Seven Virtues is an attribute of St. Benedict of Palermo.

Seamans Cemetery, Lahaina, Maui, Hawaii

The Christian attitude of the heart being the seat of emotions is best summed up in 1 Samuel 16:7—*"But the LORD said unto Samuel, Look not on his countenance, or on the height of his stature; because I have refused him: for the LORD seeth not as man seeth; for man looketh on the outward appearance, but the LORD looketh on the heart."*

Chi-Rho

Scholars say the Chi-Rho (XP) symbol is the oldest Christian symbol. Chi and Rho are the first two letters of the Greek word for Christ (ΧΡΙΣΤΟΣ, or ΧΡΙCTOC). When the two letters are overlaid they form a cross-like design. Reversing the letters to PX is said to be an abbreviation of the Latin word *pax*, which means "peace."

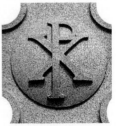

Holy Cross Cemetery, Colma, California

When Constantine defeated Maxentius in A.D. 312, he replaced the eagle with the Christian Chi-Rho on the Roman standards, which certainly solidified the Chi-Rho as the dominant Christian

symbol. But the Christians did not invent the Chi-Rho monogram. Chi and Rho are also the first two letters of the Greek word *chrestos,* meaning "auspicious," and the letters confined in a circle were a Chaldean solar symbol. Furthermore, it is also an abbreviation of the Greek word *chreston,* meaning "good omen" or "good thing," and the Chi-Rho letters were used to signify that event.

Crown

The most important Christian crown is Christ's crown of thorns, but more regal crowns are also seen in Christian art and symbolism. When the Madonna is depicted with a crown it means that she is the Queen of Heaven. Crowns are also seen from time to time gracing the heads of martyrs, indicating that its wearer was of royal lineage. As a funerary symbol the crown represents the sovereignty of the Lord.

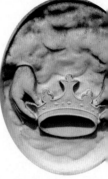

Above:
North Laurel Grove Cemetery, Savannah, Georgia

Left:
Corning Cemetery, Corning, California

Below:
Cypress Lawn Memorial Park, Colma, California

Ostensorium

In the cemetery, the ostensorium, also known as a monstrance, will mark the grave of a member of the clergy. This medieval device is an altar vessel of the Eucharist. The ostensory comes in a number of designs, but the most common design is in the form of the sun or a flower. All ostensoria have an opening in the middle that houses a Consecrated Host behind glass, so it can be easily viewed. "Ostensorium" comes from the Latin word *ostendere,* "to show." They are also used to exhibit relics.

Key

The key is usually seen in a set of two. They are an integral part of the papal coat of arms, one silver and the other gold. The two keys on the coat of arms were adapted from the

emblems of the Roman god Janus, a two-faced god—one face looking earthward and the other face looking toward the heavens. This concept can be likened to other dualities such as yin and yang. Janus used the keys to lock and unlock the seasons at the solstice. He is also illustrated with a key in one hand and a staff in the other.

In Christian iconography, the keys are held by St. Peter. In effect, Christ gave Peter the power to lock or unlock the gates of heaven when he said in Matthew 16:19—*"And I will give unto thee the keys of the kingdom of heaven: and whatsoever thou shalt bind on earth shall be bound in heaven: and whatsoever thou shalt loose on earth shall be loosed in heaven."*

And, lest we forget St. Martha, the patroness of feminine discretion and good housekeeping, she is often depicted with a sizable assortment of keys hanging from her girdle.

Lamp

The lamp is a symbol of wisdom and piety. When a person has a bright idea, the idea is often depicted as a light bulb (lamp). Lamps light our way through the darkness to a better world. The symbolism of the lamp is well explained in Revelation 21:

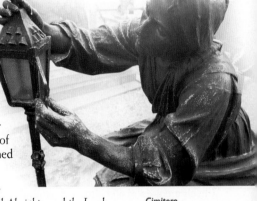

Cimitero Monumentale, Milan, Italy

22 And I saw no temple therein: for the Lord God Almighty and the Lamb are the temple of it.
23 And the city had no need of the sun, neither of the moon, to shine in it: for the glory of God did lighten it, and the Lamb is the light thereof.
24 And the nations of them which are saved shall walk in the light of it: and the kings of the earth do bring their glory and honour into it.

Scales

A pair of scales is often seen in the hands of the archangel Michael, a reference to his task of weighing the souls of the departed. In the cemetery a pair of scales is just as likely to mark the grave of a member of the law profession.

Scales are an integral part of a number of cultures. They are an attribute of Themis, the Greek goddess of law and order. The zodiac sign of

Libra is portrayed with a pair of scales signifying the equal hours of day and night at the autumnal equinox. Tibetan art depicts the scales with a white rock and a black rock in the opposing pans, symbolizing good and evil.

Tablets

See Mosaic Decalogue on page 156.

Wheel

The wheel is a symbol of the endless force of divine power. The most vivid biblical account of the symbolism of wheels occurs in Ezekiel 1:

*San Michele
Cemetery,
Venice, Italy*

> 15 *Now as I beheld the living creatures, behold one wheel upon the earth by the living creatures, with his four faces.*
> 16 *The appearance of the wheels and their work was like unto the colour of a beryl: and they four had one likeness: and their appearance and their work was as it were a wheel in the middle of a wheel.*
> 17 *When they went, they went upon their four sides: and they turned not when they went.*
> 18 *As for their rings, they were so high that they were dreadful; and their rings were full of eyes round about them four.*

Other powerful Christian wheel motifs are the Chi-Rho wheel, which is the Chi-Rho cross enclosed in a circle, like the circular rose windows in the French cathedrals that were a symbol of spiritual evolution.

Wheels are used in all cultures as symbols. Buddhists use the Wheel of Existence to illustrate the process of going from one incarnation to the next. Egyptians used the potter's wheel as a symbol of man's evolution. In June in ancient Greece, wheels were set afire and rolled down hills to encourage the sun's chariot to keep appearing every day.

*Oak Hill Cemetery,
Red Bluff, California*

Wheel, Broken

See Mortality Symbols on page 139.

HEBREW SYMBOLISM

The Hebrew people have been memorializing their dead far longer than Christians. The earliest biblical reference to burial occurs in Genesis 23:

1 And Sarah was an hundred and seven and twenty years old: these were the years of the life of Sarah.
2 And Sarah died in Kirjatharba; the same is Hebron in the land of Canaan: and Abraham came to mourn for Sarah, and to weep for her.
3 And Abraham stood up from before his dead, and spake unto the sons of Heth, saying,
4 I am a stranger and a sojourner with you: give me a possession of a buryingplace with you, that I may bury my dead out of my sight.
5 And the children of Heth answered Abraham, saying unto him,
6 Hear us, my lord: thou art a mighty prince among us: in the choice of our sepulchres bury thy dead; none of us shall withhold from thee his sepulchre, but that thou mayest bury thy dead.

The actual erection of a monument to commemorate a specific person is first mentioned in Genesis 35:

19 And Rachel died, and was buried in the way to Ephrath, which is Bethlehem.
20 And Jacob set a pillar upon her grave: that is the pillar of Rachel's grave unto this day.

Hebrew tombstones do not have nearly the vocabulary of symbols as Christian tombstones, but their brevity is deceiving. On almost all Jewish tombstones, the father of the deceased person is written on the tombstone. This piece of information gives genealogists a step back one generation.

Dates

Dates are written in Hebrew according to the Jewish calendar, which starts with the Creation of the World. It was calculated by figuring the ages of people and events referred to in the Old Testament. That figure worked out to 3,760 years before the Christian calendar. Thus, the year 2000 in the Christian calendar would be 5760 (3760+2000) in the Hebrew calendar. Occasionally, the first 5,000 years are dropped. Thus, 5760 would be written as 760.

Home of Peace Cemetery, Colma, California

It should also be noted that, as a rule, head-stones of Jews in Europe contain more symbolism than those in North America. European head-stones will often have depictions of the tools of trade of the deceased as well as an array of plants and animals. Since the headstones in Europe are older, the wealth of symbols might point to a time of lower literacy rates.

Jewish Cemetery, Colma, California

"Here Lies"

This sign is found on almost every Jewish tombstone. It is the Hebrew words *po nikbar* or *po nitman* ("here lies").

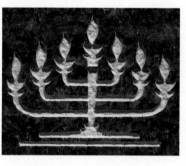

Menorah

The menorah is a seven-branched candelabra. It is usually seen on a tombstone of a "righteous" woman. Its roots go back to the destruction of the Temple of Solomon. The most vivid account of the menorah in the Bible is in Exodus 25, where the Lord explains the furnishings he wants Moses to make for the tabernacle:

> 31 And thou shalt make a candlestick of pure gold: of beaten work shall the candlestick be made: his shaft, and his branches, his bowls, his knops, and his flowers, shall be of the same.
> 32 And six branches shall come out of the sides of it; three branches of the candlestick out of the one side, and three branches of the candlestick out of the other side:
> 33 Three bowls made like unto almonds, with a knop and a flower in one branch; and three bowls made like almonds in the other branch, with a knop and a flower: so in the six branches that come out of the candlestick.
> 34 And in the candlesticks shall be four bowls made like unto almonds, with their knops and their flowers.
> 35 And there shall be a knop under two branches of the same, and a knop under two branches of the same, and a knop under two branches of the same, according to the six branches that proceed out of the candlestick.
> 36 Their knops and their branches shall be of the same: all it shall be one beaten work of pure gold.
> 37 And thou shalt make the seven lamps thereof: and they shall light the lamps thereof, that they may give light over against it.

Salem Memorial Park, Colma, California

38 And the tongs thereof, and the snuffdishes thereof, shall be of pure gold.

39 Of a talent of pure gold shall he make it, with all these vessels.

40 And look that thou make them after their pattern, which was shewed thee in the mount.

Interestingly, the seven-branched menorah is rarely seen on European headstones (usually three or five branches are seen) because the seven-branched menorah was a symbol of the Temple, and its use was prohibited on a headstone.

Star of David

The Star of David, a symbol of divine protection, is probably the most well-known Jewish symbol, although it didn't become a major symbol until the late 1880s, when it was used by Zionists to identify themselves. Ironically, the Star of David symbol became a permanent identifier of Jews when Hitler ordered Jews to wear the symbol on their arms. When Israel put the star on its flag, the transition from minor symbol to the universal Jewish symbol was complete.

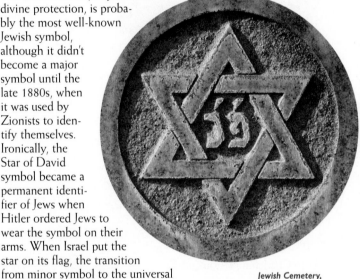

Jewish Cemetery, Oroville, California

Yahrtzeit

The *yahrtzeit* is an oil-filled basin with a floating wick. Nowadays a yahrtzeit can also be a candle. It can also refer to an event as well as an object. Thus, during Yahrtzeit, a yahrtzeit candle is burned to commemorate the dead. The yahrtzeit is also called a *Ner Neshamah*, a "Lamp of the Soul," based on the verse in Proverbs 20:27—"*The spirit of man is the candle of the LORD, searching all the inward parts of the belly.*"

Home of Peace Cemetery, Colma, California

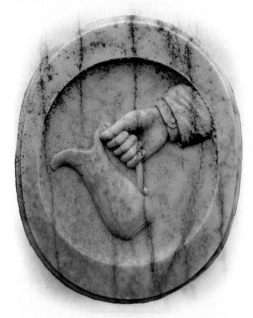

Ewer (Levite pitcher)

A pitcher signifies a Levite, who, according to
scripture was responsible for cleaning the hands
of the Temple priest (the Cohanim) prior to a
religious service. Aside from these cleansing
duties, Levites were also musicians, singers in
choirs, and gatekeepers. In today's world the
Levites are the ones called on second (after the
Cohanim) in the reading of the Torah.

The Mosaic Decalogue

Thanks to Charleton Heston and
Cecil B. DeMille, almost everyone
knows these tablets as the Ten
Commandments. In the cemetery the
two tablets are always joined.
Sometimes they are seen with the
Hebrew figures (five on each side) for
the numbers 1–10, while other times
the commandments are written out in
an abbreviated form. Christians liked

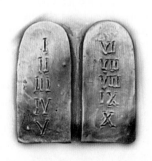

Cimitero
Monumentale,
Milan, Italy

the idea of the tablets so much that they modified
it with roman numerals and it has become a popu-
lar Christian symbol. Modern-day tombstones
generally depict five numerals on the left and five
on the right, but on older tombstones, Roman
Catholics and Lutherans tend to like three numer-
als on the left and seven on the right, while
Calvinists and the Greek Church tend to like four
numerals on the left and six on the right.

Cohanim (Kohanim) Hands

These hands with thumbs, and some-
times forefingers, joined are a symbol
of the members of the ancient priestly
tribe of Aaron, who was a Levite.
Nowadays, at certain services, the
Cohanim raise their hands in the air to
form an opening, which directs the
radiance of God to stream down on the
congregation. The Cohanim hands usu-
ally mark the graves of fallen Cohns,
Cohens, Cahns, Cowens, and their families.

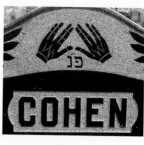

Above:
*Home of Peace
Cemetery,
Colma, California*

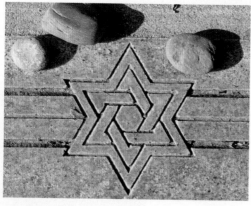

*Jewish Cemetery,
Oroville, California*

Pebbles

All cultures have ways of continuing to memorial-
ize their dead by leaving something at the grave-
site. Some of the more popular items include
flowers (real and artificial), immortelles (ceramic
flowers), food, pictures, toys, and notes. One of
the most curious memorialization practices is the
Jewish custom of leaving pebbles on and around
the tombstone. The custom has become so well
established that some Jews will bring pebbles and
small stones from their travels to place on the
tombstone. And, if pebbles are not available in
the cemetery, coins and bits of glass are sometimes
substituted. Nevertheless, the message is clear: at
its most basic level, pebbles like flowers, say that
someone still cares and remembers. But why use
stones? Like many folk customs, scholars say the
origin of the practice is somewhat shadowy. What
is clear is that using stones to memorialize a per-
son or mark a place has gone on for thousands
of years. In fact, because of the ready supply of
durable materials, building rock cairns was one
of the earliest methods man employed to mark
important places.

The Old Testament is packed with references

of stones being used to cover or mark graves. The first instance of a single stone is the pillar that Jacob erected over Rachel's grave in Genesis 35. One of the earliest references to using multiple stones to make a memorial is found in Joshua 4:

1 And it came to pass, when all the people were clean passed over Jordan, that the LORD spake unto Joshua, saying,

2 Take you twelve men out of the people, out of every tribe a man,

3 And command ye them, saying, Take you hence out of the midst of Jordan, out of the place where the priests' feet stood firm, twelve stones, and ye shall carry them over with you, and leave them in the lodging place, where ye shall lodge this night.

4 Then Joshua called the twelve men, whom he had prepared of the children of Israel, out of every tribe a man:

5 And Joshua said unto them, Pass over before the ark of the LORD your God into the midst of Jordan, and take you up every man of you a stone upon his shoulder, according unto the number of the tribes of the children of Israel:

6 That this may be a sign among you, that when your children ask their fathers in time to come, saying, What mean ye by these stones?

7 Then ye shall answer them, That the waters of Jordan were cut off before the ark of the covenant of the LORD; when it passed over Jordan, the waters of Jordan were cut off: and these stones shall be for a memorial unto the children of Israel for ever.

8 And the children of Israel did so as Joshua commanded, and took up twelve stones out of the midst of Jordan, as the LORD spake unto Joshua, according to the number of the tribes of the children of Israel, and carried them over with them unto the place where they lodged, and laid them down there.

9 And Joshua set up twelve stones in the midst of Jordan, in the place where the feet of the priests which bare the ark of the covenant stood: and they are there unto this day.

Père Lachaise, Paris, France

Tombstone of Gertrude Stein and Alice B. Toklas.

Thus, stones are a powerful symbol of "the people of Israel."

The use of rocks and pebbles on graves, ultimately, is a practical matter. Graves in a rocky or sandy environment couldn't be dug very deep. Rocky ground is hard to excavate and sand collapses before it can be dug very deep. Thus, graves were often quite shallow; hence the need

to place rocks and pebbles over the grave to prevent the remains from being disturbed by animals. These rock mounds became grave markers by default because of the nature of their form.

It should be noted that the Jews were a nomadic people and, as such, traveled from place to place. When they passed the gravesite of a member of their tribe it was entirely reasonable that they would do a bit of maintenance to that site, which, in an arid environment, would mean maintaining and, perhaps, adding to the stones. By extension, a nomadic people wouldn't leave fragile plants or flowers on a grave since they would soon be moving on and unable to care for them. Flowers, food, and other remembrances that are part of memorialization practices of other cultures were never part of early Jewish burial practices. Adding more rocks (already established as a symbol of "the people of Israel") simply served the same purpose.

There are many other pebble theories, but on close inspection, those theories may have evolved after the custom was already well in place. Several popular theories include the following: 1) the priestly Cohanim were not allowed to touch the dead, so rocks were placed over the deceased, 2) pebbles were used as an early form of counting and the pebbles on a tombstone simply count visitors, and 3) because of their durability, stones represent the immortality of the soul.

CHINESE AND JAPANESE SYMBOLISM

Although Chinese and Japanese tombstones do not have the vast repertoire of funerary symbols as do those from European cultures, they do have some interesting and significant symbols and traditions.

Chinese symbolism is seen more in the funerary rituals than on symbols that appear on tombstones. The most significant Chinese tradition is the observance of Ching Ming, translated roughly as "pure brightness." Ching Ming occurs on April 5 (106 days after the winter solstice), but is sometimes moved to the first weekend in April, if April 5 doesn't fall on a weekend. On the first day of Ching Ming, a priest conducts a thirty-four-step ceremony called the "Three Presentations Ceremony" at the oldest grave in the cemetery. This ceremony's most memorable aspect is, no doubt, the thirty-fourth step, which is the lighting of more than 10,000 firecrackers.

Another name for Ching Ming is "tomb-sweeping (or cleaning) day" and refers to the cleaning and maintenance of the graves of one's ancestors. It is important to maintain and honor the graves of one's ancestors because of the Chinese belief that all fortune or mis-fortune stems from the reverence or lack thereof of one's ancestors. These departed ancestors still have similar physical needs (hence, the leaving of food, drink, and gifts) and can assist those still bound to the earth.

Like the Chinese, the Japanese also have a period of days for remem-bering the dead. This time is called Obon or Urabon (upside down), which refers to a Buddhist legend where a disciple of Buddha rescued his mother who had been hanging upside down in hell because she had lied about eating some meat. Obon occurs in July and August and has three parts: 1) visiting graves and leaving symbolic foods, which the dead "absorb"; 2) a community dance; and 3) a parade of floating lanterns, where the name of the deceased is written on a lantern and set off down the river, symbolizing the return to the underworld.

Japanese tombstones often have family crests called *mon* or *monsho*, which are not unlike European crests, except that they are more stylized. The tradition of heraldic crests started in the seventh century when the Chinese brought the designs to Japan. Soon warriors were wearing these decorations on their armor to identify their allegiance. Through the centuries thousands of patterns have evolved and nowadays almost every family has its own crest. Most crests are strongly tied to nature—the most popular designs are plants, flowers, and trees, followed by birds and beasts. But there are many other designs representing the earth and sky, tools, geometric forms, and ideographs. The ideographs often symbolize attributes like chastity, good fortune, integrity, sincerity, perfection, peace, heaven, and many more. Examples of *mon* or *monsho* include the following images:

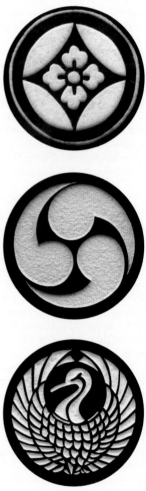

The Tsumori family crest (right) is in a circle design known as a *shippo* (seven treasures). The pattern of overlapping circles called *shippo* probably comes from *shi* (four) *ho* (directions), and the word evolved into *shippo*. The pattern symbolizes expansiveness. When the elements are more oval-like instead of perfectly round, it is a sign of maturity. The design appeared in the late Heian period (A.D. 794–1185). The overlap is exactly equal on all four sides.

This *tomoe* pattern (right) did not appear on Japanese family crests until the ninth or tenth centuries. Scholars differ on the origin of the pattern. Some say it is an adaptation of similar comma-like designs like the yin-yang symbol, while others say it was derived from the shape of a leather guard worn on the left hand of archers to protect them from the snap of the bowstring. The guard is called a *tomo* and a graphic representation (picture) of a tomo is called a *tomo-e*.

The crane (right) is a popular Japanese symbol. Cranes are associated with long life (more than 1,000 years). One Chinese and Japanese legend has hermit-sages riding on the backs of cranes. A number of different styles of cranes are

employed in origami, the Japanese art of paper folding.

The diamond, or *bishi*, (right) is a textile design that appeared before the Heian period. Based on the water chestnut *(bishi)*, the design was used by the court and warrior societies before the widespread adoption of family crests.

The Motoyama family crest is a highly stylized goose, or *kari* (right). Three goose heads are encircled with three *V*s that represent the flight of the goose.

Because of the association with warriors, family crests using various archery items are very popular. There are hundreds of variations and combinations. Arrowheads and bows are infrequently used on family crest designs, but complete arrows, feathers, and the notch on the feathers are frequently employed on the crests (right). Japanese literature refers to the life of a warrior as "the way of the bow and arrow."

The Murata family *mon* is a representation of a mulberry leaf, or *kaji* (lower right). In ancient times the *kaji* leaf, also known as the "paper mulberry," was used to fabricate representations of clothing left at Shinto shrines as an offering. The mulberry leaf was also used to make cups and plates for food offerings. More recently, during the Tanabata festival, ladies of the court write poems on the mulberry leaf. It has been incorporated into a number of family crests.

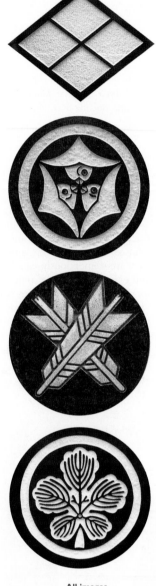

All images,
pages 160–61:
*Japanese Cemetery,
Colma, California*

HEAVENLY MESSENGERS

ANGELS IN THE CEMETERY

With a particular zeal for every slab,
Staining the uncomfortable angels that rot
On the slabs, a wing chipped here, an arm there:
The brute curiosity of an angel's stare
Turns you, like them, to stone.

Ode to the Confederate Dead
© 1937 Allen Tate

Besides tombstones, of course, the image most often associated with cemeteries is angels. If you get a glimpse of an angel while driving down the road, it's likely you are driving by a cemetery. Wander into the cemetery and you'll likely see dozens of these heavenly messengers dotting the landscape. Despite their winged countenance, they are tremendously variable in their posture and expression. While some are draped over tombs in grief, others seem ready to take flight with heavenly joy and aspiration. Tears stream from the eyes of one; another face is filled with adoration; another manages a wistful smile. Skilled sculptors have, indeed, brought cold stone and bronze to life.

Facing:
Highgate Cemetery, London, England

An ivy-covered angel resides in one of the first garden cemeteries in England.

Below:
Cimitero Monumentale, Milan, Italy

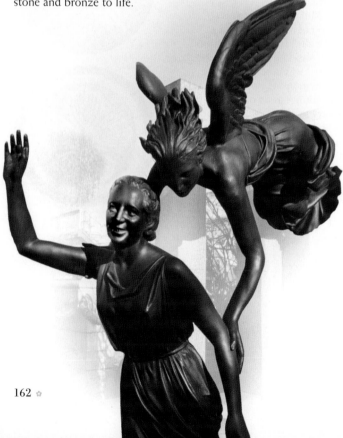

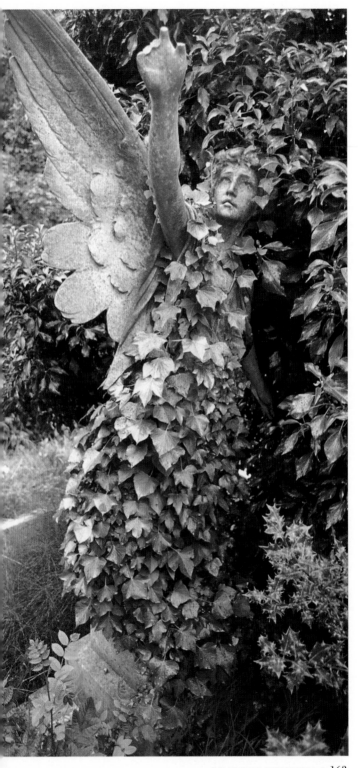

THE HISTORY OF ANGELS

Understandably, most angels in American cemeteries are rooted in Christian lore, but reference to angels can be found in most religions. The word *angel* comes from the Greek word *angelos*, which means "messenger." In Islam, founded by the Prophet Muhammad (A.D. 571–632) in Arabia, angels are an important part of the belief system. *Mala'ika*, the word for "messenger," is the Islamic term for angel. The chief duty of these angels was to carry messages to Allah. The Koran, the Islamic Holy Book, regularly mentions angels, such as Djibril (Gabriel) and Mikhail (Michael). Some Muslim scholars talk of a multi-winged angel that brought the text of the Koran to Mohammed. Others say that it was Djibril (Gabriel) who contacted Muhammad and dictated the Koran to him.

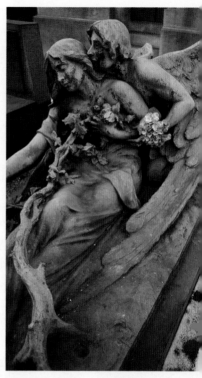

Cimitero Monumentale, Milan, Italy

An angel comforts a young woman in this beautiful bronze sculpture.

The Bible refers to angels in both the Old and the New Testaments. Christian angels were inherited from Hebrews of the Old Testament. In Genesis, God sent cherubim armed with a flaming sword to guard the way of the tree of life.

And Michael, as leader of the angels who remained faithful to God after the great war in heaven, overcame and cast Satan from their midst. Most angels aren't nearly as fierce as those cherubim, though. In fact, their demeanor is usually gentle and comforting. The best-known angel is Gabriel, who is usually depicted with some sort of horn. Gabriel is the angel of the Annunciation. It was Gabriel whom God sent to announce (annunciate) the birth of Jesus. Gabriel is perhaps the most depicted angel, aside from generic angels, in the cemetery. The angel with a horn portrayed in paintings of the Annunciation is a natural device for signaling the departure of a soul from the earth and its arrival in heaven.

While Michael and Gabriel may be the best-known angels, there are many more. At least seven angels are mentioned in Revelation 8:2—

"And I saw the seven angels which stood before God; and to them were given seven trumpets."

The Book of Enoch is full of angel names. Other angels make appearances as messengers, oftentimes in human form, in other chapters of the Bible. Most named angels actually come from secular writings—so many that fourteenth-century cabalists, employing an interesting calculation using words as numbers and numbers as words, calculated the number of practicing angels at 301,655,722. Albertus Magnus put the number as "6,666 legions with 6,666 angels per legion," or 44,445,556. Either calculation seems like a weighty number. While not enough for everyone to have their own personal angel, it is certainly enough to have one to call on in times of need. Church sects may not agree on the exact numbers of angels but most biblical scholars agree that the number is fixed. Angels are not eternal like God, but they are immortal (a subtle but important difference). Aside from a few who fall from grace now and then, their numbers have been fixed since creation. Now the bad news: As our human

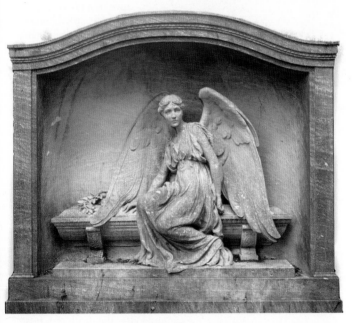

Woodlawn Cemetery, Bronx, New York

In 1912, author Harry Bliss had this to say about the Kinsley memorial: "While it is ancient in its suggestion, it is modern in treatment; especially in the character of the figure which sits gazing into the distance with an expression of expectancy that suggests hope and Resurrection." The Kinsley monument was crafted by noted sculptor Daniel Chester French, best known for the Lincoln Memorial and the Minuteman Statue.

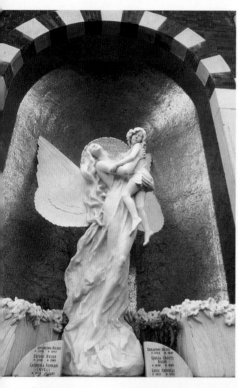

Cimitero Monumentale, Milan, Italy

An angel ushers a young child to the heavens.

population continues to increase, it spreads out the angels-to-humans ratio. Even worse, angel adversaries—demons and devils—are able to reproduce. According to one scholar "they multiply like flies." In fact, in a work produced by Martin Luther's followers titled *Theatrum Diablorum* the estimate was put at 2.5 billion and later revised to 10,000 billion. This angels-to-demons ratio may help to explain the current troublesome times on planet Earth. While demons are able to reproduce as men do, they also die as men do. This aspect does, at least, give us a ray of hope.

Some early churches were worried that far too much attention was being focused on angels instead of on God. This obsession with angels even has a name: angelolatry, or the worship of angels. The Council of Nicaea in A.D. 325 declared belief in angels a part of dogma and all was well for a few years. But the belief in angels often crossed the idolatry line, and people started to actually worship angels. So much so that in A.D. 343 the Synod of Laodicaea condemned the practice of angel worship as idolatry. However, people were reluctant to give up their angels, and in A.D. 787, the Seventh Ecumenical Synod reintroduced angels but was very specific about their mission and their place in the heavens. This was in large part due to an angelic order that was first introduced by a man named Dionysius.

ANGEL HIERARCHY

Within a few centuries after the death of Christ there were so many angels flying and hovering around that it became important to classify them as well as enumerate them. In the fifth century A.D. Middle Eastern scholar and mystic Dionysius the Areopagite created "The Celestial Hierarchy" as well as treatises in Christian angelology. Dionysius deliberated over the references to angels in the

scriptures as well as non-biblical sources. He postulated that there were nine classes, or choirs, of angels that were divided into three spheres. Other scribes such as Dante, St. Jerome, and Gregory the Great have made their own adjustments to "The Celestial Hierarchy," but Dionysius' list is the one generally accepted today:

1ST SPHERE—1ST, 2ND, 3RD ORDERS

Seraphim

The highest order of angels. These are the angels who constantly sing God's praise by unceasingly intoning "holy, holy, holy." Their duty it is to regulate the heavens. Some texts refer to many seraphim while other sources say there are only four—corresponding to the four winds.

Oak Hill Cemetery, Red Bluff, California

Cherubs are often used on the graves of children. An angel of the order of cherubim adorns the grave of Marel Halley, who died at the tender age of three.

Cherubim

These angels were sent to guard the way of the tree of life. The name comes from the Assyrian or Akkadian word *karibu*, meaning "one who intercedes." Originally they were depicted as the bearers of God's throne, as the charioteers, and as powerful beings with four wings and four faces. Various occult works put Gabriel, Raphael, and Satan (before his fall) as rulers of the cherubim. Nowadays they are more associated with Valentine's Day cards than gatekeepers. In the cemetery they are often seen on monuments for children.

Thrones

Called the "many eyed ones," they have the duty of carrying out God's decisions. They are often represented as fiery wheels. In *Paradise Lost*, Milton speaks of "the Rebel Thrones."

2ND SPHERE—4TH, 5TH, 6TH ORDERS

Dominions

Dionysius says that their job is to regulate the other angels and to ensure that they are constantly aspiring to a true lordship.

Virtues

They are said to be the angels of grace and valor who bring God's blessings and messages to Earth, usually in the form of miracles, and are associated

RELIGIOUS DEVOTION ✿ **167**

with acts of heroism and bring courage when needed. In *The Book of Adam and Eve*, two Virtues, accompanied by twelve other angels, prepared Eve for the birth of Cain.

Powers

These are the traffic police of the heavenly pathways. Their job is to maintain order in the heavens and to prevent the "fallen angels" from taking over the world. This keeps the universe in balance. They are also seen as the angels of birth and death.

3RD SPHERE——7TH, 8TH, 9TH ORDERS

Principalities

Also known as Princedoms, they are the guardian angels of cities, nations, and rulers, guarding against the invasion of evil angels.

Archangels

These are the best known of all angels since among them are Michael, Gabriel, and Raphael. They carry God's most important messages to humans. Some sources put them as standing next to God, while others put them farther down the scale.

Angels

These celestial beings are the closest to humans. They act as intermediaries between God and humanity, and are often called our "guardian angels."

10TH ORDER

Fallen Angels

Other scribes add to this list and note that there is a tenth order of angels. These are the fallen angels and they are ruled by Satan. The word *Satan* is a derivation of the Hebrew word *ha-satan*, meaning "adversary."

Mt. Auburn Cemetery, Cambridge, Massachusetts

Five different views of the same girl appear in a mausoleum on this stained-glass window, which is a copy of a 1787 painting by Sir Joshua Reynolds (1723–1792), who achieved fame as a painter and an art critic. He was especially adept at painting women and children. Some of his paintings include *The Strawberry Girl, Master Hare, The Age of Innocence, The Duchess of Devonshire and Her Daughter*, and this painting, *Heads of Angels*, copies of which have hung in the bedrooms of many a young girl.

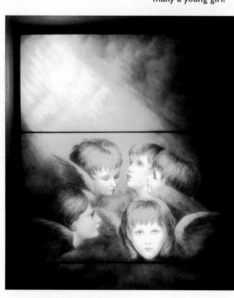

ANGELS GET THEIR WINGS

Despite all the references to angels in the Bible, nowhere is the physical description of angels described in any detail. The earliest depictions of angels, which are found on sarcophagi, depict angels as solemn young men. But, since angels have always been seen as messengers between heaven and Earth, it was inevitable that sooner or later they would sprout wings. The earliest depiction of an angel with wings is in a fifth-century mosaic in the Church of St. Prudencia in Rome. Much of the way we perceive the form of angels developed in the Middle Ages and was refined during the Renaissance. The vast amount of church and religious art during the Renaissance provided artists with a ready canvas to refine the appearance of angels and separate them from their human counterparts. Halos, white garments, swords, horns, harps, and wings, all provided grist for a Renaissance artist's angel-making mill.

The typical Renaissance angel was portrayed as heroic, beautiful, and glowing. At the same time, little childlike angels known as Putti (think Cupid) began making an appearance. These lighthearted angels opened the angel floodgates and have never been significantly ratcheted back since.

The Protestant Cemetery, Rome, Italy

The angel sculpted by William Wetmore Story is a memorial to his wife Emelyn, who died in Rome in 1895.

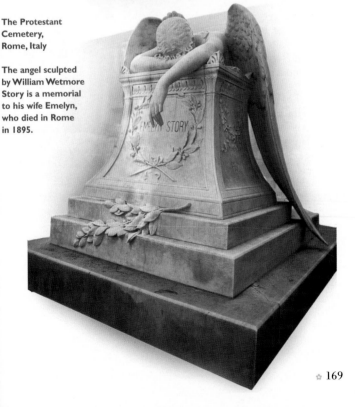

Philosophical discussions of "angelology" became topics of religious conferences. Folks like Thomas Aquinas (1225–1274) stated that while angels have form they do not have matter, thereby being eternal and incorruptible. He said that angels would and could assume a physical body but only temporarily or until they had fulfilled their mission, and that since they had matter, only one angel could be in one place at a time. In contrast, Johannes Duns Scotus (ca. 1264–1308) held to strong beliefs that angels consisted of form and non-corporeal matter particular to them alone, thus allowing more than one angel to occupy the same space.

Cementiri del Sud-Est, Barcelona, Spain

This angel holding a shield appears to be a depiction of the archangel Michael, who is often sculpted with sword and shield.

ANGELS IN CEMETERIES

When it comes to viewing these winged messengers, cemeteries are the place to go. Many cemeteries have self-guided angel tours. Most angels in cemeteries are of a generic variety, but with a little sleuthing a cemetery visitor can usually find an example of Gabriel, since he is portrayed with a horn; statues of Michael with his sword or shield are also fairly common. Cherubs are often found adorning children's graves.

Oftentimes a cemetery has one particular angel that gets significantly more attention than others. The Jennie Roosevelt Pool angel, which is modeled after the famous angel sculpted by William Wetmore Story in the Protestant Cemetery in Rome, is the favorite angelic destination for visitors to Cypress Lawn Memorial Park in Colma, California. She was a cousin of Theodore Roosevelt. Across the bay in Oakland, visitors flock to the Crocker angel. Hollywood Forever Cemetery is home to a rather sensuous statue of Eros (a sort of grown-up Cupid) and Psyche. Cemeterians tell us that people seem to adopt specific angels and call them their own. Certain angels seem to attract fresh-cut flowers; others attract toys and teddy bears.

Unfortunately angels can also attract the wrong kind of people. Their fragile wings and sometimes lofty perches are frequent targets for vandals: Wyuka Cemetery in Lincoln, Nebraska, had two angels toppled by vandals in 1999. Some have even been spirited away by thieves: a $1,000

reward has been offered by San Antonio, Texas, police for information leading to the recovery of a three-foot angel that was stolen.

Still, angels seem to have weathered well in America's cemeteries. They comfort us; they give us hope and sometimes even inspire us. There is no angel on the tomb of Tyrone Power in the Hollywood Forever Cemetery, but there is an angelic verse from William Shakespeare, *Hamlet*, Act 5, Scene ii—*"Now cracks a noble heart. Good night sweet prince: / And flights of angels sing thee to thy rest!"*

Mountain View Cemetery, Oakland, California

This magnificent example of the stone-carver's art is one of three unique angels. The seated angel gazing pensively toward the heavens is a common theme in funerary sculpture. In this example, which is carved in granite rather than marble, the sculptor seems to have captured a very special human quality. The angel is seated on the edge of the sarcophagus of Mary Crocker, who was the niece of Charles Crocker, one of the "big four" of railroading and mining fame.

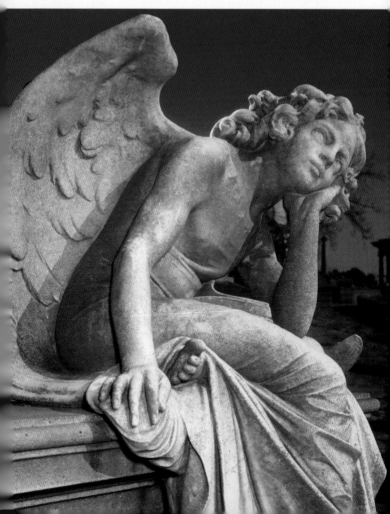

THE CROSS

It's hard to think of a symbol more closely associated with a religion than the cross is with Christianity. But the use of the cross as a symbol predates its association with Christianity by thousands of years. In fact, the cross may be humankind's oldest symbol. In its simplest form of two intersecting lines of the same length, it makes an X, as in "X marks the spot." The circle, the X-shaped cross, and the cross that looks like a plus (+) sign are used by all cultures. The ancient + cross took on many meanings among pagan cultures, most notably as a symbol signifying the division between heaven and earth. This + cross was eventually adopted by Christians and is now known as the Greek Cross.

THE ORIGIN OF THE CROSS

But long before Christians utilized the cross as their supreme symbol, other cultures were employing it and modifying it to fit with their cultures. The ancient Druids were known to cut off all the branches of a giant oak tree except for two branches on either side of the trunk, thus forming a huge natural cross. Other cultures took the basic cross form and added to it. One of the earliest modifications of the + cross was by Eastern civilizations who added arms to the end of the cross to form a swastika, or fylfot cross. The original swastika cross was a symbol of good fortune and has decorated ancient pottery, jewelry and coins. It also became a power symbol among ancient fire-worshiping Aryan tribes because the arms of the swastika resembled the sticks with handles that the tribal members rubbed together to make fire. Its various forms often represented the highest attainment possible, and it was used to represent both spiritual and worldly pursuits. Unfortunately, the swastika was also used by power-hungry rulers such as Charlemagne and Hitler and is now associated with evil.

Another type of cross that has its roots in ancient civilizations is the Tau cross, which is shaped like a capital *T*. This cross has frequently been referred to as the Old Testament cross because it was often used by Hebrew tribes. The Tau cross was probably derived from the cross of Horus, known as an ankh, which looks like a Tau cross with an elongated *O* attached to the top. The ankh is often seen in hieroglyphics, most often held in the hand of a god or person of power.

The Christian cross was eventually adopted by

The fylfot cross (swastika) has become one of the world's most hated symbols. This particular cross, known as a Buddhist swastika, is on a Japanese grave. In seventeenth-century Japan, Christians who feared persecution for their beliefs used this symbol as a way of disguising the more identifiable Latin cross.

adherents of that religion, but it wasn't Christendom's first symbol. Most scholars agree that, despite popular mythology that says early Christians scratched crosses everywhere they went, the first symbol Christians actually used was a fish. The use of a fish as a symbol may be because Christ is often portrayed as instructing his disciples to be fishers of men, or some even say that the word for fish in Greek contains the first letters of the phrase, Jesus Christ, the Son of God, Savior. But, whatever the reason, within a few centuries, Christians tossed aside the fish as their prime symbol and adopted the cross.

It's quite amazing that any form of the cross was adopted by Christians as their prime symbol, since crosses had been used for centuries to punish and persecute Christians as well as common criminals. In early Christian literature the cross on which Christ was crucified is referred to as the "accursed tree." Nevertheless, the story goes that around the year A.D. 320, the Roman Emperor Constantine couldn't make up his mind whether he should continue practicing paganism, which had served his predecessors well, or embrace Christianity, which many of the Roman citizenry (including his own mother) were either following or exploring. The situation at hand for Constantine was a huge battle he was about to engage in with Maxentius. Maxentius was apparently enlisting the aid of supernatural and magic forces, so Constantine decided to pray to the God of the Christians to help him defeat his foe. During a midnight prayer Constantine gazed toward the heavens and saw a grouping of stars that looked like a huge, glowing, luminous cross. After he fell asleep, Constantine had a dream in which he saw Christ holding the same symbol and instructing Constantine to affix it to his standards. This dream of Christ appearing to Constantine is, to many Christians, the source of the monogram IHS, which often appears on Christian tombs. The IHS is supposed to be an abbreviation of the words *In Hoc Signo Vinces* ("in this sign conquer"). A nice

Oak Hill Cemetery, Red Bluff, California

This tomb emblem has a cross and crown (a symbol of the sovereignty of the Lord), surrounded by the Latin words *In Hoc Signo Vinces* ("In this sign, conquer"), which Christian ideology says Roman Emperor Constantine applied to his standards before going into battle against Maxentius.

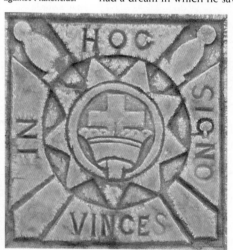

story, but, unfortunately, not true. In reality, the source of the monogram IHS is the first three letters of Jesus' name in Greek (see page 146).

IHS or not, Constantine defeated Maxentius. What Constantine more than likely saw (or thought he saw) was an intersection of the two letters *X* and *P,* which was a popular symbol used by the Christians and known as a Chi-Rho, or Labarum, cross. The Chi-Rho represents the first two letters of Christ, or *Christos,* in Greek: ΧΡΙΣΤΦΕ. In short order Constantine had the emblem applied to all of his standards and banners, and placed upon the altars of the church. Thus began the use of the cross as a Christian symbol. Although the Chi-Rho cross is seldom seen in modern times, its basic meaning has been preserved in the abbreviated form of the word for Christmas: Xmas.

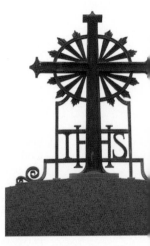

Metairie Cemetery, New Orleans, Louisiana

A Latin cross in "Glory" tops one of the tombs in this cemetery. A Glory combines a halo (a zone of light around the head) and an aureole (rays of radiating light surrounding the whole body). It expresses the most exalted form of divinity. At the base of the cross is the monogram IHS, which is the first three letters of Jesus' name in Greek: Ihsus.

CROSSES IN CEMETERIES

Although there are dozens of types of crosses in cemeteries and thousands of types of religious crosses, there are basically three types that others evolved from: the Greek cross, which looks like a + sign; the Latin cross, which looks like the letter *t;* and the Celtic cross, which has a circle (nimbus) connecting the four arms of the cross.

St. Michele Cemetery, Venice, Italy

Crosses are quite apparent on this cemetery island established in 1810.

The Greek Cross

Greek-style crosses and other crosses with equidistant arms are more likely to appear as part of a decoration on a tomb rather than as freestanding crosses. The St. Andrew's cross looks like an *X.* When St. Andrew was condemned to be crucified, the story goes that he requested to be nailed to a cross that was unlike the cross on which Jesus was crucified because St. Andrew thought he was unworthy to be put in the same category as Jesus.

Thus, the St. Andrew's Cross has come to signify suffering and humility.

The Maltese cross looks like a + sign with flared ends that are usually indented to form eight points. These eight points represent the Beatitudes. It is often associated with such fraternal orders as the Knights Templar.

Many of the Greek-style crosses are associated with heraldry, and they were worn by a multitude of Christian warriors as they marched off to the Crusades. These crosses can often be seen in a cemetery gracing a family crest or as part of an emblem of a fraternal order. Best known among these are

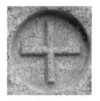

Oak Hill Cemetery, Red Bluff, California

Greek Crosses are usually found applied to tombstones as a decoration rather than as freestanding crosses.

Oak Hill Cemetery, Red Bluff, California

An abbreviated version (most have indented tips) of the Maltese cross is nestled in the pediment of a mausoleum.

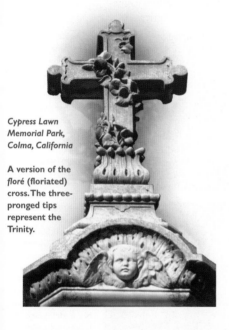

Cypress Lawn Memorial Park, Colma, California

A version of the *floré* (floriated) cross. The three-pronged tips represent the Trinity.

the *floré* (floriated) cross, which has arms that end in three petal-like projections, and the *patté* (broadfooted) cross, where the arms look like triangles with the tip of the four triangles pointed at the center. These rather broad arms represent the wings of a bird and symbolize the protective power of the cross.

The Latin Cross

The cross most commonly associated with Christianity is the Latin cross. Some of its many variations are the Cross of Calvary, which is a Latin cross with a three-stepped

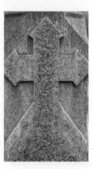

Cypress Lawn Memorial Park, Colma, California

An elaborate *floré* cross graces a tomb. The triple-flared ends of the cross arms represent the Trinity of the Father, the Son, and the Holy Ghost.

base, representing the Trinity; the Cross of the Resurrection, which is a simple Latin cross with a spiked end; and the Crucifix, or Rood, which has Christ nailed to it. Cemetery wanderers will also spy many Latin crosses with more than one cross arm. The most common of these is the Cross of Lorraine, which has a shorter arm above the long one. It was applied to the standards of Godfrey of Lorraine, one of the first Crusaders, after he was chosen ruler of Jerusalem. This symbol is familiar to us as the cross that graces Easter Seals. A variation of the style of the Cross of Lorraine is the Russian Orthodox cross, or Eastern Orthodox cross. This cross has an angled crossbar below the main crossbar. Where one is seen, often many are seen, since they generally appear in ethnic cemeteries or in ethnic areas of large cemeteries.

Highgate Cemetery, London, England

The simplicity of the unadorned Latin cross makes it one of the most powerful religious symbols.

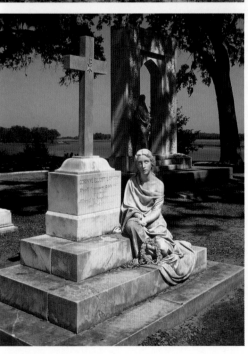

Bonaventure Cemetery, Savannah, Georgia

According to the Bonaventure Historical Society in Savannah, Georgia, an Italian sculptor by the name of Civiletti carved this beautiful sculpture of Corrine Lawton, who died on her wedding day. She is portrayed with a wedding headdress in her open hand. The cross is a simple Latin cross mounted on three bases, which can be symbolic of the Trinity or of the three Christian virtues of Faith, Hope, and Charity. This combination of the three-stepped base and the Latin cross is sometimes known as the Calvary cross.

Sometimes Latin crosses and
Russian Orthodox crosses
are seen with angled pieces
on top of the cross that look like
a little roof. These crosses are
known as wayside crosses, which
can be seen by roadsides all over
Europe. They are usually simple wooden affairs and
were erected by the thousands. Unlike American
roadside crosses, which usually commemorate vic-
tims of automobile accidents, wayside crosses are
erected for the convenience of travelers who
may be compelled to stop and pray. The more
repentant of these travelers may become quite
emotional, which gives the wayside crosses
their alternate name: weeping crosses.
Despite their rather flimsy nature, wayside
crosses can often be seen in American
ethnic cemeteries.

The Celtic Cross

Celtic crosses are, without a
doubt, the most effervescent of
all crosses. Entire books have
been devoted to their history. In
American cemeteries they can be
found as plain stone monuments,
but more often they are embellished
with intricate tracery and symbolism.
Of the dozens of varieties of crosses, the Celtic
cross is most intensely associated with a person's
roots. A vast array of sizes and styles of Celtic
crosses adorn the graves of Irish and Scottish fam-
ilies. In fact, most Scots have a cross that is par-
ticular to their clan. The basic form of a Celtic
cross is of a cross enclosed in a circle (nimbus).
The Celtic cross is pagan in origin and predates
Christianity by a number of centuries. In its early
form, it was devoid of decorations, and the top
three arms of the cross (representing the male
reproductive power) were totally enclosed within
the circle (representing the female reproductive
power). As Christianity was adopted by the Celts,
the circle began to get smaller, symbolizing either
the triumph of Christianity or the loss of the
Goddess influence, depending on how you look
at it. The symbolism of the Irish cross is strongly

*Hollywood Forever
Cemetery,
Hollywood, California*

This cemetery has
seen a dramatic
increase in burials
of people of eastern
European descent.
The Eastern
Orthodox cross,
also known as the
Russian Orthodox
cross, has a slanted
bar underneath the
main cross member.

tied to Mother Earth and national pride. The four arms can represent the four elements—air, earth, fire, and water. In some Celtic crosses the four arms correspond with four provinces of Ireland, with the circle used in creating a fifth province by incorporating pieces of the other four.

One of the most heralded modern-day Celtic crosses is the Ruskin cross, found in a churchyard in Coniston, Cumbria, England, a memorial to famous author and art critic John Ruskin (1819–1900). It is an unusual Celtic cross because it does not have a nimbus (the circle encompassing the four arms), but it is a great example of funerary architecture that tells a story. Chiseled into the cross is the story of John Ruskin's life, using symbols.

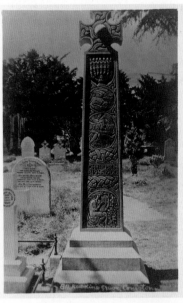

Coniston Churchyard, Cumbria, England

An old postcard depicts the Ruskin cross in England, one of the most celebrated modern Celtic crosses. All four sides of the cross tell the life story of noted author and critic John Ruskin.

On the front of the cross, facing east into the rising sun, are Ruskin's name and birth/death dates separated by an ornamental swastika. At the base of the cross is a youthful figure with a lyre, suggesting Ruskin's early life as a poet. Just above that panel is interlace ornamentation under which the title of his first great work, *Modern Painters*, is cleverly placed. Above Ruskin's name is a carved figure in an artist's smock, also suggesting *Modern Painters*. The rising sun further suggests the east-facing monument and Ruskin's early years. The mountains in the background represent his time in Switzerland. Above the figure of the artist are panels featuring a winged lion and a seven-tipped lamp, or candlestick. The lion is the winged lion of St. Mark (see page 97), which is the emblem of Venice, a reference to his book *Stones of Venice*, while the candlestick represents his book *Seven Lamps of Architecture*. Candlesticks with seven tips appear in many other types of memorials because of the number seven's mystical value and the Old Testament story of Earth being created in seven days.

The other three sides of the Ruskin cross are also bursting with symbols. The south side has a nature theme replete with robins, squirrels, a kingfisher, and Ruskin's favorite flower, the wild rose; the west side has references to his later works; and the north side is a tangle of interlaced

knots, referring to Ruskin's last years of world weariness, sickness, and manic depression.

Most American cemeteries have an intricate Celtic cross, or two, or three. But few are as elaborate as the Rogers-Palfrey-Brewster Cross in Metairie Cemetery, New Orleans, Louisiana. Many of the elements on the cross bear more than a little resemblance to the Ruskin cross, lending one to speculate if the designer may have used the Ruskin cross for inspiration. Famed New Orleans tomb-contractor Albert Weiblen fabricated the stone from an 18-foot, 15-ton block of Indiana limestone, chosen because it would weather to look like an ancient stone. Although Weiblen fabricated the monument, Charles L. Lawhon actually designed the monument, based on research and family data.

Just like the Ruskin cross, the Rogers-Palfrey-Brewster cross has an almost identical seven-armed candlestick on the east side. And like the Ruskin cross, this one tells a bit of history of the family. On the second panel below the candlestick is the Louisiana pelican seal, embossed with crossed cannons and inscribed with the date 1862 and the letters CSA (Confederate States of America), recognizing the members of the family who fought in the Civil War. Most of the rest of the cross is devoted to traditional religious symbols. At the center of the crossed arms on the east side of the cross is the Agnus Dei, the Lamb of God. Surrounding this are depictions of the attributes of the Four Evangelists: The cherub with the scroll is St. Matthew, portrayed as a writer of the Gospel; the winged lion is the attribute of St. Mark; the winged ox is an attribute of St. Luke; the eagle is one of the principal attributes of St. John (see page 95). On the west side of the cross the arms have the same depictions of the attributes of the evangelists, but in the center is a dove, a symbol of the Holy Ghost.

Of particular interest is the style of writing on the cross. Lawhon specified that the lettering be in a runic script, which is an ancient lettering style of the Nordic tribes. Many names of family members are inscribed in runic at the base of the monument, and there is still ample room for more. Also inscribed in runic on the nimbus are the words "I am the way and the truth and the life" on the east side, and "I know that my redeemer liveth" on the west side.

Metairie Cemetery, New Orleans, Louisiana

Every square inch of the Rogers-Palfrey-Brewster Celtic cross is covered in symbols that describe the family's history and religious beliefs.

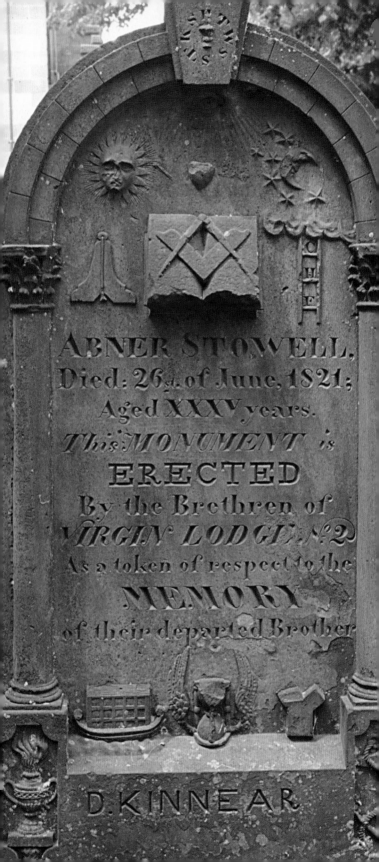

secret societies, clubs, and fraternal organizations

WE ARE A NATION of joiners. Sociologists say that we humans are herd animals; if enough of us are thrown together for any length of time, sooner or later we'll form a club or start a competition and appoint leaders. We do this for companionship as well as protection and security. In the years before formal health and life insurance, "benevolent societies" were founded to provide their members with companionship, medical care, and death care. Immigrant groups originated many of these societies as a way to preserve and honor the traditions of the old country. Conversely, people who wanted to distance themselves from the new arrivals formed their own organizations. Understandably, the greatest popularity of these clubs and societies was during the years of the heaviest immigration, particularly after the Civil War. The membership of most organizations took a pronounced nosedive during the tough financial times of the Great Depression and subsequent enactment of the New Deal, which provided a number of the same benefits as the benevolent societies.

Many societies provided a death benefit as part of their membership, ranging from a tombstone, to a plot in the organization's cemetery, to a space in a community mausoleum. Some organizations even had their own cemeteries: most notably, the Masons and Odd Fellows. For the finest examples of tombs of benevolent societies, explore the

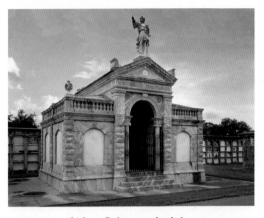

Page 180:
St. Paul's Cemetery,
Halifax, Nova Scotia,
Canada

Left:
Cristoforo Colombo
Society,
Metairie Cemetery,
New Orleans, Louisiana

cemeteries of New Orleans, which boast row
after row of society tombs, like the Cristoforo
Colombo Society tomb in Metairie Cemetery,
the Screwmen's Benevolent Association tomb in
St. Roch Cemetery, and the Italian Benevolent
Society tomb, St. Louis Cemetery # 1.

Below:
Italian Benevolent
Society,
St. Louis Cemetery #
New Orleans, Louisian

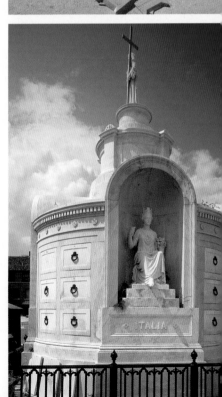

Of course, not all
organizations provided
death benefits and some
were more for fun and
drinking than anything
else. Alas, groups like
the Exalted Order of Big
Dogs (EOBD), an organ-
ization of musicians that
held their meetings in
Kennels, and the Order
of Bugs (OofB), which
met in Bughouses
presided over by the
Supreme Exalted
Bugaboo, no longer
exist. Others, like the
Ancient and Honorable
Order of the Blue Goose
(AHOBG), which was
founded in 1906 as a
society for fire insurance
men and whose officers
consist of a Most Loyal
Gander (president),
Wielder of the Goose
Quill (secretary), and
Keeper of the Golden
Goose Egg (treasurer),
have fallen into obscu-
rity. But organizations
like the Freemasons,

Woodmen of the World, Elks, Eagles, and Moose continue to prosper.

In the cemetery, by far the most-represented society is the Freemasons. But even in small cemeteries, tombstones with the symbols of the Odd Fellows, Woodmen of the World, and their female equivalents can be found. A little sleuthing will also reveal that many tombstones have the symbols of more than one society. This is particularly true of the Freemasons and the Odd Fellows, who shared not only members but also a number of symbols. Less common but still fairly easy to find are the symbols of many of the "animal societies," like the Elks, Eagles, and Moose. Not so easy to find are the symbols of some of the less-popular animal societies, like the Buffalo, Beavers, Bears, Camels, and Owls.

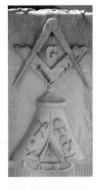

Masonic Cemetery, Virginia City, Nevada

Eagles (FOE)
Ladies Auxiliary of the Eagles (FOE)

Below:
Winnemucca Cemetery, Winnemucca, Nevada

The Fraternal Order of Eagles, originally named "The Order of Good Things," was founded in Seattle, Washington, in 1898 by a group of theater owners. According to the Eagles, their first organizational meetings revolved around a keg of beer, and before long the wishy-washy name, the Order of Good Things, was changed to the more authoritarian Fraternal Order of Eagles. A constitution and bylaws were drawn up and the name *Aerie* was adopted as the designation for their meeting places and groups. The Eagles were originally composed of people working in the theater business (actors, stagehands, playwrights, etc.), and word of the organization spread rapidly because of the mobile nature of its members. Although the organization was like many others of the time, providing brotherhood, health benefits, and a funeral benefit ("no Eagle was ever buried in a Potter's Field"), the Eagles went farther by providing an "Aerie physician" and having its own Eagle-appropriate stirring script for a funeral service.

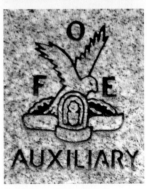

Above:
Chico Cemetery, Chico, California

Frank Hering, who was a Past Grand Worthy President of the Eagles, made the first public plea for a national day to honor mothers; thus, he is known as the "Father of Mother's Day."

The Eagles still thrive. Much of their work

Facing, lower:
Screwmen's Benevolent Association, St. Roch Cemetery, New Orleans, Louisiana

revolves around lobbying for improving workman's compensation and social security, and sponsoring a number of health-related charities.

Knights of Pythias (KP)

If you see a heraldic shield coupled with a suit of armor on a tombstone, chances are it marks the spot of a fallen Knight of Pythias. Usually the letters *F*, *C*, and *B*, which stand for Friendship, Charity, and Benevolence, accompany the shield. It has been said that the Pythians have used upwards of 20,000 different symbols, so it's not unusual to find an array of symbols on one of their tombstones.

The Knights of Pythias was officially founded in 1864 as a secret society for government clerks. The name *Pythias* is a misspelling of the Greek name *Phintias*, a Pythagorean philosopher from Syracuse whose story dates to the fifth century B.C. Evidently, the infamous tyrant Dionysius was about to put Phintias to death for questioning his rule. Phintias' friend Damon requested that he be held as a hostage so Phintias could go out and say goodbye to his friends and put his house in order before he died. At the appointed time of execution, Phintias was nowhere to be found, so Damon offered himself in Phintias' stead. But Phintias arrived at the last minute, prepared to accept his fate. Dionysius was so impressed with the trust and loyalty of these two men that he stayed the execution and asked both of the men to join him in friendship.

Wailuku Cemetery, Wailuku, Maui, Hawaii

One Justus H. Rathbone was so favorably influenced by the tale, which he had seen as a play, that he formed a fraternal society (albeit misspelled) based on the traits of friendship, benevolence, and charity. It took a while for the Knights of Pythias to get started, including the expulsion, (on two occasions) of Rathbone. At its peak in 1923 the society boasted more than 900,000 members, but the Great Depression took its toll, and by the end of the twentieth century, membership had dropped to less than 10,000.

Pythian Sisters (PS)

The female auxiliary of the Knights of Pythias is the Pythian Sisters. Their symbol is a Maltese cross embossed with the letters *P* (Purity), *L* (Love), *E* (Equality), and *F* (Fidelity).

Elks (BPOE)

Tombstones of Elks are easy to identify. They have an emblem with an elk in the center, surrounded by a clock with roman numerals and the letters *B P O E*

Oahu Cemetery, Honolulu Hawaii

(Benevolent Protective Order of Elks). The clock's hands are frozen at eleven o'clock, a sacred time to all Elks. At eleven o'clock at any Elks ritual, the following toast is read:

> *My Brother, you have heard the tolling of the eleven strokes. This is to impress upon you that the hour of eleven has a tender significance. Wherever an Elk may roam, whatever his lot in life may be, when this hour falls upon the dial of night, the great heart of Elkdom swells and throbs. It is the golden hour of recollection, the homecoming of those who wander, the mystic roll call of those who will come no more. Living or dead, an Elk is never forgotten, never forsaken. Morning and noon may pass him by, the light of day sink heedlessly in the West, but ere the shadows of midnight shall fall, the chimes of memory will be pealing forth the friendly message, "to our absent Brothers."*

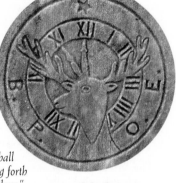

Oahu Cemetery, Oahu, Maui, Hawaii

The Elks were an offshoot of a drinking club, the Jolly Corks (JC), that was formed by actors in 1866. The purpose of the club was to avoid a New York law that prohibited the sale of spirits on Sundays. Gatherings of the Corks became very popular, and it was deemed necessary to formalize the club. The name *Jolly Corks* must have seemed a bit too explicit, so a search was conducted to find a more suitable name. It's said the name *Elks* came from a stuffed head one of the members saw on display at the P. T. Barnum Museum (some say it was actually a moose head; but after all, it was a drinking club and mistakes do happen). The Elks became much more than a drinking club, and with more than 1,500,000 members, it is now one of the largest of the "animal clubs." The Elks are very strong on patriotism, public service, and caring for Elks who have fallen onto hard times.

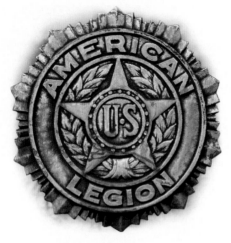

*Chico Cemetery,
Chico, California*

American Legion (AL)

The American Legion was founded in Paris,
France, in 1919. It is primarily an association for
ex-servicemen, and works especially hard for vet-
erans' rights for the wounded, infirm, and elderly.
Because of its substantial membership, it also
exercises quite a bit of political clout. The
American Legion has gone to great lengths to
explain the symbolism of their emblem. Here is
the official explanation:

The Rays of the Sun *form the background of
our proud Emblem, and suggest that the Legion's
principles will dispel the darkness of violence and evil.*

The Wreath *forms the center, in loving memory of
those brave comrades who gave their lives in the serv-
ice of the United States, that liberty might endure.*

The Star, *victory symbol of World War I, signal-
izes as well honor, glory and constancy. The letters
U.S. leave no doubt as to the brightest star in the
Legion's star.*

Two Large Rings, *the outer one stands for the
rehabilitation of our sick and disabled buddies. The
inner one denotes the welfare of America's children.*

Two Small Rings *set upon the star. The outer
pledges loyalty and Americanism. The inner is for
service to our communities, our states and the Nation.*

The words **American Legion** *tie the whole
together for truth, remembrance, constancy, honor,
service, veteran's affairs and rehabilitation, children
and youth, loyalty, and Americanism.*

Boy Scouts of America (BSA)

The Boy Scouts were founded in 1910 by a group of five like-minded men who extolled the virtues and simple values of outdoor skills and public service. The Boy Scouts were inspired by similar groups in England and have spawned a number of imitators. At the beginning of the twenty-first century there were more than 3.3 million youth members and 1.2 million adult members of the Boy Scouts.

The fleur-de-lis on the Boy Scout emblem was adapted from the north point of a mariner's compass; the three points are reminders of the three parts of the scout's oath. The two stars symbolize the outdoors as well as the attributes of truth and knowledge. At the bottom of the emblem is the well-known Boy Scout motto, "Be Prepared." According to official Boy Scout literature, the upward swoop of the banner "hints that a Scout smiles as he does his duty." This particular example is the Americanized version that was adopted in 1911 by the addition of the eagle and shield, which stands for "freedom and readiness to defend that freedom." Most Boy Scout emblems also have a small knot at the bottom, which is a reminder to "do a good turn daily."

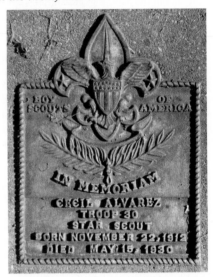

Oahu Cemetery, Oahu, Hawaii

Moose (LOOM)
Women of the Moose (WOM) (WOTM)

Oak Hill Cemetery, Red Bluff, California

Dr. John Henry Wilson founded the Loyal Order of the Moose, now known as Moose International, in 1888 in Louisville, Kentucky, apparently on little more than a whim. Wilson's plan was to establish a fraternal organization loosely based on other animal fraternities. Membership in the Loyal Order of the Moose didn't exactly skyrocket, but in a few years there were about 1,000 members who met in lodges called *Watering Places*, a reference, no doubt, to the alcoholic beverages that were consumed. Wilson's initial enthusiasm must have waned because in a few more years

there were only several hundred loyal members.

Enter one James J. Davis, who was a government clerk from Elwood, Indiana. In 1906 he attended a rather grim Moose convention (at this point there were only 246 active members) and was sworn in as member 247. Davis, who in today's world would have been labeled a "self-starter," saw hidden potential in the Moose world and in short order talked the struggling society into bestowing him with the title of Supreme Organizer. Davis came up with the idea of providing a "safety net" for working-class families as the benefit of Moose membership. For $5 to $10 a year a member could buy protection for his wife and children if he died or became disabled. For the next twenty years Davis toured the country, extolling the virtues of membership in the Loyal Order of the Moose. And his proselytizing paid off: by 1928 there were more than 650,000 members.

Today membership hovers around 1.8 million. Two of Moosedom's proudest achievements are Mooseheart, a campus-like environment that provides care for the families of fallen Moose, and Moosehaven, a retirement community in Florida. The Moose emblem usually contains the letters *P A P*—Purity, Aid, Progress. The female auxiliary, the Women of the Moose, was established in 1913. Its emblem is essentially the same, but contains the letters *H F C*—Hope, Faith, Charity.

Hollywood Cemetery, Richmond, Virginia

Woodmen of the World (WOW)

Treestones, also known as "tree-stump tombstones," often mark the resting place of a Woodman of the World. Joseph Cullen Root, a native of Lyons, Iowa, founded Woodmen of the World in Omaha, Nebraska, on June 6, 1890. Root was an inveterate joiner and at various times had been a member of the Odd Fellows, Freemasons, Knights of Pythias, and others. Root's organization was originally open to white males aged eighteen to forty-five from the twelve healthiest states, and specifically excluded men in hazardous vocations like train brakeman, gunpowder factory employee, bartender, and even professional baseball player. Today Woodmen of the World has relaxed most of its restrictions and totals more than 800,000 members. It is now known as the Woodmen of the World Life Insurance Society/Omaha Woodmen Life Insurance Society.

Although its membership is modest compared to other insurance-like organizations, it is one of the best-represented organizations in the cemetery. Why? Because until the 1920s, membership in the Woodmen of the World provided each member with a tombstone. Even today, the insurance company claims that "no Woodmen shall rest in an unmarked grave." At first, the Woodmen of the World supplied the tombstone designs directly to local manufacturers, but they soon found that it was best to have local suppliers handle the design, manufacture, and setting of the tombstones. Rustic treestones were already a popular style of tombstone and, with their woodsy name, the Woodmen of the World popularized treestones even more.

Although Woodmen of the World was primarily an insurance company, Root established a variety of ceremonies and rituals, and adopted a number of symbols because of his history with other fraternal organizations. Many of the symbols were formalized at the Woodmen Sovereign Camp in 1899, when the tree stump was officially adopted to symbolize equality and commonwealth. On tombstones there are usually the Latin words *Dum Tacet Clamet*, roughly translated as "Though Silent, He Speaks," or in popular language as "Gone But Not Forgotten." Also embossed on the tombstone are usually a dove with an olive branch (peace) and an ax, beetle, and wedge, which, according to Root, symbolize workmanship and progress of culture.

Like many organizations, the Woodmen had internal problems, and a number of schisms and splinter groups developed. Some of them are Neighbors of Woodcraft (NOW), Woodmen Circle (WC), Royal Neighbors (RN), Supreme Forest Woodmen Circle (SFWC), Modern Woodmen of the World (MWW), and Woodmen Rangers and Rangerettes (WRR).

Women of Woodcraft (WOW)

Chico Cemetery, Chico, California

The Women of Woodcraft was a female auxiliary organization to the Woodmen of the World. Organized in 1897, they covered nine western states, and for a time their headquarters were in Leadville, Colorado. Their officers had titles such as Guardian Neighbor, Captain of the Guards, Inner Sentinel, Outer Sentinel, and Magician. Unfortunately, it is not known what the duties of the Magician entailed. In 1917, the Women of Woodcraft changed their name to Neighbors of Woodcraft.

From a distance, the emblem looks identical to the Woodmen of the World, but close inspection reveals that besides the different name, the motto *Dum Tacet Clamet* has been replaced with "Courage, Hope, Remembrance," and the tree stump is often broken, symbolizing the end of life.

Modern Woodmen of America (MWA)

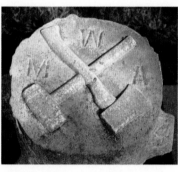

The Modern Woodmen of America was the original name of the Woodmen of the World. It is still an active organization and with more than 750,000 members in 2003, it claims to be the country's fifth-largest fraternal life insurance company. Although most of the symbolism has been abandoned or toned down, up until the 1950s members could purchase various items like cuff links and rings to identify them as a Modern Woodmen of America. This jewelry featured the ax, wedge, and beetle (industry, power, and progress); the log and maple leaf (shield of protection and brotherhood), and a palm, five stars, and a shield (peace, light, and safety). Modern Woodmen used the color red to signify life and action, white to signify innocence and purity of intention, and green to signify immortality. Employing a Victorian funerary tradition, some necklaces and watch fobs used braided human hair.

Chico Cemetery, Chico, California

Neighbors of Woodcraft (NOW)

The Women of Woodcraft, also known as the Pacific Circle, Women of Woodcraft, covered the states of Colorado, Montana, Utah, Wyoming, Idaho, Nevada, Washington, Oregon, and California. The organization moved to Portland, Oregon, in 1906, where articles of incorporation were filed with the state of Oregon. In 1917, the Women of Woodcraft changed its name to Neighbors of Woodcraft to reflect the organization's acceptance of both men and women for membership. On July 1, 2001, the 7,000 Neighbors of Woodcraft merged with the Woodmen of the World.

Chico Cemetery, Chico, California

Freemasons/Masons
(AAONMS) (AASR) (AF&AM) (F&AM)
(IGGCRSM) (K of M) (RAM)

The primary symbol of the Freemasons is the square and compass. Often, inside the symbol is the letter G, which some say stands for geometry while others say it stands for God. Sometimes the symbol also contains clasped hands. The square and compass represent the interaction between mind and matter and refer to the progression from the material to the intellectual to the spiritual. The Freemasons have a gift for clouding the origins of their organization, but historians say the roots of Freemasonry were among the stonemasons who built the great cathedrals in Europe. Since they went from job to job and were essentially self-employed, they were *free* masons. When they worked on a large job they banded together to form lodges. The Masons have grown to become the largest fraternal organization in the world. They are noted for their wide use of symbols and secret handshakes.

Chico Cemetery, Chico, California

Besides the square and compass, also be on the lookout for other Masonic symbols such as the all-seeing eye, often with rays of light, which is an ancient symbol for God. Although many cultures have eye symbols, some good and some evil, when seen in a cemetery it usually means that the person was a Mason. This symbol is familiar to us as one of the mysterious images on the reverse of the dollar bill. Its placement on the dollar bill is largely the result of America's founding fathers, among them George Washington, Benjamin Franklin, Alexander Hamilton, Paul Revere, and John Paul Jones, who were Masons. In fact, one scholar describes Washington's Continental Army as a "Masonic convention."

The Old Cemetery, Barcelona, Spain

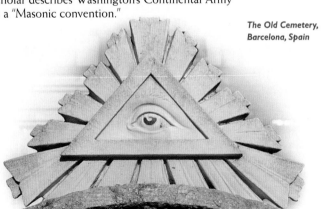

Shriners (Mystic) (AAONMS)

The Imperial Council of the Ancient Arabic
Order of the Nobles of the Mystic Shrine, better
known as the Shriners, was founded in 1872 by
Freemasons Walter M. Fleming, an M.D., and
William J. Florence, an actor, who apparently
weren't having enough fun at Freemason
functions. The Shriners were only
open to 32nd Degree Master
Masons and Knights Templar.
They adopted many of the
symbols of Islam but in a
parody form, which, under-
standably, has irritated followers
of that religion. They routinely
wear amusing garments, including
fezzes; give themselves titles like
Most Illustrious Grand Potentate;
engage in humorous antics; and have
rather boisterous conventions. At one time
the Freemasons considered banning any member
who was also a member of the Shriners. When
the letters of the Ancient Arabic Order of the
Nobles of the Mystic Shrine are rearranged, they
spell "A MASON."

Chico Cemetery,
Chico, California

The emblem of the Shriners contains a scimitar
from which hangs a crescent, "the Jewel of the
Order." In the center is the head of a sphinx (not
always seen in simple emblems) and a five-
pointed star. On elaborate renditions of the
emblem, the crescent contains the motto *Robur et
Furor* ("Strength and Fury").

The Shriners go beyond the fun aspects to
give large sums of money to hospitals that care
for badly burned and crippled children and to a
number of other causes. They still engage in their
antics, most notably driving miniature cars and
scooters in parades. Famous Shriners include
Harry Truman, Barry Goldwater, J. Edgar Hoover,
Chief Justice Earl Warren, and Red Skelton.

Chico Cemetery,
Chico, California

Masonic Keystone
(HTWSSTKS)

The letters HTWSSTKS, arranged in a
circle and usually within a keystone, are
known as the Masonic Mark of an Ancient
Grand Master. The letters are an acronym
for "Hiram The Widow's Son Sent To
King Solomon." Sometimes the center
of the keystone contains a sheaf of wheat.

The Freemasons are not only big on
symbols, they also have a multitude of

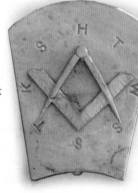

degrees and attributes that they abbreviate on tombstones. Some of the most often seen include the following:

AAONMS	Ancient Arabic Order of Nobles of the Mystic Shrine
AASR	Ancient and Accepted Scottish Rite
AF&AM	Ancient Free and Accepted Masons
F&AM	Free and Accepted Masons
IGGCRSM	International General Grand Council of Royal and Select Masons
K of M	Knights of Malta
RAM	Royal Arch Masons

For more Masonic symbols, see the Eagle, Two-Headed (page 81), Cross with Crown (page 113), Crook (Crosier) (page 114), and Tent (page 121).

Knights Templar (KT)
Social Order of the Beauceant (SOOB)

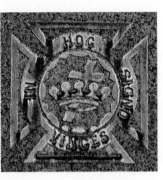

Chico Cemetery, Chico, California

In cemetery symbolism, the Knights Templar is part of the convoluted Freemasons structure. The Knights claim to have been founded by a group of warrior monks in 1118 whose job was to keep the roads safe for pilgrims traveling to Jerusalem. They eventually grew very wealthy and were overthrown in 1307 by King Phillipe le Bel of France, who desired their income. Many of them escaped to England, Portugal, and Scotland, where they are said to have formed the Freemasons in the late 1700s. So many of their affairs have been shrouded in secrecy that it is impossible to put together an accurate history, except to say that in the cemetery, the Knights Templar emblem is almost always seen in its Masonic form, which is the symbol for York Rite Templarism: a cross with a crown enclosed in a Maltese cross, often containing the phrase *In Hoc Signo Vinces* ("In This Sign Conquer"), mistakenly thought to be the origin of the Christian monogram IHS (page 146).

The female auxiliary of the Knights Templar is the Social Order of the Beauceant. The organization, which was founded in 1890, was originally named the "Some of Our Business Society," a reference to the help the ladies were going to provide at the Knights Templar Grand Encampment in 1892. The organization grew to more than 15,000 members, a set of rituals was established,

and a more flowery name, the Social Order of the Beauceant, was adopted in 1913. The emblem of the SOOB, a cross and a crown, is the same as the Knights Templar.

Eastern Star
(OES) (PHES) (ES) (PHGCES)

The Order of the Eastern Star has a complex history; simply put, it is the female counterpart to Free-masonry. There are three organizations that use the name Eastern Star: the General Grand Chapter, Order of the Eastern Star; the Prince Hall–affiliated Eastern Stars; and the Federation of Eastern Stars. The original group, the General Grand Chapter, Order of the Eastern Star, was formed in 1876. It has been in decline in recent years, no doubt because of its powerful patriarchal rules. All degrees must be administered by a Master Mason (male).

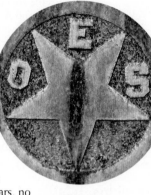

Chico Cemetery, Chico, California

A five-pointed star with the tip pointing down marks the grave of a member of the Eastern Star. Each symbol within the star points represents a heroine: Adah, Ruth, Esther, Martha, and Electa. They also symbolize the tenets of the Eastern Star: fidelity, constancy, loyalty, faith, and love. On tombstones, sometimes between the points of the star and other times in the center of the star, are the letters *F A T A L*. This refers to a double meaning of an oath taken by a member of the Eastern Star when a degree is bestowed on her: the first is simply the word *F A T A L*, which means that it would be fatal to the character of a lady if she disclosed any of the secrets of the order; the other is an acronym meaning "Fairest Among Ten-thousand Altogether Lovely."

Chico Cemetery, Chico, California

Eastern Star Past Matron

The emblem of an Eastern Star Past Matron has the Eastern Star symbol with a gavel suspended on a link of chain (or some-times a gavel mysteriously levitating on a link of chain). Occasionally a laurel wreath circles the star and a gavel is attached to the wreath by a chain.

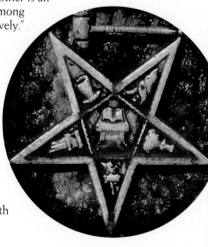

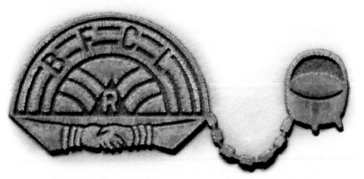

International Order of the Rainbow for Girls
(RG) (IORG) (BFCL/R)

*Chico Cemetery,
Chico, California*

The meaning of the letters *B F C L* is only known to Rainbow Girls. When superimposed over an *R* with a pot of gold, it becomes the symbol for the International Order of the Rainbow for Girls (DeMolay is for boys). A clergyman, William Mark Sexton, founded the club in 1922 as a fraternal and social club for girls aged eleven to twenty who are related to members of the Freemasons or Eastern Star. Although all of the Masonic organizations profess to be nonsectarian, the Rainbow for Girls is strongly associated with the Bible and Christian beliefs. Rainbow Girls are encouraged to follow the seven-step path of 1) effective leadership, 2) church membership and active participation in the church of their choice, 3) patriotism, 4) cooperation with equals, 5) love of home, 6) loyalty to family, and 7) service to humanity. The completion of these seven steps results in the pot of gold (charity).

It is relatively rare to find this symbol in the cemetery because of the narrow age group of its members and the relatively low mortality rate of teenage girls.

*Oak Hill Cemetery,
Red Bluff, California*

Knights of the Maccabees (KOTM)

The Knights of the Maccabees was one of the more successful mutual assessment fraternal societies that sprang up after the Civil War. Although they took on many of the trappings of other societies, such as the establishment of lodges, which they called Subordinate Camps (a Supreme Tent was the highest level), the KOTM was basically a pass-the-hat organization. When a member of the society died, each member was assessed ten cents, which

was given to the widow. The name of the organization was changed to the Maccabees in 1914, and it became more like a regular insurance company, although some of its older members insisted that its rituals and ceremonies remain. At its peak, the Maccabees boasted more than 300,000 members. But the Great Depression took its toll and there are few members today.

The name Knights of the Maccabees refers to a Jewish tribe of the second century B.C. that revolted against Antiochus IV of Syria in the name of religion. The tribe was led by Judas Maccabeau, who eventually secured a Jewish state, Judea. The founders of the Maccabees were impressed by Maccabeau's feats, especially his instruction to his soldiers that they reserve a portion of their spoils for the widows and orphans of their fellow comrades in arms.

Ladies of the Maccabees of the World (LOTM)

There was also a female counterpart to the Maccabees known as the Ladies of the Maccabees of the World. It became a national auxiliary in 1892 known as the Supreme Hive of the Ladies of the Maccabees of the World, and is said to be the first fraternal benefit group run by women. This particular tombstone is inscribed with the Latin phrase *ad astra per asperi* ("toward the stars [heavens] through adversity").

Oak Hill Cemetery, Red Bluff, California

Knights of Columbus
(KC) (KofC)

The Knights of Columbus, founded in 1882, has often been described as the "Catholic Masons" because Catholics were forbidden by a Papal edict from joining the Freemasons. The purpose of the fraternal organization, which was originally open to Catholic men over the age of eighteen, was to provide assistance to widows and orphans of the parish. It had close to 1.5 million members in 1994. Although it has many similarities to the Freemasons, including degrees and rituals, it is mainly an insurance company. But in recent years it has become more active in community affairs and politics.

Holy Cross Cemetery, Colma, California

The emblem of the Knights of Columbus was designed by Supreme Knight James T. Mullen and officially adopted on May 12, 1883. It incorporates a medieval knight's shield mounted on a *formée* cross. The *formée* cross is an artistic representation of the cross of Christ. Mounted on the shield are three objects: 1) a fasces—an ancient Roman symbol of authority composed of a bundle of rods bound together around an ax, 2) an anchor, which is the mariner's symbol for Columbus, and 3) a short sword, which is the weapon of the knight when engaged in an "errand of mercy."

Chico Cemetery, Chico, California

Odd Fellows (IOOF)

The primary symbol of the Independent Order of Odd Fellows is three links of a chain. They share this symbol and a number of other symbols, such as the all-seeing eye, with the Freemasons, but the Odd Fellows use it as their dominant sign. Indeed, sometimes the Odd Fellows are known as the "poor man's Freemasonry." The Odd Fellows are also known as the "Three Link Fraternity." The links represent Friendship, Love, and Truth. On tombstones, the letters *F L T* are often enclosed within the links of the chain.

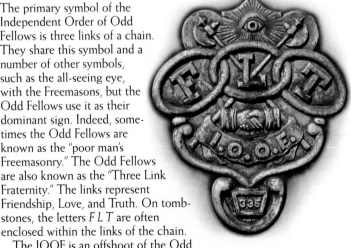

The IOOF is an offshoot of the Odd Fellows, which was formed in England in the 1700s as a working-class social and benevolent

association. The United States branch was founded in Baltimore, Maryland, on April 26, 1819, when Thomas Wildey and four members of the Order from England instituted Washington Lodge No. 1. By the Civil War it had more than 200,000 members, and by 1915 there were 3,400,000 members. The Great Depression and lack of interest in fraternal orders took their toll, and by the 1970s there were fewer than 250,000 members. But, the society claims there has been a resurgence of interest and states that now it has close to 500,000 members. Death care, including funerals, was one of the major benefits of Odd Fellows membership. One of the first orders of business, after establishing a lodge in a new town, was to purchase plots in an existing cemetery or to establish a new cemetery where plots were sold to members at a modest fee.

Daughters of Rebekah (DR)

The Daughters of Rebekah were formed in 1851 as a female auxiliary of the Odd Fellows. Like other women's auxiliaries of fraternal organizations, they were subservient to the male organization and, understandably, their numbers have fallen off in modern times.

Chico Cemetery, Chico, California

In the cemetery, look for a circular emblem with a half moon sometimes containing seven stars on the right, which, according to the Rebekahs, represents "the value of regularity in all our work." The emblem also consists of a dove (peace), a white lily (purity), and the intertwined letters *D* and *R*. Sometimes the emblem also contains a small beehive, which symbolizes "associated industry and the result of united effort."

The Grand Army of the Republic (GAR)

The GAR was an organization with built-in extinction, since membership was limited to honorably discharged veterans of the Union Army, Navy, Marine Corps, or Revenue Cutter Service who had served between April 12, 1861, and April 9, 1865. Benjamin F. Stephenson founded it in Decatur, Illinois, on April 6, 1866. Many of the ceremonies and rituals of the GAR were based on Masonic principles, including the infamous "black ball" method of voting, except that the GAR required more than one black ball to deny membership.

The main activities of the GAR were to provide companionship through organized encampments and, more importantly, to establish soldiers' homes and to lobby for soldiers' pensions. The organization grew to 409,000 members by 1890 and was a political force to be reckoned with. Five U.S. presidents were GAR members, and any Republican candidate who had any hope of becoming president needed an endorsement from the GAR. This organization was also instrumental in establishing Memorial Day, May 30, as a national holiday and day of remembrance.

Alas, the GAR is no more. The final Encampment of the Grand Army of the Republic was held in 1949 in Indianapolis, Indiana, and the last member, Albert Woolson, died in 1956 at the age of 109 years.

The Society of Mary (SM)

In Catholic cemeteries the emblem of the Society of Mary is found in areas where priests are buried, often called Priests' Circles. The circle of twelve stars probably represents the twelve founders of the school. The banner at the bottom reads *Sub Mariae Nomine* ("Under Mary's Name"), the society's motto.

The Society of Mary is a Roman Catholic religious congregation comprised of priests and brothers. Fr. John Claude Colin and eleven of his companions founded the congregation in 1836, while they were attending seminary in Lyon, France. It considers Mary, the Mother of God, to be its first and perpetual superior. Because they bear the name of Mary and are called "Marists," the members of this congregation try to imitate Mary's life and virtues. In the words of their founder, they strive to "think as Mary, judge as Mary, and feel and act as Mary in all things." They are now an international congregation, and Marist communities are found worldwide.

Oahu Cemetery, Honolulu, Hawaii

Holy Cross Cemetery, Colma, California

Foresters

For no particular reason there seem to be more varieties of Foresters than any other organization. The Forester tradition says that the group was started in medieval times in the royal forests of England. But the first officially organized group of foresters, The Royal Order of Foresters, wasn't formed until 1813. As with most groups, the Royal Order of Foresters had an initiation ceremony. One of the parts of the initiation was something called "combat with cudgels." A cudgel is a short heavy stick also called a billy club, shillelagh, or nightstick. Not surprisingly, a number of schisms developed with less-aggressive initiation rituals. The first was the Ancient Order of Foresters (AOF), which was formed in 1832 and made its way to the United States in 1864. In 1879, the Independent Order of Foresters (IOF) broke away from the Ancient Order of Foresters; in the same year, the Catholic Order of Foresters (COF) was formed. Along the way, more schisms as well as auxiliaries developed; among them were the Companions of the Forest of America (CFA) (see illustration below), the Irish National Order of Foresters (INOF), the United Order of Foresters (UOF), the Junior Foresters of America (JFA), the Massachusetts Catholic Order of Foresters (MCOF), and the Canadian Foresters Life Insurance Society (CFLIS). The most successful Foresters organization is the Independent Order of Foresters, headquartered in Canada, which boasts more than one million members. While primarily a life insurance company, it gives support to a number of charities, most of which involve caring for the needs of children.

Chico Cemetery, Chico, California

Companions of the Forest of America (CFA)

This is the emblem of the Companions of the Forest of America, a women's auxiliary of the Ancient Order of Foresters (AOF). In addition to the letters *C of F of A* on the emblem, there are the letters *S S C*, which stand for Sociability, Sincerity, and Constancy.

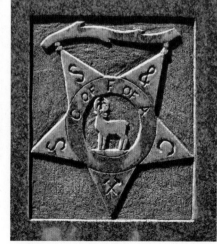

The Improved Order of Red Men (IORM)
The Degree of Pocahontas (DOP)

In the cemetery, the initials *T.O.T.E.* (Totem of the Eagle) indicates a member of the Red Men, which traces its origin (although no direct evidence can be found) to certain secret patriotic societies founded before the American Revolution, such as the Sons of Liberty (SL). The Society of Red Men was officially founded in 1813 but was dissolved shortly thereafter, apparently because of its reputation for drunkenness. It was re-formed as the Improved Order of Red Men, and its stated aim is "to perpetuate the beautiful legends and traditions of a vanishing race and keep alive its customs, ceremonies, and philosophies." Interestingly, until recently, American Indians were banned from admission. The female auxiliary of the Red Men is the Degree of Pocahontas, which was organized in 1885.

Chico Cemetery, Chico, California

Salvation Army

The Salvation Army is best known nowadays as a place for the downtrodden and disadvantaged to get help. It is well known for its drug and alcohol rehabilitation centers, thrift stores, and of course, its yuletide bell-ringing Santas. The Christian, quasi-military organization (its leader is addressed as General, employees are known as Officers, and volunteers are known as Soldiers) was founded in 1865 by Englishman William Booth. It was officially named the Salvation Army in 1878.

Salvation Army Building, Truro, Nova Scotia, Canada

Salvationists wore metal shields as badges in the early 1880s. The 1886 *Orders and Regulations for Field Officers* implored every Soldier to wear a uniform, "even if it be but the wearing of a shield," so that they could be identified as Salvationists. The first shields were white with red lettering, but this

was soon changed to red with white lettering, and that shield is the one most recognized today.

A more complex formal shield with abundant symbolism is sometimes seen. According to the Salvation Army the symbolism is thus:

> The round figure, "the sun," represents the light and fire of the Holy Spirit
> The cross in the center represents the cross of our Lord Jesus Christ
> The letter *S* stands for salvation
> The swords represent the warfare of salvation
> The shots represent the truths of the gospel
> The crown represents the crown of glory, which God will give to all his soldiers who are faithful to the end

Fraternal Brotherhood (FB)

Alas, no one seems to know what has become of the Fraternal Brotherhood. What is known is that they were a secret beneficial society with all the usual passwords and symbols; they were organized in 1896; they had a substantial building in Los Angeles that was featured on circa 1910 postcards that stated they accepted both sexes. Why they no longer exist remains a mystery.

Chico Cemetery, Chico, California

B'nai B'rith (IOBB)

The Independent Order of B'nai B'rith (Children of the Covenant) is one of the few Jewish fraternal organizations. It was formed in New York in 1843, partly because Jews were denied membership in the more mainstream fraternal organiza-

tions like the Freemasons. (Eventually Jews were admitted into organizations like the Freemasons and the Odd Fellows, and those organizations are surprisingly well represented in Jewish cemeteries. B'nai B'rith has evolved into a huge charitable organization, giving out and receiving significant donations). Today B'nai B'rith is best known through its Anti-Defamation League, which serves to combat anti-Semitism.

In Summary

There are literally hundreds of secret societies, clubs, and organizations. Many no longer exist while others remain strong. When you see an emblem with an acronym that you aren't familiar with or simply find an acronym without an emblem, try matching up the acronym with the following list. Then enter the name you find into an Internet search engine. You may be pleasantly surprised with how many results you get.

A case in point is the emblem (illustration) with the letters *N D G W* and *P P.* Consulting the list led to the identification of the organization as the Native Daughters of the Golden West. Further sleuthing led to the Web site www.NSGW.org, the Native *Sons* of the Golden West. An e-mail to the Sons solved the riddle of the other two letters: *PP* stands for Past President.

The Native Daughters of the Golden West, which was founded in 1886 (the Sons were founded in 1875) maintain records of California pioneers who resided or were born in California before December 31, 1869. To date they have compiled information on more than 33,000 pioneers.

40 & 8	Forty and Eight Veterans organization
A∴A∴	Argentium Astrum (or Astrum Argentinium)
A∴A∴S∴R∴	Ancient and Accepted Scottish Rite (Consistory)
AA	Alcoholics Anonymous
AAL	Aid Association for Lutherans
AAONMS	Ancient Arabic Order of the Nobles of the Mystic Shrine (Shriners)
AASR	Ancient and Accepted Scottish Rite (Consistory)
AAU	Amateur Athletics Union
AB	American Brotherhood
AB	Arctic Brotherhood
ABA	American Benefit Association
ABA	American Bankers Association
ABoD	Apprentice Boys of Derry
ABS	American Benefit Society
ACA	Association Canado-Americaine
AEOS	Ancient Egyptian Order of SCIOTS
AF	American Freemen
AFA	Associated Fraternities of America
AFA	American Foundrymen's Association
AFC	American Fraternal Congress
AFGE	American Federation of Government Employees
AFL	American Federation of Labor
AFL-CIO	American Federation of Labor–Congress of Industrial Organizations (see AFL; CIO)
AFU	American Fraternal Union
AFU	Acme Fraternal Union (see TAFU)
AHCS	American Hungarian Catholic Society
AHEPA	American Hellenic Educational Progressive Association
AHOBG	Ancient and Honorable Order of the Blue Goose (see HOBGI)
AHTA	Anti Horse Thief Association
AHW	American Home Watchmen
AI Ahvas Israel	(Jewish fraternal benefit society)
AIOBA	Ancient and Independent Order of Buffaloes of America
AIU	American Insurance Union
AK	American Krusaders
AKIA	A Klansman I Am
AKP	American Knights of Protection
AL	American Legion
ALAC	Knights Templar Ladies Auxiliary
ALH	American Legion of Honor
ALOH	American Legion of Honor
ALPA	Airline Pilots Association
ALS	American Lombardi Society
ALW	Association of Lithuanian Workers
AMD	Allied Masonic Degrees of USA
AMOBB	Ancient Mystic Order of Bagmen of Bagdad
AMORC	Ancient Mystical Order Rosae Crucis (Rosicrucians)
AMOS	Ancient Mystic Order of Samaritans
AMVETS	American Veterans
ANA	American Numismatic Association
ANS	American Numismatic Society

ANS	Free Gardeners
AOC	American Order of Clansmen (not associated with KKK)
AOD	American Order of Druids
AOF	American Order of Foresters
AOF	Ancient Order of Foresters
AOF	Ancient Order of Freesmiths
AOFB	Angelic Order of Fairy Bells
AOG	Ancient Order of Gleaners
AOH	Ancient Order of Hibernians
AOKMC	Ancient Order of the Knights of the Mystic Chain
AOLA	Ancient Order of Loyal Americans
AOM	Ancient Order of Muts
AOM	Ancient Order of Mysteries
AOMP	Artisans Order of Mutual Protection
AOO	American Order of Owls
AOO	Ancient Order of Osiris
AOP	Ancient Order of Pyramids
AOS	Ancient Order of Sanhedrins
AOUC	American Order of United Catholics
AOUW	Ancient Order of United Workmen
AOZ	Ancient Order of Zuzimites
AP	Alliance of Poles (in America)
APA	American Protective Association
APA	American Protestants Association
APhA	American Pharmaceutical Association
APL	American Protective League
APS	American Philatelic Society
ARI	American Rangers, Inc.
ASA	Anthroposophical Society in America
ASE	American Stars of Equity
ASEAA	Atlantic Self-Endowment Association of America
ASO	American Star Order
ASP	Association of the Sons of Poland
ASS	Arion Singing Society
AT	American Turnerbund
ATA	Anti Thief Association (*see* AHTA)
ATS	Alliance of Transylvanian Saxons
AUM	Ancient Order of Mysteries (Masonic)
AUSA	Association of the United States Army
AUSWV	American Union Spanish-American War Veterans
AUV	Association of Union Veterans
AW	American Woodmen
AW	American Workmen
AWM	American War Mothers
AWS	Air Weather Service
AZC	Albany Zouave Cadets
BA	Brotherhood of America
BA	Builders of the Adytum
BARE	Benefit Association of Railway Employees
BAW	Brotherhood of American Workmen
BAY	Brotherhood of American Yeomen
BBI	B'nai B'rith International
BEE	Brotherhood of Electrical Employees
BFCL/R	International Order of the Rainbow for Girls

BFFLA	Big Four Fraternal Life Association
BHLA	Ben Hur Life Association
BJMS	Bishop James Madison Society
BKA	Benevolent Knights Association
BKofM	Black Knights of Molders
BL	Black Legion
BLA	Baptist Life Association
BLE	Brotherhood of Locomotive Engineers
BLF	Brotherhood of Locomotive Firemen
BLF&E	Brotherhood of Locomotive Firemen and Engineers
BNL	Brotherhood of the New Life
BMW	Brotherhood of Maintenance of Way
BNA	Bavarian National Association of North America
BNMB	Beavers National Mutual Benefit
BOB	Benevolent Order of Bereans
BOB	Benevolent Order of Buffaloes
BofRTM	Brotherhood of Rail Road Track Men
BOM	Benevolent Order of Monkeys
BOR	Brotherhood of Railroad Clerks
BOSC	Benevolent Order of Scottish Clans (see OSC)
BPOD	Benevolent and Patriotic Order of Does
BPOE	Benevolent and Protective Order of Elks
BPOEC	Benevolent and Protective Order of Elks of Canada
BPOEW	Benevolent and Protective Order of Elks of the World
BRCA	Brotherhood of Railway Carmen
BRFF	Beavers Reserve Fund Fraternity
BRRB	Brotherhood of Railroad Brakemen
BRRC	Brotherhood of Railroad Clerks
BRT	Brotherhood of Railroad Telegraphers
BRT	Brotherhood of Railroad Trainmen
BRTM	Brotherhood of Rail Road Track Men
BSA	Boy Scouts of America
BU	Brotherhood of the Union
BUC	Boston Union Club
BUL	Boston Union League
BWG	Brotherhood of the West Gate
BZ	B'nai Zion
CAA	Catholic Aid Association
CAOF	Catholic Association of Foresters
CAR	Children of the American Revolution
CBKA	Commandery Benevolent Knights Association
CBL	Catholic Benevolent Legion
CBSH	Colored Brotherhood & Sisterhood of Honor
CC	Columbian Circle
CCC	Chicago Coin Club (see CNS; CNR)
CCTAS	Crusaders-Catholic Total Abstinence Society
CCU	Croatian Catholic Union of the U.S.A. and Canada
CCU	Czech Catholic Union
CD	Christian Democrats
CDA	Catholic Daughters of America
CDoA	Catholic Daughters of America
CE	Christian Endeavor
CERVUS ALCES	(Elks related)

CFA	Canadian Fraternal Association
CFA	Columbian Fraternal Association
CFA	Companions of the Forest of America
CFFT	Catholic Family Fraternal of Texas
CFL	Catholic Fraternal League
CFL	Catholic Fraternal Life (Society)
CFLI	Catholic Family Life Insurance (Society)
CFLIS	Canadian Foresters Life Insurance Society
CFU	Continental Fraternal Union
	(Order of Continental Fraternal Union)
CFUA	Croatian Fraternal Union of America
CG	California Grays
CIO	Congress of Industrial Organizations
CK	Catholic Knights
CK&HEEWH	Christian Knights & Heroines of Ethiopia
	of the Eastern & Western Hemispheres
CK&LI	Catholic Knights & Ladies of Illinois
CKA	Catholic Knights of America
CKIS	Catholic Knights Insurance Society
CKO	Catholic Knights of Ohio
CKofA	Catholic Knights of America
CKP	Colored Knights of Pythias
CKSG	Catholic Knights of St. George
CL	Columbian League
CLC	Catholic Ladies of Columbia
CMA	Coming Men of America
	(youth organization, Masonic influenced)
CMBA	Catholic Mutual Benefit Association
CMLA	Concordia Mutual Life Association
CMLAS	Columbian Mutual Life Assurance Society
CNR	Chicago Numismatic Roundtable
CNS	Chicago Numismatic Society
COCF	Canadian Order of Chosen Friends
COF	Canadian Order of Foresters
COF	Catholic Order of Foresters
COH	Circle of Honor
COH	Court of Honor
COOF	Catholic Order of Foresters
CP	Chevaliers of Pythias (not affiliated with Knights of Pythias)
CPL	Christian Protective League
CPL	Council of Prison Locals
	(American Federation of Government Employees)
CS	Columbian Squires (boys' organization, Knights of Columbus)
CSA	Confederate States of America
CSA	Czechoslovak Society of America
CSNS	Central States Numismatic Society
CSPS	Cesko-Slovanska Podporujici Spolecnost
	(now known as the Czechoslovak Society of America [CSA])
CSSIW	Continental Society Sons of Indian Wars
CTAS	Catholic Total Abstinence Society
CUOI	Catholic Union of Illinois (*see* DKV)
CW	Catholic Workman (Insurance Society)
CWA	Canadian Wheelmen's Association
CWA	Cold Water Army
	(nineteenth-century temperance youth group)

CWV	Catholic War Veterans
CYO	Catholic Youth Organization
DA	Daughters of America
DA	Degree of Anona (youth organization, Degree of Pocahontas)
DAC	Daughters of the American Colonists
DAR	Daughters of the American Revolution (NSDAR)
DAV	Disabled American Veterans
DBA	Danish Brotherhood in America
DC	Daughters of Columbia
DES	Daughters of the Eastern Star
DH	Daughters of Hope
DH	Degree of Hiawatha (youth organization, IORM)
DH	Degree of Honor
DIBPOEW	Daughters of the Independent, Benevolent, and Protective Order of Elks of the World
DKV	Deutsch-Kath. Vereinsbunds: German Catholic Association
DL	Daughters of Liberty
DM	Dames of Malta
DM	DeMolay (Order of DeMolay)
DOA	Daughters of America
DOC	Daughters of Columbia
DODR	Daughters of Duke Richard
DofA	Daughters of America
DofC	Daughters of Columbia
DofL	Daughters of Liberty
DofM	Dames of Malta
DOH	Degree of Honor
DOHPA	Degree of Honor Protective Association
DOI	Daughters of Isabella
DOI	Daughters of Isis
DOKK	Dramatic Order of Knights of Khorassanm (K of P)
DOL	Daughters of Liberty
DOLLUS	Dames of the Loyal Legion of the United States
DOM	Dames of Malta
DOM	Daughters of Mokanna
DON	Daughters of Norway
DON	Daughters of the Nile (Masonic)
DOP	Daughters of Penelope
DOP	Degree of Pocahontas (ladies auxiliary, IORM)
DOR	Daughters of Rebekah
DOS	Daughters of St. Richards
DOS	Daughters of Scotia
DOS	Daughters of Scotland
DOV	Daughters of Veterans
DR	Daughters of Rebekah
DRT	Daughters of the Republic of Texas
DUCWV	Daughters of Union Civil War Veterans
DUV	Daughters of Union Veterans of the Civil War
EA	Eclectic Assembly
EAU	Equitable Aid Union
EAUA	Equitable Aid Union of America
EBA	Emerald Benefit Association
EC	Emblem Club of the U.S.A.

ECV	E Clampus Vitus
EFU	Equitable Fraternal Union
EKR	Empire Knights of Relief
EL	Epworth League
ELA	Equitable League of America
ELHA	Elida Lodge Home Association (IOV)
EMBA	Elks Mutual Benefit Association
EOBD	Exalted Order of Big Dogs
ERA	Equitable Reserve Association
ES	Eastern Star
ESOH	Exalted Society of Order Hounds (salesmen's organization)
ESU	English Speaking Union
EUBM	Eternal and Universal Brotherhood of Mystics
EWBA	Electrical Workers Benefit Association
F&AM	Free and Accepted Masons (Blue Lodge)
FA&IU	Farmers Alliance & Industrial Union
FAA	Free and Accepted Americans
FAM	Free and Accepted Masons (Blue Lodge)
FATAL	Fairest Among Ten Thousand, Altogether Lovely (Eastern Star)
FAU	Fraternal Aid Union
FB	Fraternal Brotherhood
FCB	Friendship, Charity, and Benevolence (Knights of Pythias)
FCF	Freedom, Charity, and Friendship (Red Men)
FCSLA	First Catholic Slovak Ladies Association
FCSU	First Catholic Slovak Union of the U.S.A. and Canada (Prva Katolicka Slovenska Jednota)
FEC	Framingham Emblem Club
FECMU	Faith, Endurance, Courage, Modesty, and Unselfishness (Royal Neighbors of America)
FFA	Future Farmers of America
FFF	Fraternity of Friendly Fellows
FFI	(French resistance group, France, 1944)
FG	Fraternal Guild
FHIS	Fraternal Home Insurance Society
FL	Fraternal Legion
FLE	Fraternity of Linemen and Wiremen
FLIA	Federation Life Insurance of America (Polish Catholic Fraternal Order)
FLT	Friendship, Love, and Truth (Odd Fellows)
FMC	Fraternal Mystic Circle
FML	Fraternal Mystic Legion
FMW	Federation of Masons of the World
FO	Fraternal Order of Orioles
FOA	Foresters of America
FOAST	Fraternal Order of Alaska State Troopers
FOB	Fraternal Order of Bears
FOB	Fraternal Order of Beavers
FOC	Fraternal Order of Colonials
FOCL	Fraternal Order of Clover Leaves
FOE	Fraternal Order of Eagles
FOF	Fraternal Order of Firefighters
FofA	Foresters of America
FOFF	Fraternity of Friendly Fellows
FofO	Fraternal Order of Orioles

FOMES	Fifth Order of Melchizedek and the Egyptian Sphinx
FOO	Fraternal Order of Orioles
FOP	Fraternal Order of Police
FOR	Fraternal Order of Reindeer
FPOA	Fraternal Patriotic Order of Americans
FPSA	Freemen's Protective Silver Association
FPSF	Freemen's Protective Silver Federation
FRA	Fraternal Reserve Association
FRC	Fraternitas Rosae Crucis (Rosicrucians)
FRP	Free and Regenerated Palladium
FSOI	Free Sons of Israel
FT	Fraternal Tributes
FUA	Fraternal Union of America
FUF	Fraternity of United Friars

G∴D∴	Hermetic Order of the Golden Dawn (Fringe Masonry)
GALSTPTR	German American Legion of St. Peter
GAR	Grand Army of the Republic
GBU	German Beneficial Union
GBUP	Greater Beneficial Union of Pittsburgh
GCAVOH	Grand Chapter of the Ancient and Venerable Order of Harodim
GCOC	Grand Court Order of Calanthe
GCR	Grand College of Rites of the U.S.A.
GCU	Greek Catholic Union of the U.S.A.
GDA	Grain Dealers Association
GF	Grand Fraternity
GFS	German Freedom Society
GGC	Girls of the Golden Court (*see* OGC)
GL	Guardians of Liberty
	(an anti-Catholic organization founded about 1911)
GLAUM	Grand Lodge Ancient Order of Mysteries (Masonic)
GLDS	Grand Lodge Daughters of Scotia
GLIS	Gleaner Life Insurance Society
GM	Grail Movement
GMMNA	Grand Masters of Masons in North America, Conference of
GNA	Grottoes of North America (*see* GROTTO)
GOH	German Order of Harugari
GRANGE	Order of the Patrons of Husbandry
GROTTO	Mystic Order of Veiled Prophets of the Enchanted Realm
	(MOVPER, Masonic related)
GSF	Golden Star Fraternity
GUOofGF	Grand United Order of Galilean Fishermen
GUOofOF	Grand United Order of Odd Fellows (the Black IOOF)
GUOOF	Grand United Order of Odd Fellows (the Black IOOF)
GUOTR	Grand United Order of True Reformers (African-American)
GVS	Giuseppe Verdi Society (Verdi Club, Rockford, Illinois)
GWMNMA	George Washington Masonic National Memorial Association
GWS	Gospel Workers Society

H	The Homesteaders
H	The Hunters (U.S., ca. 1838–41)
H (in circle)	Home Circle
HBL	Hermetic Brotherhood of Luxor
HC	Home Circle
HF	Hermetic Fraternity

HFBO	Home Forum Benefit Order
HJ	Heroines of Jericho
HL	Hunters Lodges (Canadian branch of the Hunters)
HLA	Homesteaders' Life Association
HLC	Homesteaders' Life Company
HLMD	Hooded Ladies of the Mystic Den (auxiliary of Ku Klux Klan)
HN	Highland Nobles
HNS	Holy Name Society
HOBGI	Honorable Order of the Blue Goose International (*see* AHOBG)
HOGD	Hermetic Order of the Golden Dawn
HOJ	Heroines of Jericho (Masonic organization)
HOKBHC	Holy Order of Knights Beneficent of the Holy City
HOO-HOO	International Order of Hoo-Hoo
HP	Home Palladium
HRFA	Hungarian Reformed Federation of America Kossuth in America
HTI	High Twelve International (a.k.a. High Twelve Club; Masonic related)
HTWSSTKS	Masonic "mark" of Ancient Grand Master. Especially noted on Masonic "mark" or chapter pennies. York Rite Royal Arch Mason. ("Hiram The Widow's Son Sent To King Solomon": letters arranged in a circle within keystone)

IAFF	International Association of Fire Fighters
IANU	Italo-American National Union
IARA	International Association of Rebekah Assemblies
IATSE	International Alliance of Theatrical Stage Employees
IBBH	International Brotherhood of Blacksmiths and Helpers
IBEW	International Brotherhood of Electrical Workers
IBOB	International Brotherhood of Old Bastards
IBPOE	Improved Benevolent Protective Order of Elks
IBPOEW	Improved Benevolent Protective Order of Elks of the World
IBT	International Brotherhood of Teamsters
IC	Invincible Club
IC	Iroquois Club
ICBU	Irish Catholic Benevolent Union
IDES	Brotherhood of the Divine Holy Spirit
IFSC	International Firefighters' Square Club
IGA	International Geneva Association
IGCRAM	International Grand Chapter of Royal Arch Masons
IGGCRSM	International General Grand Council of Royal & Select Masters
IH	Iron Hall (Order of Iron Hall)
IHSV	Red Cross of Constantine (Masonic)
IIDA	Iowa Implement Dealers Association
IIOO	Independent International Order of Owls
ILEOSC	International Law Enforcement Officers' Square Club
ILH	Iowa Legion of Honor
ILM	Illinois Lumber Merchants
IML	Imperial Mystic Legion
Imp'd ORM	Improved Order of Red Men
INOF	Irish National Order of Foresters
IOA	International Order of Alhambra
IOBA	Independent Order of B'rith Abraham
IOBB	Independent Order of B'nai B'rith
IOCF	Independent Order of Chosen Friends

IOD	Improved Order of Deer
IODE	Imperial Order Daughters of the Empire
IOF	Independent Order of Foresters
IOFI	Independent Order of Foresters of Illinois
IOGSDS	Independent Order of Good Samaritans & Daughters of Samaria
IOGT	International Order of Good Templars
IOH	Improved Order of Heptasophs
IOHH	International Order of Hoo-Hoo
IOI	Independent Order of Immaculates of the United States of America
IOIUSA	Independent Order of Immaculates of the United States of America
IOJD	International Order of Job's Daughters
IOKP	Independent Order of Knights of Pythias
IOM	Imperial Order of Muscovites
IOM	Independent Order of Mechanics
IOMB	Independent Order of Mystic Brothers
IOOF	Independent Order of Odd Fellows
IOP	Independent Order of Puritans
IOR	Independent Order of Rebekahs
IOR	Independent Order of Rechabites
IORG	International Order of Rainbow Girls (Masonic)
IORM	Improved Order of Red Men
IOS	Independent Order of Shepherds
IOS	Independent Order of Svithiod
IOSA	Independent Order of Sons of Abraham
IOSB	Independent Order of Sons of Benjamin
IOSL	Independent Order of St. Luke
IOStL	Independent Order of St. Luke
IOTK&DT	International Order of Twelve Knights & Daughters of Tabor
IOV	Independent Order of Vikings
IOYD	Improved Order of Yellow Dogs (*see* OYD)
IPA	Irish Protestant Association
IPhA	Illinois Pharmaceutical Association
IRB	Irish Republican Brotherhood
IS&SA	Illinois Soldiers and Sailors Association
ISCWM	International Supreme Council of World Masons, Inc.
ISDA	Italian Sons & Daughters of America Fraternal Association
ISDAFA	Italian Sons & Daughters of America Fraternal Association
ISH	Independent Sons of Honor
IUOM	Independent United Order of Mechanics
IWW	Industrial Workers of the World
IYOB FILIAE	Job's Daughters

JA	Junior Achievement
JAOUW	Junior Order–Ancient Order of United Workmen
JBS	John Birch Society
JC	Jolly Corks (founded in 1868; now the BPOE)
JCD	Jednota Ceskych Dam (the Society of Bohemian Ladies)
JCDA	Junior Catholic Daughters of America
JFA	Junior Foresters of America
JL	Junior Lodge (youth organization, Odd Fellows)
JOAM	Junior Order of American Mechanics
JOPS	Junior Order of Princes of Syracuse
JOUAM	Junior Order of United American Mechanics

JPS	Junior Order of Princes of Syracuse
JROUAM	Junior Order of United American Mechanics
K&LofH	Knights & Ladies of Honor
K&LofS	Knights & Ladies of Security
KA	Knights of the Altar
KA	Knights of the Apocalypse
KAEO	Knights of the Ancient Essenic Order
KAMELIA	Ku Klux Klan (women's auxiliary)
KASB	Knights of Ar-Sar-Ben (Omaha, Nebraska)
KBCW	Knights of the Blue Cross of the World
KBHC	Knights Beneficent of the Holy City
KC	Knights of Columbus
KC	Knights of the Cork
KC	Knothole Club / Knot-Hole Club (Rotary)
KCI	Kiwanis Club International
KD	Knights of Dunamis (National Eagle Scout Association)
KFM	Knights of Father Matthew
KG	Keystone Guard
KG	Knights of St. George
KG	Knights of the Globe
KGC	Knights of the Golden Circle
	(known as Copperheads, a secret order of Southern
	sympathizers in the North during the Civil War)
KGE	Knights of the Golden Eagle
KGL	Knight Grand Legion
KGR	Knights of the Golden Rule
KH	Knights of Honor
	(a fraternal beneficiary society founded about 1877)
KHC	Knights of the Holy Cross
KHS	Knights of the Holy Sepulchre
KICK	Knights of the Invisible Colored Kingdom
KIGY	"Klansman, I Greet You" / "Klan Interests Guide You"
	(KKK slogan)
KIM	Knights of the Immaculate Movement
KIN	Kinsmen
KJ	Knights of Jericho
KJ	Knights of Jubilation
KJZT	Catholic Women's Fraternal of Texas (Slovak benefit society)
KK	Knights of Khorasan (Dramatic Order of Knights of Khorasan)
KKK	Ku Klux Klan
KKKK	Knights of Ku Klux Klan
KL	Knights of Liberty
KL	Knights of Lithuania
KL	Knights of Loyola
KL	Knights of Luther
KL	Knights of Labor
KLA	Knights & Ladies of Azar
KLG	Knights of the Loyal Guard
KLGP	Knights & Ladies of the Golden Precept
KLGR	Knights & Ladies of the Golden Rule
KLGS	Knights and Ladies of the Golden Star
KLH	Knights & Ladies of Honor
KLS	Knights & Ladies of Security
KM	Knights Militant (KKK)

KM	Knights of Malta (Masonic: York Rite Commandery, KT)
KM	Knights of the Maccabees
KMC	Knights of the Mystic Chain
K-N	Know-Nothings
KNP	Know-Nothing Party
KofA	Knights of the Altar
KofA	Knights of the Apocalypse
KofC	Knights of Columbus
KofC	Knights of the Cork
KofD	Knights of Dunamis (National Eagle Scout Association)
KofFM	Knights of Father Matthew
KofG	Knights of the Globe
KofH	Knights of Honor
	(a fraternal beneficiary society founded about 1877)
KofJ	Knights of Jericho
KofJ	Knights of Jubilation
KofJ	Knights of St. John
KofK	Knights of Khorasan (Dramatic Order of Knights of Khorasan)
KofL	Knights of Labor
KofL	Knights of Liberty
KofL	Knights of Lithuania
KofL	Knights of Loyola
KofL	Knights of Luther
KofM	Knights of Malta (Masonic: York Rite Commandery, KT)
KofM	Knights of the Maccabees
KofP	Knights of Pythias
KofSA	Knights of St. Andrew
KofSJ	Knights of St. John
KofSTP	Knights of St. Patrick
KofSTW	Knights of St. Wenceslas
KofT	Knights of Tabor
KOGEL	(probably related to Knights of the Golden Eagle)
KoGF	Knights of the Green Forest
	(a group similar to the KKK, ca. 1800s)
KOL	Knights of Labor
KOS	Knights of the Sword
KoSJ	Knights of St. John
KOTM	Knights of the Maccabees
KP	Knights of Pythias
KPC	Knights of Peter Claver
	(founded in 1909 for Black Catholic men)
KRA	Knights of the Royal Arch (non-Masonic)
KRC	Knights of the Red Cross (KT)
KRCC	Knights of the Red Cross of Constantine
KRT	Knights of the Round Table
	(a.k.a. Loyal Knights of the Round Table)
KSA	Knights of St. Andrew
KSC	Knights of St. Columcille (better known as St. Columba)
KSC	Knights of Southern Cross (skull and crossbones, ca. 1879)
KSF	Knights of Sherwood Forest (Foresters, ca. 1887)
KSJ	Knights of St. John
KSKJ	American Slovenian Catholic Union
KSL	Knights of St. Lawrence
KSR	Knights of St. Richards
KST	Knights of the Square Table

KSTG	Knights of St. George
KSTI	Knights of St. Ignatius
KSTJ	Knights of St. Joseph
KSTM	Knights of St. Martin
KSTP	Knights of St. Paul
KSTP	Knights of St. Peter
KSTT	Knights of St. Thomas
KT	Knights of Tabor
KT	Knights Templar
KWC	Knights of the White Cross
KWM	Knights of Wise Men
KYCH	Knights of the York Cross of Honor (Convent General)
LAA	Lithuanian Alliance of America
LAFF	Luso-American Fraternal Federation (Portuguese-American)
LAFIS	Luso-American Fraternal Federation (Portuguese-American)
LAL	Ladies of Abraham Lincoln
LALA	Loyal American Life Association
LALIS	Luso-American Life Insurance Society (Portuguese-American)
LAOH	Ladies Ancient Order of Hibernians
LAPM	Ladies Auxiliary Patriarch Militant
LB	Lutheran Brotherhood
LBA	Luxembourg Brotherhood of America
LBS	Canadian Order of Foresters (motto)
LCA	Lithuanian Catholic Alliance
LCBA	Loyal Christian Benefit Association
LDG	Independent Order of Foresters (moose head)
LE	Lady Elks
LEML	Locomotive Engineers Mutual Life (& Accident Insurance Association)
LFMOS	League of Friendship of the Mechanical Order of the Sun
LGAR	Ladies of the Grand Army of the Republic
LGE	Ladies of the Golden Eagle
LH	Legion of Honor
LI	Lions International
Libertas et Patria	Sons of the American Revolution (motto)
LIFE	Liberty, Integrity, Fraternity, and Equality (Fraternal Order of Orioles)
LIOR	Ladies Independent Order of Reindeer
LK&L	Loyal Knights & Ladies
LKA	Loyal Knights of America
LKL	Loyal Knights & Ladies
LK of A	Loyal Knights of America
LKRT	Loyal Knights of the Round Table
LL	Lincoln League
LL	Loyal League(s)
LLISC	Lutheran Life Insurance Society of Canada
LLL	Live and Let Live (fraternal group in Rockford, Illinois, est. 1908)
LLL	Lutheran Laymen's League
LLLL	Loyal Legion of Lumbermen and Loggers
LLRA	Loyal Ladies of the Royal Arcanum
LM	Ladies of the Maccabees
LMLA	Loyal Mystic Legion of America

LMW	Ladies of the Maccabees of the World
LOA	Loyal Orange Association (a.k.a. Orangemen)
LOBA	Ladies Orange Benevolent Association
LOBB	Loyal Order of Beer Buffalo
LofM	Ladies of the Maccabees
LOL	Loyal Order Orange Lodge (Orange Order)
LOM	Legion of the Moose
LOOB	Loyal Order of Buffaloes
LOOM	Loyal Order of Moose
LOS	Ladies Oriental Shrine
LOSNA	Ladies Oriental Shrine of North America
LOTM	Ladies of the Maccabees
LPS	Loyal Publication Society
LPSCU	Ladies' Pennsylvania Slovak Catholic Union
LSA	Loyal Sons of America
LUB&C	Foresters (*see* UBC)
LW	Laundry Workers International Union
LWAL	Loyal Women of American Liberty

MAFO	Modern American Fraternal Order
MB	Mystic Brothers (Independent Order of Mystic Brothers)
MBA	Modern Brotherhood of America
MBARTE	Mutual Benefit Association of Rail Transportation Employees, Inc.
MBS	Mutual Benefit Society
MBSCC	Maine Boys Sweet Corn Club
MCFA	Michigan Cock Fanciers Association
MCOF	Massachusetts Catholic Order of Foresters
MFC	Masonic Fraternal Congress
MGGS	Mutual Guild of Grand Secretaries
MIAFA	"My Interests Are For America" (KKK slogan)
MKFL	Modern Knights Fidelity League
MKSP	Modern Knights of St. Paul
MLA	Masonic Life Association
MMAA	Mennonite Mutual Aid Association (Anabaptist congregation)
MMSA	Mineral Mine Smelters Association
MoA	Maids of Athens (changed to Maids of Athena; *see* Sons of Pericles)
MOC	Military Order of the Cootie (the honor degree of the Veterans of Foreign Wars)
MOC	Modern Order of Chaldeans
MOLLUS	Military Order of the Loyal Legion of the United States
MOP	Modern Order of Praetorians
MOPH	Military Order of the Purple Heart
MOS	Mechanical Order of the Sun
MOS	Military Order of the Serpent (Spanish-American War veterans, secret society)
MOS&B	Military Order of the Stars and Bars (*see* SCV)
MOVPER	Mystic Order of Veiled Prophets of the Enchanted Realm
MPA	Miner's Protective Association
MPMO	Motion Picture Machine Operators
MPPM	Missouri Paw Paw Militia (Paw Paws)
MR	Modern Romans
MR-A	Moral Re-Armament
MRA	Masonic Relief Association

MRA	Royal Arcanum
MS	Modern Samaritans
MS	Mystic Seven
MS	Mystic Star (Order of the Mystic Star)
MSA	Masonic Service Association
MSMV	Medical Society of the Missouri Valley
MTA	Mosaic Templars of America
MVA	Mexican Veterans Association (U.S.–Mexican War of 1846–48)
MWA	Modern Woodmen of America
MWW	Mystic Workers of the World
MYF	Methodist Youth Fellowship
NAACP	National Association for the Advancement of Colored People
NABA	North American Benefit Association
NAH	National Association of Haymakers
NASA	North American Swiss Alliance
NASA	Norwegian American Seaman's Association
NATB	National Association of Tunerbunds
NAU	North American Union
NBS	National Benefit Society
NCSF	National Catholic Society of Foresters
ND	National Defenders
NDGW	Native Daughters of the Golden West
NEA	National Education Association
NEA	New Era Association
NEFMC	New England Fat Men's Club
NELPS	New England Loyal Publication Society
NEOP	New England Order of Protection
NF	National Fraternity
NFC	National Federated Craft (Masonic)
NFCA	National Fraternal Congress of America
NFL	National Fraternal League
NFSD	National Fraternal Society of the Deaf
NFU	National Fraternal Union
NG	National Guard
NGA	National Guard Association
NGDA	National Grain Dealers Association
NHA	National Hay Association
NHA	National Haymaker's Association
NHG	National Home Guard(s)
NIRDC	National Indian Runner Duck Club
NLMC	National League of Masonic Clubs
NMB	National Mutual Benefit
NOA	National Order of America
NOAC	National Organization of Alley Cats
NOB	New Order Builders
NOCR	National Order of Cowboy Rangers
NOK	New Order of Knights (KKK)
NOV	National Order of Videttes (a.k.a. Order of Thirteen)
NOW	Neighbors of Woodcraft
NPB&EA	National Poultry, Butter and Egg Association
NPLA	National Protective Life Association
NRA	National Recovery Administration
NRA	National Rifle Association
NS	National Sojourners, Inc.

NSI	National Sojourners, Inc.
NSBA	North Star Benefit Association
NSCDA	National Society of the Colonial Dames of America
NSDAC	National Society Daughters of the American Colonists
NSDAR	National Society Daughters of American Revolution
NSGW	Native Sons of the Golden West
NSS	National Slovak Society of the U.S.A.
NSSUP	National Society Sons of Utah Pioneers
NTCM	National Travelers Club for Masons
NUAS	National Union Assurance Society
NUL	National Union League
NUTS	National Utah Token Society
NWLH	Northwestern Legion of Honor
O∴T∴O∴	Ordo Templi Orientis (Order of the Templars of the East)
OA	Order of Aegis
OA	Order of Ahepa
OA	Order of Alfredians
OA	Order of Alhambra
OA	Order of Amaranth (Masonic)
OA	Order of Americus
OA	Order of Amitie
OA	Order of the Arrow (Boy Scouts)
OA-P-N	Order of Anti-Poke-Noses
OAC	Order of American Cincinnatus
OAFC	Order of the American Fraternal Circle
OAK	Order of American Knights
OAO	Order of Ancient Oaks
OAPN	Order of Anti-Poke-Noses
OAT	Order of Artistic Typists
OAU	Order of the American Union
OB	Order of Bananas
OB	Order of the Bath of the U.S.A.
OB	Order of Bugs
OB	Order of the Builders (Masonic youth)
OBA	Orange Benevolent Association
OBA	Order of B'rith Abraham
OC	Optimist Club
OC	Order of Camels
OCF	Order of Chosen Friends
OCFU	Order of the Continental Fraternal Union
OCJS	Order of the Constellation of Junior Stars (youth, Order of Eastern Star)
OD	Order of Desoms
OD	Order of DeMolay (Masonic boys)
ODHS	Des Schwestern Verbandes (Sisters of the Federation)
ODM	Order of DeMolay (Masonic)
ODS	Order of the Daughters of Scotia
ODS	Order of the Daughters of Scotland
OE	Order of Equity
OES	Order of the Eastern Star (Masonic)
OofA	Order of Aegis
OofA	Order of Ahepa
OofA	Order of Alfredians
OofA	Order of Alhambra

OofA	Order of Amaranth (Masonic)
OofA	Order of Americus
OofA	Order of Amitie
OofA	Order of the Arrow (Boy Scouts)
OofAC	Order of American Cincinnatus
OofB	Order of Bananas
OofB	Order of Bugs
OofB	Order of the Bath of the U.S.A.
OofB	Order of the Builders (Masonic youth)
OofD	Order of Desoms
OofE	Order of Equity
OofF	Order of Foresters
OofH	Order of Heptasophs
OofH	Order of Homebuilders
OofI	Order of Iroquois
OofO	Order of Orioles (*see* FOO)
OofP	Order of Pente
OofS	Order of Sparta
OofS	Order of the Square
OofT	Order of Thirteen
OofU	Order of Order of Unity
OGC	Order of the Golden Chain
OGC	Order of the Golden Circle
OGK	Order of the Golden Key
OGL	Order of the Golden Links
OGR	Order of the Golden Rod
OGT	Order of Good Templars
OGT	Order of Good Times
OH	Order of Heptasophs
OH	Order of Homebuilders
OHB	Order of Home Builders
OHD	Order of Houn' Dawgs
OI	Order of Iroquois
OIA	Order (of) Independent Americans
OIH	Order of (the) Iron Hall
OKF	Order of the Knights of Friendship
OKM	Order of Knight Masons
OLRS	Order of the Little Red Schoolhouse
OLRSH	Order of the Little Red School House
OMBA	Occidental Mutual Benefit Association
OMP	Order of Mutual Protection
OMS	Order of the Mystic Star
OO	Order of Orioles (*see* FOO)
OOB	Order of the Builders (Masonic youth)
OOC	Order of Calanthe
OOD	Order of Desoms
OOE	Order of Equity
OOF	Order of Odd Fellows (usually seen as IOOF)
OofIA	Order (of) Independent Americans
OofUF	Order of United Friends
OOHP	Oriental Order of Humility and Perfection
OOIA	Order (of) Independent Americans
OOO	Order of Owls
OOYD	Order of Yellow Dogs
OP	Order of Pente

OPG	Order of Pink Goats
OPH	Order of the Patrons of Husbandry (Grange)
ORC	Order of Railroad Conductors
ORC	Order of the Red Cross (York Rite, Commandery)
ORM	Order of Red Men
ORP	Order of Royal Purple (see ROOP)
ORT	Order of Railroad Telegraphers
OS	Order of Sparta
OS	Order of the Square
OSA	Order of the Sons of America
OSA	Orthodox Society of America
OSB	Order of the Shepherds of Bethlehem
OSC	Order of Scottish Clans
OSC	Order of the Society of Cincinnati
OSE	Order of the Star in the East
OSH	Order of the Shield of Honor
OSI	Order of the Sons of Italy
OSIA	Order of the Sons of Italy in America
OSJ	Order of St. John of Jerusalem (see SOSJ)
OSL	Order of the Sons of Liberty
OSM	Order of the Secret Monitor
	(Brotherhood of David and Jonathan)
OSSB	Order of the Star Spangled Banner
OSSG	Order of the Sons of St. George
OT	Order of Thirteen
OTK	Order of the True Kindred
	(Brotherhood of David and Jonathan)
OTO	Ordo Templi Orientis (Order of the Templars of the East)
OTr	Order of the Trapezoid
OTT	Old Time Telegraphers
OU	Order of Order of Unity
OUA	Order of United Americans
OUAM	Order of United American Mechanics
OUCTA	Order of United Commercial Travelers of America
OUF	Order of United Friends
OWSJ	Order of the White Shrine of Jerusalem
OYD	Order of Yellow Dogs (see IOYD)
PA	Philanthropic Assembly
PAA	Pancretan Association of America
PAKC	Providence Association of Ukrainian Catholics in America
PAP	Purity, Aid, and Progress (Moose)
PAUCA	Providence Association of Ukrainian Catholics in America
Pax Aut Bellum	"Peace or War": Uniform Rank (motto)
PBA	Police Benevolent Association
PBA	Polish Beneficial Association
PBU	Presbyterian Beneficial Union
PCA	Patriarchal Circle of America
PCSS	Pacific Coast Numismatic Society (medals issued)
PCU	Portuguese Continental Union of the U.S.A.
PEO	P.E.O. Sisterhood ("Protect Each Other")
PF	Pilgrim Fathers, United Order of
PFA	Pioneer Fraternal Association
PFA	Polish Falcons of America

PFIA	Police and Firemen's Insurance Association
PFO	Pioneer Fraternal Order
PG	Pink Goats (a.k.a. Order of Pink Goats)
PGA	Professional Golfers Association
PH	Patrons of Husbandry (Grange)
PHA	Peter Hauck Association (Harrison, New Jersey)
PHC	Protected Home Circle
PHES	Prince Hall (Grand Chapter of the) Eastern Star
PHF	Prince Hall Freemasonry (African-American)
PHGCES	Prince Hall (Grand Chapter of the) Eastern Star
PIA	Perfect Initiates of Asia
PKA	Protestant Knights of America
PLEF	Purity, Love, Equality, and Fidelity (Pythian Sisters)
PM	Patriarchs Militant
PMA	Progressive Miners Association
PMC	Past Master Councilor (Order of DeMolay)
PNA	Polish National Alliance
PNNA	Pacific Northwest Numismatic Association
PNU	Polish National Union
POA	Patriotic Order of Americans
POF	Pennsylvania Order of Foresters
PofH	Patrons of Husbandry (Grange)
POG	Provincial Old Guard
POS	Priory of Sion
POSofA	Patriotic Order of the Sons of America
POSA	Patriotic Order of the Sons of America
PPBA	Portuguese Protective & Benevolent Association
PPOSW	Patriotic & Protective Order of the Stags of the World
PPP	Prudent Patricians of Pompeii of the U.S.A.
PRCUA	Polish Roman Catholic Union of America
PS	Philalethes Society
PS	Princes of Syracuse
PS	Pythian Sisters
PSCU	Pennsylvania Slovak Catholic Union
PSofA	Princes of Syracuse
PSW	Pythian Sisters of the World
PTA	Parents and Teachers Association
PUA	Polish Union of America
PUL	Philadelphia Union League
PWAA	Polish Women's Alliance of America
QA	Quarrymen's Association
QCI	Quota Club International (business & professional women)
QS	Quill & Scroll Society
QSS	Quill & Scroll Society
RA	Rebekah Assemblies
RA	Royal Ambassadors
RA	Royal Arcanum
RAA	Rakoczi Aid Association
RAM	Royal Arch Masons (York Rite)
RAOB	Royal Antediluvian Order of Buffalo
RB	Rochester Brotherhood
RBO	Russian Brotherhood Organization of the U.S.A.
RBS	Royal Benefit Society

RC	Red Cross
RCC	Red Cross of Constantine
RCK	Red Cross Knights
RCMP	Royal Canadian Mounted Police
RCofC	Red Cross of Constantine (*see* IHSV)
RE	Red Eagles
REOF	Royal & Exalted Order of Fleas
RF	Rosicrucian Fraternity
RFB	Royal Fellows of Bagdad
RG	Rainbow Girls (*also* Rainbow for Girls, Masonic)
RH	Royal Highlanders
RI	Rotary International
RIMAS	Russian Independent Mutual Aid Society
RK	Roman Knights (The Brotherhood of the Rosy Cross)
RM	Red Men
RMBI	Royal Masonic Benevolent Institution
RMBI	Royal Masonic Institution for Boys
RMOKH	Religious & Military Order of the Knights of the Holy Sepulchre
RMOKHJ	Religious & Military Order of the Knights of the Holy Sepulchre of Jerusalem
RN	Royal Neighbors of America
RNA	Royal Neighbors of America
RO	Rosicrucian Order (a.k.a. AMORC)
RO-AUM	Rosicrucian Order
ROCMAS	Russian Orthodox Catholic Mutual Aid Society
ROCWMAS	Russian Orthodox Catholic Women's Mutual Aid Society
ROJ	Royal Order of Jesters
ROL	Royal Order of Lions
ROOP	Royal Order of Purple (Elks auxiliary, Canada)
ROS	Royal Order of Scotland
RP	Royal Purple (Order of Royal Purple)
RRRR	Royal Riders of the Red Robe (KKK-like organization for naturalized Americans)
RSGF	Royal Society of Good Fellows
RSM	Royal and Select Masters (Masonic: York Rite)
RSTV	Rite of St. Vaclav
RSTV	Rite of St. Vitus
RSW	Rathbone Sisters of the World
RT	Round Table
RTJ	Royal Tribe of Joseph
RTT	Royal Templars of Temperance
RW&B	Red, White & Blue
RWB	Red, White & Blue
SA	Sons of Abraham
SA	Sons of Adam
SAF	Scandinavian American Fraternity
SAL	Sons of the American Legion
SAR	Sons of the American Revolution
SAS	St. Ambrogio Society
SAS	St. Andrews Society
SAWV	Spanish-American War Veterans
SB	Sons of Benjamin
SB	Star of Bethlehem
SB	Spartan Band

SBCL	St. Boniface Catholic Union
SBF	Society of Blue Friars (correspondence-based fraternal order)
SBL	Society B. Lafayette, General Lafayette
SCA	Society for Creative Anachronisms
SCAW	Supreme Camp of the American Woodmen
SCS	Slavonic Catholic Society (*see* SKS)
SCS	Slovak Catholic Sokol (gymnastic/fitness and fraternal organization)
SCTK	Supreme Conclave of True Kindred (Masonic related)
SCV	Sons of Confederate Veterans
SCVCW	Sons of Confederate Veterans of the Civil War
SDA	Shrine Directors Association of North America
SDANA	Shrine Directors Association of North America
SDL	Sons & Daughters of Liberty
SDP	Sons & Daughters of Protection
SEC	Supreme Emblem Club of the U.S.A.
SES	Society Espirito Santo of the State of California
SESSC	Society Espirito Santo of the State of California
SFA	Scandinavian Fraternity of America
SFLIS	Sloga Fraternal Life Insurance Society (Slovenian; *see* SLOGA)
SFWC	Supreme Forest Woodmen Circle
SG	Sunshine Girls (youth organization, Pythian Sisters)
SGUS	Slovak Gymnastic Union Sokol of the U.S.A.
SH	Sons of Hermann
SI	Sons of Italy
SKA	Silver Knights of America (bimetallism organization)
SKS	Slavonic Catholic Society
SL	Sexennial League
SL	Sons of Liberty
SLOGA	Sloga Fraternal Life Insurance Society (Slovenian; *see* SFLIS)
SLTV	St. Louis Turn Verein
SM	Sons of Malta
SMAA	Scandinavian Mutual Aid Association
SMB	Societa di Mutuo Beneficio/Beneficienza
SMBA	Slovenian Mutual Benefit Association
SMOC	Supreme Mechanical Order of the Sun
SMOM	Sovereign Military Order of Malta
SMOTJ	Sovereign Military Order of the Temple of Jerusalem, Knights Templar
SMS	Societa di Mutuo Soccorso
SM	Society of Mary
SN	Sons of Norway
SNA	Shrine of North America (Masonic)
SNBS	Slovene National Benefit Society
SNCC	Student Nonviolent Coordinating Committee
SNF	Serb National Federation
SNPJ	Slovene National Benefit Society
SOB	Society of Bearded Numismatists
SoB	Society of the Bell
Socio Hispano	Hispanic-American Alliance
SoCV	Sons of Confederate Veterans
SofA	Sons of Abraham
SofA	Sons of Adam
SofH	Sons of Hermann
SofI	Sons of Italy

SofM	Sons of Malta
SofN	Sons of Norway
SOFN	Sons of Norway
SofSG	Sons of St. George
SofP	Sons of Pericles
SofP	Sons of Poland
SofW	Patriotic & Protective Order of the Stags of the World (*see* PPOSW)
SOKOL	Sokol U.S.A. (Slovak gymnastic/fitness and fraternal organization)
SON	Sons of Norway
SOOB	Social Order of the Beauceant (Christian women's organization; members are wives & widows of Knights Templar)
SOP	Sons of Pericles
SOSJ	Sovereign Order of St. John of Jerusalem (*see* OSJ)
SOV	Sons of Veterans
SOWR	Supreme Order of White Rabbits (founded by ex-members of OOO)
SP	Sons of Pericles
SP	Sons of Poland
SPAA	St. Patrick's Alliance of America
SPCSCPG	Society for the Prevention of Calling Sleeping-Car Porters "George"
SPEBSQSA	Society for the Preservation & Encouragement of Barbershop Quartet Singing in America
Spes Mea in Deo Est	32nd Degree Mason (motto)
SPJST	Slovanska Podporujici Jednota Statu Texas (Slavonic Benevolent Order of the State of Texas)
SPRSI	Sociedade Portuguesa Rainha Santa Isabel
SR	Societas Rosicrusiana (England)
SRA	Shrine Recorders Association of North America
SRA	States' Rights Association
SRANA	Shrine Recorders Association of North America
SRCF	Societas Rosicruciana in Civitatibus Foederatis (Masonic related)
SRCFW	Supreme Royal Circle of Friends of the World
SS-LL-KD	Rochester Brotherhood (Search the Scriptures—Live the Life—Know the Doctrine; pairs of letters at corners of triangle, with RB in center)
SSAL	Sunday School Athletic League (active in New York area ca. 1900)
SSON	Sons of Norway
SSS	S.S.S. & Brotherhood of the Z.Z.R.R.Z.Z. (Theosophy related)
SSSS	Sveas Soner Singing Society
ST	Sons of Temperance
STOPS	Supreme Temple Order of Pythian Sisters
SUI	Society of United Irishmen
SUV	Sons of (Union)
SV	Sons of (Union)
SW	Patriotic & Protective Order of the Stags of the World (*see* PPOSW)
SYMWA	Spend Your Money With Americans (KKK slogan)
SYMWAO	Spend Your Money With Americans Only (KKK slogan)
TAFU	Acme Fraternal Union (*see* AFU)
TBH	Tribe Ben Hur
TC	Triangle Club

TCL	Tall Cedars of Lebanon (Masonic)
TCLNA	Tall Cedars of Lebanon of North America (Masonic)
TDS	The Danish Sisterhood
Tebala	(Masonic)
TF	Temple of Fraternity
	(occult order; unrelated to Knights Templar)
TH	Temple of Honor (Independent Order of Odd Fellows)
THT	Templars of Honor and Temperance
TK	True Kindred
TKKKK	Templar Knights of the Ku Klux Klan
TL	Templars of Liberty
TLPF	Temple of Honor and Temperance (IOOF)
TofF	Temple of Fraternity
	(occult order; unrelated to Knights Templar)
TofH	Temple of Honor (Independent Order of Odd Fellows)
TofL	Templars of Liberty
TOGD	Thelemic Order of the Golden Dawn
TOS	Temple of Set (see TS)
TOTE	Totem of the Eagle (Red Men)
TPAA	Travelers Protective Association of America
TR	True Reformers (see GUOTR)
TRC	Theta Rho Clubs (Rebekah Assemblies youth organization)
TS	Temple of Set (see TOS)
TS	Theosophical Society
TS	True Sisters (see UOTS)
UA	United Americans (Order of United Americans)
UAM	United American Mechanics
UAOD	United Ancient Order of Druids
UBC	Unity, Benevolence, Concord (Ancient Order of Foresters)
UBF	United Brothers of Friendship (African-American)
UC	Union Club
UCC	Union Congressional Committee
UCCE	Universal Craftsmen Council of Engineers (Masonic engineers)
UCT	United Commercial Travelers
UCTA	United Commercial Travelers of America
UCV	United Confederate Veterans (Civil War)
UDC	United Daughters of the Confederacy
UE	United Electrical Workers
UF	United Friars (a.k.a. Fraternity of United Friars)
UFA	Ukrainian Fraternal Association
UFL	Union Fraternal League
UFM	United Friends of Michigan
UI	United Irishmen (a.k.a. Society of United Irishmen)
UKA	United Klans of America (KKK)
UL	Union League
ULA	Union League of America
ULK	Union League of Kentucky
ULNY	Union League of New York
ULT	Union League of Tennessee
UMWA	United Mine Workers of America
UNA	Ukrainian National Association
UNAA	Ukrainian National Aid Association
UNAAA	Ukrainian National Aid Association of America
UNLIS	United National Life Insurance Society

UNPC	Union National Party Committee
UO	Union Orange
UOA	United Order of Americans
UOF	United Order of Foresters
UofA	United Americans (Order of United Americans)
UOGC	United Order of the Golden Cross
UOPF	United Order of Pilgrim Fathers
UOTS	United Order of True Sisters (Jewish women's organization)
UPEC	Unai Portuguesa do Estado da California
UPW	Union of Polish Women
UPWA	Union of Polish Women in America
UR	Uniform Rank (Knights of Pythias, ca. 1877)
USA	United States Army
USAF	United States Air Force
USJB	Union Saint-Jean Baptiste (U.S. Catholics of French descent)
USMC	United States Marine Corp
USN	United States Navy
USofA	United Steelworkers of America
USOTUS	United Societies of the United States (Greek Catholic organization)
USPSL&C	Union of Stone Pavers, Sidewalk Layers and Curbsetters
USWV	United Spanish War Veterans
UTUIA	United Transportation Union Insurance Association (railroad workers)
UVL	Union Veterans League
UVUL	Union Veterans Union of Louisville
UW	Ancient Order of United Workmen (see AOUW)
UWA	Ukrainian Workingmen's Association
VAA	Verhovay Aid Association
VAS	Vera Amicitia Sempiterna
VFIA	Verhovay Fraternal Insurance Association (formerly VAA)
VFW	Veterans of Foreign Wars
VFW	Veterans of Future Wars (ca. 1930s college men's organization)
VMC	Royal Arcanum
VO	Vasa Order of America
VOA	Vasa Order of America (Swedish)
VFW	Veterans of Foreign Wars
VVA	Vietnam Veterans of America
WA	Wide Awakes (political)
WA	Women's Auxiliary
WB	Western Bees (founded by ex-Knights of Maccabees)
WBA	Woman's Benefit Association
WBF	Workmen's Benefit Fund of the U.S.A.
WBFA	Western Bohemian Fraternal Association (now WFLA)
WC	Woodmen Circle (ladies' auxiliary of WOW)
WC	Workmen's Circle (Jewish)
WCTU	Women's Christian Temperance Union
WCU	Western Catholic Union
WEC	White Eagle Club
WFA	World Federalist Association
WFJ	Western Fruit Jobbers
WFLA	Western Fraternal Life Association
WFM	Western Federation of Miners

WKKK	Women of the KKK
WKSC	White Knights of the Southern Cross (KKK)
WM	International Supreme Council of World Masons, Inc. (*see* ISCWM)
WMS	Women's Missionary Society
WMU	Women's Missionary Union
WOL	Women's Overseas Service League
WOM	Women of the Moose
WOSL	Women's Overseas Service League
WOTM	Women of the Moose
WOW	Soldiers of Woodcraft
WOW	Women of Woodcraft
WOW	Woodmen of the World
WOW	Woodmen of the World Life Insurance Society
WPA	William Penn Association
WPEC	World Plan Executive Council (Transcendental Meditation)
WR	Supreme Order of White Rabbits (*see* SOWR)
WR&R	Woodmen Rangers & Rangerettes
WRC	Women's Relief Corps (GAR Auxiliary)
WRR	Woodmen Rangers Rangerettes
WS	Western Samaritans
WSA	Western Slavonic Association
WSCS	Women's Society of Christian Service
WSJ	Order of the White Shrine of Jerusalem (*see* OWSJ)
WSLA	Western Samaritans Life Association
XI PSI PHI	(dentists' professional fraternity; established 1889)
XI SIGMA PI	(forestry honorary organization; established 1908)
XSB	Xavier Society for the Blind (Catholic related)
YAOC	Ye Ancient Order of Corks (members are Royal Arch Masons; lodges are "Cellars")
YD	Order of Yellow Dogs (*see* OYD; IOYD)
YMCA	Young Men's Christian Association
YRSC	York Rite Sovereign College (Masonic)
YWCA	Young Women's Christian Association
ZCBJ	Western Bohemian Fraternal Association (founded in 1897 as a Czech fraternal insurance benefit society. In 1971 it became the Western Fraternal Life Association. More than 50 thousand members in 1990, with about 200 local chapters. Headquarters in Cedar Rapids, Iowa)
ZI Zonta	International (business and professional women)

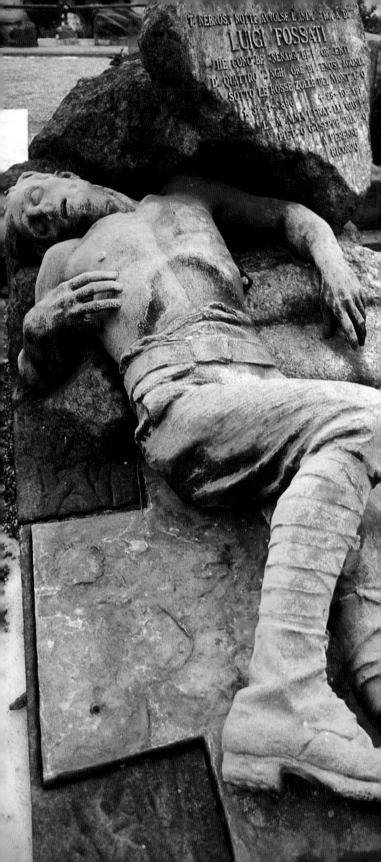

FINAL
IMPRESSIONS

I T'S BEEN SAID that a person has one chance to make a first impression. Conversely, one only has one chance to make a last impression, and where better to make that impression than in the cemetery, where your statement has the best chance for longevity? Tombstones, of course, have the name of the person and the birth and death dates. Often the stones will sport an interesting symbol or a pithy quotation, but the tombstones that get the most cemetery visitors—besides the last resting places of celebrities—are the ones with interesting depictions of the deceased's occupation or passion. The genesis of this tradition was depictions of tools of a person's trade that appeared in European cemeteries, particularly in the seventeenth and eighteenth centuries. Most of the population was illiterate; thus, these depictions served better than a written inscription.

There has been a renaissance of highly personal monuments in modern times. After decades in the doldrums, monument makers have experienced a surge in orders from people who want to leave a lasting impression and go out in style.

Tradesmen Tombstones

One of the best places to see tombstones with the tools of one's trade are in the churchyards of Scotland. These emblems first appeared in the seventeenth century and continued to appear on tombstones well into the eighteenth century. These "Trade Incorporations" were similar to today's unions, and a person's craft was celebrated with emblems that appeared on banners, artwork, and tombstones. Besides the tools of one's trade, these tombstones will often sport a carving that looks like a reversed 4, a symbol that denotes a merchant.

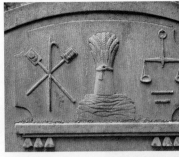

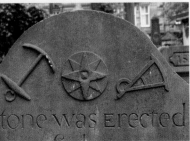

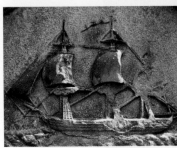

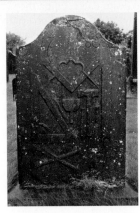

Clockwise, upper right:

Maltman

Mariner

Merchant

Mason

Shipmaster

Gardener

There are certainly lots of folks whose last statement is a big ostentatious mausoleum or tomb, but the tombs we remember best are the ones where the life's work of the deceased is celebrated. It has often been said that a rich fulfilling life is one containing passion for one's craft. All of the following tombs definitely make a lasting and impressive final statement.

Page 228: Soldier, Cimitero Monumentale, Milan, Italy

Brusa Monument

Louis Brusa loved sculpting in granite. Ironically, he died tragically as the result of his love. While still a teenager he left his native Italy and journeyed to America, settling in Barre, Vermont, the self-proclaimed "Granite Capital of the World."

Young Louis was soon carving stories in stone amid choking clouds of dust created by the recently invented compressed air tools. These tools may have made the work go faster, but they also made his life pass by faster.

After a few years he became a partner at Brusa Brothers, one of the many stone sheds in Barre. There he toiled for a number of years, paying little attention to the clouds of granite dust swirling around the busy shop. He also paid scant attention to a constant nagging cough. Then, in his late forties, his cough was accompanied by blood-specked gray spittle, the sign of deadly silicosis. The silicosis soon drained his strength and he became unable to work.

Louis wanted to find a way to tell his story and send a warning to others to beware of the deadly clouds of gray dust. So he turned to the very thing that was about to take his life—granite. He commissioned fellow granite-carver Don Colletti to craft a statue of a man dying of silicosis. Louis would be the model for the man, and Louis' wife Mary would pose as the woman. Or, it was supposed to be Mary. Local legend (and we need to caution that it is only a legend) has it that the woman cradling Louis in his last moments of life bears a striking resemblance to his . . . uh . . . mistress.

Louis Brusa died in 1937, the first full year that dust-filtering systems in granite sheds were required by law.

Brusa Monument.
Hope Cemetery,
Barre, Vermont

Corel Sherwood

Young Corel Sherwood died in a plane crash just shy of his twenty-first birthday. He was giving rides to people near Ellis, Nebraska, and had just given a series of rides to a group of children. His last flight was with another adult. After crashing the plane, which killed his passenger, he was rushed to a hospital in nearby Beatrice, Nebraska, where he soon died.

His grave in Wyuka Cemetery is marked by the propeller of his plane, a photograph of him, and a letter from one of his buddies he had attended flight school with in Lincoln. The letter told Sherwood of another pilot's engine problems and requested that Sherwood send a maintenance book to that pilot to help him out. It's unclear if Sherwood ever sent the book, but the writer of the letter did go on to achieve considerable aviation fame. He was Charles Lindbergh.

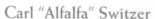

Corel Sherwood,
*Wyuka Cemetery,
Lincoln, Nebraska*

The Sherwood family still carefully maintains the grave. Every year they make a pilgrimage to the family plot to put a fresh coat of shellac on the propeller and make needed repairs.

Carl "Alfalfa" Switzer

Hollywood Forever Cemetery (formerly Hollywood Memorial Park) is the final resting place of Carl "Alfalfa" Switzer (1927–1959), who gained fame as the kid with the unruly cowlick in the "Our Gang" comedies of the 1930s. Switzer never had much luck in Hollywood after the series, landing only an occasional bit part. He toiled away at numerous jobs, but his life was cut

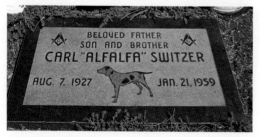

Carl "Alfalfa"
Switzer,
*Hollywood Forever
Cemetery,
Hollywood, California*

short after an altercation involving a gun and a knife (he had the knife). Switzer's grave marker pays homage to "Our Gang" dog, Petey, minus the black circle around his eye, which was painted sometimes on his left eye, sometimes on his right.

Carl and Constance Bigsby

An exact scale replica of an Atlas Pioneer rocket marks the graves of Carl and Constance Bigsby in Hollywood Forever Cemetery. The rocket represents Bigsby's pioneering achievements in the publishing and graphic arts fields. He had no direct involvement in America's space program. Constance Bigsby was a bit more modest—the inscription on her tombstone (on the right-hand side of the rocket) reads simply, "too bad, we had fun."

Tyrone Power

The bench-tomb of Tyrone Power (1914–1958) in Hollywood Forever Cemetery has carved bookends holding a single book. Carved into the top of the bench are lines from Hamlet, Act 5, Scene ii: "Now cracks a noble heart. Good night, sweet prince / and flights of angels sing thee to thy rest."

Right:
Carl and
Constance Bigsby,
Hollywood Forever
Cemetery,
Hollywood, California

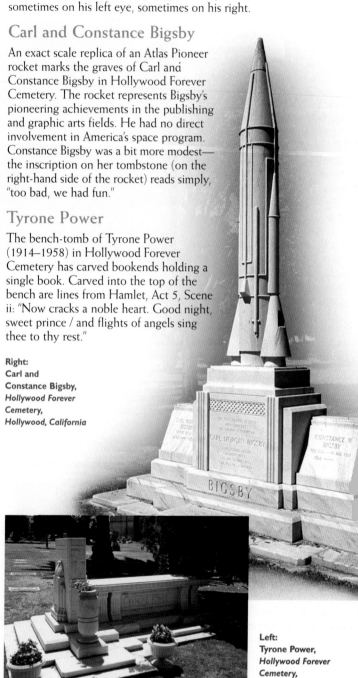

Left:
Tyrone Power,
Hollywood Forever
Cemetery,
Hollywood, California

Francis Joseph "Lefty" O'Doul

One would be hard-pressed to think of an epitaph more simple, loving, and poetic than O'Doul's: "He was here at a good time, and had a good time while he was here." Lefty O'Doul (1897–1969) grew up in San Francisco and played for the New York Yankees, Boston Red Sox, New York Giants, Philadelphia Phillies, Brooklyn Robins, and Brooklyn Dodgers. After his retirement from active playing, he coached the San Francisco Seals and the San Diego Padres to league pennants, but his heart was always with his San Francisco roots. A San Francisco bar bears his name and San Francisco even has the "Lefty O'Doul Memorial Drawbridge" spanning a small canal near the site of the San Francisco Giants' new ballpark.

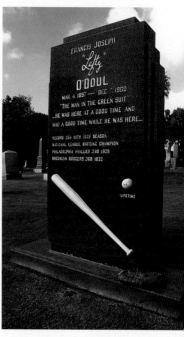

Francis Joseph "Lefty" O'Doul, Cypress Lawn Memorial Park, Colma, California

His black granite tombstone in Cypress Lawn Memorial Park, complete with ball and bat, recalls his major-league statistics, including his lifetime .349 batting average, which is etched into the baseball. Fans young and old often leave well-worn baseball gloves and the occasional ball and bat to honor his memory. Recently another baseball great, Joe DiMaggio (whom O'Doul helped tutor and groom), was buried at Holy Cross Cemetery just down the road from Cypress Lawn.

Penny

It's hard to think of what to say about Penny, who died in 1969 and is spending eternity in Pet's Rest Cemetery. Alas, since Penny isn't here to speak for herself, we'll take the liberty to postulate that in 1969, at the dawn of the the age of self-discovery, the word's "Who Am I" reverberated throughout the land. If people could ponder that question, why not animals too. But after looking at the picture on your tombstone, we can safely say that, Penny, you are, indeed, a rabbit.

Penny, Pet's Rest Cemetery, Colma, California

Saundra Twist

Louisville sculptor Barney Bright fashioned this sculpture of Saundra Curry Twist (1941–1981), who died tragically in an automobile accident and was described as a fashion model and a cheerleader. The monument in Cave Hill Cemetery was ordered by her family. It is comprised of the statue, a colonnade, and a plaque with a eulogy.

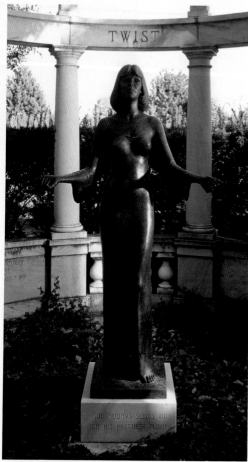

Saundra Twist
Cave Hill Cemetery, Louisville, Kentucky

Lester Moore,
Boothill Cemetery, Tombstone, Arizona

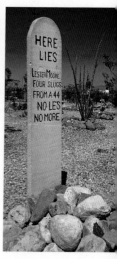

Lester Moore

Epitaph writers at Boothill Graveyard in Tombstone, Arizona, sometimes found a bit of humor in death, as in the case of one Lester Moore, who was one of many residents of Tombstone who met his end through violence. Boothill Cemetery is best known as the final resting place of three of the men who died in the gunfight at the O. K. Corral.

Marie Laveau

This is the reputed burial place of one of New Orleans' most notorious voodoo queens, Marie Laveau. The mystic cult of voodooism has its origins in Africa, although it was brought to New Orleans by way of the Caribbean island of Santo Domingo. Voodoo developed quite a following in the nineteenth century and still exists today. There are always offerings of some sort in front of the tomb. The exterior of the tomb is awash in the letter *X*, a voodoo sign of good luck.

Guidebooks describe this tomb as Greek Revival, but at best, it is a rather stripped-down version of the style.

These brick and plaster "house tombs" often contain the remains of generations of families. They are usually designed with two vaults, one above the other, and a pit (*caveau*) below. When room is needed for another body, the tomb is opened and the bones of the previous occupant are removed and placed in the *caveau*. If the casket hasn't completely disintegrated, it is used for firewood. Very practical, those New Orleanians!

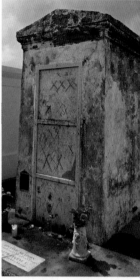

Marie Laveau,
St. Louis Cemetery # 1,
New Orleans, Louisiana

Gracie Watson

Ever since the publication of the book *Midnight in the Garden of Good and Evil*, Savannah's Bonaventure Cemetery has been overrun with tourists hoping to find the "Bird Girl" sculpture that appears on the cover of the book. They won't find the Bird Girl because she's been moved to a local museum, but they will find Little Gracie.

Gracie Watson, who died of pneumonia in 1889 at the age of six, was the only daughter of Savannah hotel owner W. J. Watson and his wife, Frances. The year after Gracie's death, Mr. Watson took a photograph of Gracie to local monument sculptor John Walz and requested a suitable memorial to his

Gracie Watson,
Bonaventure
Cemetery,
Savannah, Georgia

daughter. Rather than give Gracie an angelic or heroic look, Walz sculpted this stunning statue with lifelike accuracy to look like a pensive child lost in thought. Although Gracie's grave is one of the most visited sites in Bonaventure Cemetery, she is spending eternity quite alone. She is the only burial in the large family plot. Her mother and father moved away from the area and are buried in another cemetery.

Angele Marie Langles

There is a curious inscription carved into the thirty-foot Langles obelisk. Passersby might think the inscription "105 La. 39" is a maker's mark or perhaps a parts number from a funerary supply catalog. In fact, it refers to a statute in the State of Louisiana's laws of succession.

In a thick fog on the early morning of July 4, 1898, the French steamship *LaBourgoyne* was threading its way along the Nova Scotia coast. Suddenly, an ironclad British freighter, the *Cromartyshire,* was spotted through the fog, but it was too late to avoid a collision. The *Cromartyshire* rammed the French ship, which sank in less than thirty minutes. There were few survivors. Most were asleep in their quarters and, amid the chaos and confusion, were not able to make it above deck.

Among those lost at sea were Angele Marie Langles and her mother, Madame Pauline Costa Langles, wealthy widow of the owner of a New Orleans cracker factory. A month before, each of them had made out wills that were, for the most

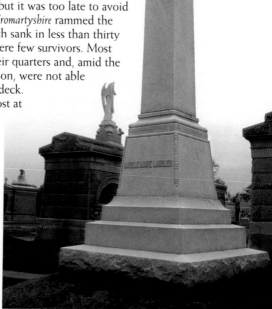

Angele Marie Langles, *Metairie Cemetery,* **New Orleans, Louisiana**

part, reciprocal, although each one did have a few specific requests. Since neither one had specifically willed the bulk of her estate to particular relatives, the question of who died first would have a tremendous effect on which set of heirs would get the estate.

Lawyers were hired; family members took sides, and angry words were hurled back and forth. After much expense, the case finally came before the court of Judge N. H. Rightor. But after hearing all the evidence, the jury came back to the judge and stated that it could not reach a decision. Judge Rightor took it upon himself to settle the case and ruled that even though the evidence suggested that Madame Langles was in better physical health than Angele and was likely to survive a physical peril longer, Angele knew how to swim and Madame Langles did not. After all, ruled the judge, they were on a ship and it was likely that, though the bodies were never recovered, they would have died from drowning. Angele simply would have been able to keep her head above water a bit longer.

Madame Langles's heirs appealed to the Louisiana Supreme Court, but to no avail. Angele's heirs were victorious, but their legal battles were not over. Angele's will called for the allocation of three thousand dollars for the erection of a monument upon her death. Her heirs greedily wanted to keep what was left of her estate after their lawyer's fees, and argued that "we don't think there needs to be a monument since there isn't a body to put there." Luckily, good sense prevailed and the judge ruled that it was Angele's intention to have a monument erected to her memory, not necessarily her physical remains.

The attorney, and now executor of the estate, ordered a monument from legendary New Orleans tomb designer Albert Weiblen and directed him to carve "Angele Marie Langles, 105 La. 39" into the base of the monument.

As a final punctuation to the case, there were three other New Orleanians, Mrs. Jules Aldigé, her daughter, and her granddaughter, who also perished in the shipwreck. The family waited until after the outcome of the Langles case to decide on the succession. The remaining Aldigé family members placed a tomb just a few feet away from the Langles monument, topped with two angels riding the bow of a sinking ship. Inscribed on the tomb are ALL the names of the members of the Aldigé family who perished that fateful July morning.

Harding Family Plot

This one-of-a-kind monument is the centerpiece of the Harding family plot. The marble full-size replica of the rolltop desk in the office of insurance agent N. C. Harding is covered with office supplies, including notepads, inkwell, and blotter. The desk also displays open books that are engraved with the birth and death dates of various Hardings and their close relatives. N. C. Harding died in 1915 and is buried beneath the desk.

Harding Family Plot,
Wyuka Cemetery,
Nebraska City,
Nebraska

Newfoundland Dog

What is clear is that a cast-iron Newfoundland dog was manufactured by Hayward, Bartlett and Company of Baltimore, Maryland. But nobody is exactly sure why it is in Hollywood Cemetery. The dog, which gets a regular coat of paint to keep it clean and shiny, is one of the most popular monuments in the cemetery—no small feat for the metal mutt, since it competes with the monuments to two presidents (James Monroe and John

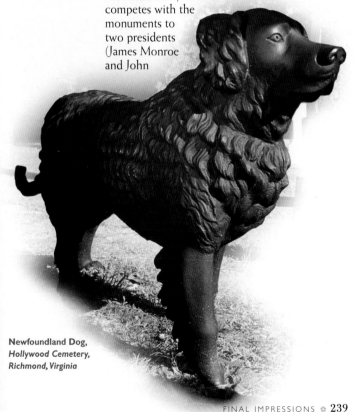

Newfoundland Dog,
Hollywood Cemetery,
Richmond, Virginia

Tyler) and numerous Confederate monuments, including the grave of Jefferson Davis, president of the Confederate States of America.

One story about the dog's presence in the cemetery says that it graced the storefront of a building on Richmond's Broad Street and was very popular with children, especially one little girl. When the girl died unexpectedly, the store owner had the cast-iron canine moved to the grave of the girl so the dog could symbolically keep her company and guard her grave. Another less romantic story is that during the Civil War, ornamental iron was collected and melted down to reemerge as military equipment. Fearing the approbation of the Newfoundland dog, the owner had it moved to the cemetery for safekeeping. Whatever the story, it has stood regally at the corner of Cedar and Confederate Avenues for almost 150 years and will, no doubt, maintain its vigil for eons to come.

Def

While he was a student at Long Island College in the early 1980s, Rick Rubin founded Def Jam Records, which he operated out of his dorm room. In 1983 he teamed up with Russell Simmons and released a number of hip-hop records. One of the first artists they signed was sixteen-year-old James Todd Smith, known to the hip-hop community as LL Cool J. Rubin and Simmons produced a number of hit records with various artists until 1988, when Rubin left the company to found Def American records. Under the Def American label, Rubin released records by a number of artists, including The Red Hot Chili Peppers and Mick Jagger.

Def,
Hollywood Forever
Cemetery,
Hollywood, California

By 1993 Rubin, tired of the violent stigma that was attached to the term *Def,* changed the name Def American Records to American Records. To formalize the passing of Def, Rubin purchased a plot and a tombstone inscribed with "Def" at Hollywood Memorial Park Cemetery (now Hollywood Forever Cemetery). On August 27, 1993, a New Orleans–style funeral at the cemetery with a eulogy by Reverend Al Sharpton (who Rubin had flown in from New York) put the name *Def* to rest.

Referring to the origin of the term *Def* as a synonym for "excellent," Sharpton said it meant

"more than excellent. Like, def-iantly excellent with a bang. Now the bang is out of def. It lost its exclusivity to the in def-iant crowd. It died of ter-minal acceptance."

Before Def was officially buried, some of the 2,000 or so mourners placed flowers, record albums, and personal mementos in the open cas-ket. As the casket was lowered, guarded by Black Panthers with prop shotguns, The Amazing Kreskin (who usually doesn't do funerals) per-formed his mind-reading act on a grieving Tom Petty and Rosanna Arquette. After the ceremony, 500 or so of the bereaved retired to a bowling alley for an "after party."

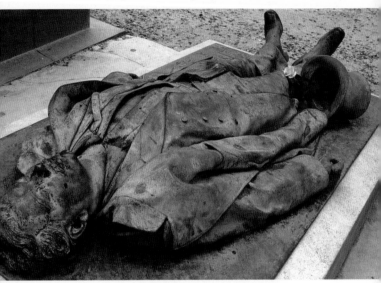

Victor Noir,
Père Lachaise
Cemetery,
Paris, France

Victor Noir Tomb

Fertility symbols come in many shapes and sizes and are found in many places. But one thinks a cemetery, with its obvious preoccupation with death, would be an unlikely place to find one. Such is not always the case.

Consider the fateful saga of Victor Noir (1848–1870), who died of a gunshot wound inflicted by Prince Pierre Bonaparte, a cousin of Napoleon III. It seems that Noir, a Republican journalist, was caught in the middle of a dispute between Pierre Bonaparte and one of Noir's fellow journalists. The journalist sent his seconds, which included Noir, to the Prince to challenge him to a duel. The Prince refused the challenge, but tem-pers flared and a pistol shot felled young Victor Noir. Noir, whose real name was Yvan Salmon, became an instant martyr to the Republican cause.

Twenty thousand Parisians trekked up the stairs to Noir's room, where his body was laid out, and more than 100,000 people lined the streets leading to Père Lachaise Cemetery on the day of his funeral. Noir's death was one of the key factors that eventually led to the collapse of Napoleon III's Second Empire government.

The artist who sculpted Noir was careful to be anatomically correct. Noir's face, hair, mustache, and hands are extraordinarily well crafted. Even the folds of his clothing, buttons, and boots are perfectly detailed. And, ahem, it is more than a little obvious that Victor Noir is a man, one who is quite well endowed.

Apparently, a legend soon developed that young women wishing to get pregnant could improve their chances by giving Victor a rub "down there," and on his boots and nose for good measure. The tradition continues, and judging by the luster that has developed, a lot of the female population of Paris is trying to get pregnant— though one suspects that there are a number of the "I'm just curious" visitors who are helping maintain Victor's mirror-like shine.

Oscar Wilde

It took a number of years after Oscar Wilde's death before he could truly rest in peace. Even now, a century after his departure from this realm, there is a constant stream of tourists milling about over his head. Wilde, who was born in Dublin, Ireland, is best known as the author of *The Importance of Being Earnest* and *The Picture of Dorian Gray*. He is just as well known for his own escapades as his literary works. Certain aspects of his not-so-private life resulted in imprisonment for "homosexual acts." Physically broken by the harsh jail conditions, he died in 1900, three years after his release.

He was interred in an unremarkable grave in Bagneaux Cemetery in Paris and resided quietly there for nine years. In 1908, at a dinner at the Ritz Hotel in London, the executor of Wilde's estate revealed that he had received an anonymous gift of £2,000 from a lady "to place a suitable monument at Père Lachaise and that this work should be carried out by the brilliant young sculptor, Mr. Jacob Epstein." Years later it was revealed that "a lady" was Helen Kennard Carew.

On July 18, 1909, the night before the transfer of Wilde's remains to Père Lachaise, the sextons at Bagneaux Cemetery dug up Wilde's grave and placed two ropes beneath the coffin. Since it was

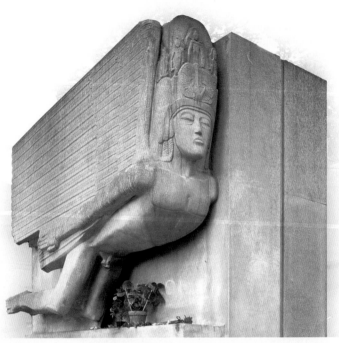

Oscar Wilde, Père Lachaise Cemetery, Paris, France

raining they placed a couple of tombstones on top of the freshly dug soil to keep it from falling back into the grave. The next day a number of journalists and other onlookers gathered at the grave to witness the exhumation. At some point, one of the tombstones holding the soil in place slipped off its perch, fell into the open grave, and crashed onto Wilde's coffin, splitting it open. For a brief moment, Oscar's face was exposed to the heavens, then torrents of mud came rushing in. Wilde's mud-encrusted remains were transferred to another coffin and moved to Père Lachaise, but his post mortem saga was just beginning.

After receiving his commission, Jacob Epstein decided to base the monument for Wilde on Wilde's poem "The Sphinx." Epstein chipped away at it for more than three years. Finally the monument was moved to Père Lachaise and installed over the grave of Wilde. But when Epstein arrived at the cemetery to apply some final touches, he found his creation wrapped in a shroud. The cemetery conservator had determined that the depiction of the genitalia on the statue was indecent and refused to have the statue revealed for public display. Despite public protests the conservator would not yield. Eventually a compromise was reached and a fig leaf/plaque was placed over the offending parts. In 1914 the Egyptian-style monument was finally unveiled.

Alas, the offenses to poor Oscar were not quite over. One night in 1922, a group of students entered the cemetery determined to set things right and free him from his fig leaf. Unfortunately, when they hacked away at the fig leaf, a substantial part of the statue's offending parts were severed from the statue. Local legend says that for years the "parts" served as a paperweight in the cemetery superintendent's office. But such is the stuff of legends. Rest in peace, Oscar.

Merello/Volta Monument

This eight-foot-tall bronze sculpture is a depiction of a grief-stricken young woman in her wedding dress. She is clutching a bouquet of flowers and appears to have fallen on the church's steps. Time and weather have only served to make this sculpture more forlorn by etching stains running down her face that look remarkably like tears. Above her and not in this photograph is a rough-hewn cross and the name *Merello/Volta*.

Merello/Volta Monument, Green-Wood Cemetery, Brooklyn, New York

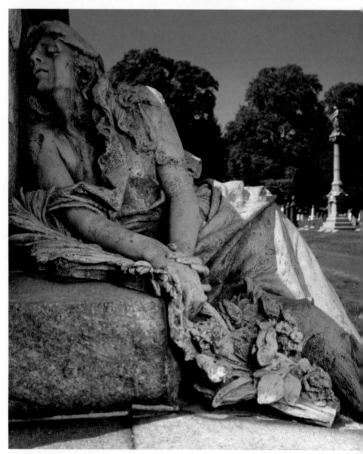

Amazingly, nothing else is known about the monument, but the rumor persists that she was a relative of a gangster and was shot for revenge.

**Tse Monument/
Mausoleum,**
*Rosedale Cemetery,
Linden, New Jersey*

Tse Monument/Mausoleum

Next to the Tse mausoleum in Linden, New Jersey (a suburb of Newark), stands the monument to young Raymond Tse. He was a sixteen-year-old Chinese American boy who longed for a Mercedes when he grew up. Unfortunately he died unexpectedly of pneumonia in 1983 while in Hong Kong as a foreign-exchange student.

His family chose to give him the car of his dreams posthumously by commissioning Michael DiPiazza, a monument dealer in Hackensack, New Jersey, to produce an exact replica of a Mercedes 240D stretch limousine. DiPiazza subcontracted the work to Rock of Ages Granite in East Barre, Vermont. Rock of Ages called upon two of its best sculptors, Dante Rossi and Warren Sheldon, to produce this stunning work. Rossi and Sheldon carved the monument out of a 34-ton block of granite using an actual Mercedes as a model. They were further assisted by blueprints supplied by Mercedes-Benz.

"They had the car right in front of them," says Scott Rahenfuher of Rosedale Cemetery. "What they produced is an exact replica, from the headlights to the grillwork, the tailpipes and the windshield wipers. Even the license plate screws are there." It was decided not to sculpt the hood ornament or side-view mirrors as it was thought they would be vandalized or stolen.

"The story goes," says Rahenfurer, "that the boy wanted a Mercedes when he reached driving age, and his older brother promised him he'd have one."

Cost for Raymond Tse's Mercedes: $250,000.

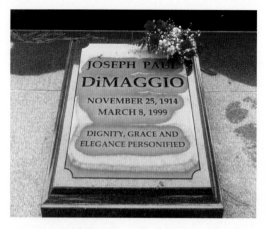

Joe DiMaggio

On June 11, 1999, three months after his death, Joltin' Joe DiMaggio was finally laid to rest in a gleaming black granite tomb. Cold Springs Granite Company of Cold Springs, Minnesota, manufactured the aboveground tomb, designed by Chris Vierhaus of the American Monument Company in Colma, California. Like DiMaggio, the tomb is unpretentious, simple, and elegant.

Vierhaus said that the family had a very clear vision of what they wanted the monument to represent and that the basic design came out of the first meeting.

"We met with the family after Joe's death and discussed design options for the tomb," said Vierhaus. "I showed them a number of basic ideas in monument catalogs and we went from there. The family wanted something that was high enough above the ground to be noticed, but not something that was pretentious. We settled on a six-foot-high sarcophagus-style tomb that has two crypts, but in this case, only one will ever be used."

Vierhaus did a rough sketch and after some small adjustments, a formal design sketch was sent to Cold Springs. Cold Springs manufactured the tomb, but Vierhaus carved all of the lettering, including the cross with an intertwined rose. (Crosses are required on all tombs in Catholic cemeteries.) While waiting for the delivery of the tomb, Vierhaus busied himself preparing the site and building the tomb's foundation. The foundation of the tomb and the surrounding area is a cruciform (cross shape). Besides the cruciform, the orientation of the tomb on the plot is also a key element in the design. Joe's brother, Dominic DiMaggio, requested that the tomb be near the

priests' plot and wanted Joe to face a mural of the *Last Supper*, which is part of the plot.

"If you stand facing the tomb, then turn around 180 degrees, you'll be looking at the figure of Jesus on the *Last Supper* mural just a short distance away," said Vierhaus. "We actually took a string line and ran it from Jesus all the way to the site of the DiMaggio tomb to make sure it was lined up correctly."

The anticipated increase in traffic at the cemetery was a factor in choosing the location of the tomb. Neither the family nor the cemetery wanted to impede traffic on the busy avenues surrounding the cemetery. So, while the tomb is easy to find in the cemetery, it cannot be seen from the road. Expecting a sizable number of visitors to the DiMaggio tomb, Vierhaus incorporated a substantial patio-like area around the tomb as part of his design. This allows visitors to walk around the tomb without stepping on the grass.

Even the placement of the footstone was another factor that was taken into consideration. "We wanted people to be able to read the footstone and view the entire plot and the surrounding grounds at the same time," explained Vierhaus.

To achieve that effect, Vierhaus placed the footstone away from the tomb. On the footstone are words chosen by Dominic DiMaggio: "Joseph Paul DiMaggio, November 25, 1914–March 8, 1999. Dignity, Grace and Elegance Personified."

DiMaggio will be spending eternity with more than 343,000 others in Holy Cross Cemetery, including DiMaggio's parents, an array of San Francisco mayors, and various other notables. But the DiMaggio tomb will no doubt be the most visited burial site in the cemetery. Already an assortment of American flags, Italian flags, hundreds of roses, and balls and bats have been found at the tomb.

But, according to Katherine Atkinson, administrator of Holy Cross, the most curious sightings at the Yankee Clipper's eternal home have been a number of platinum-haired women who place roses on his grave—Marilyn Monroe impersonators.

Davis Memorial

One of the most fascinating tombs in the United States is in Mount Hope Cemetery in the sleepy little town of Hiawatha, Kansas. Built over a period of years in the 1930s, the Davis Memorial and its two permanent residents are still the talk of the town.

John Davis was born on January 18, 1855, in Bowling Green, Kentucky. While attending Urania College in Glasgow, Kentucky, he was orphaned. Apparently he did not have the means to continue with college, and like many young men of his time, he wandered west. He worked at various jobs for a year before settling in the northeastern Kansas town of Hiawatha in 1879. Before long he was hired as a farm laborer by a prosperous local landowner, Tom Hart. Almost immediately, young John Davis fell in love with and married the farmer's daughter, Sarah. The Hart family was in an uproar over this union, and the newlyweds were unceremoniously cast out and disinherited by the well-to-do Hart clan.

But John and Sarah bought a 260-acre place of their own, worked hard, and spent and invested wisely. According to a local Hiawatha woman who knew the Davises and is still alive today (1999), "They

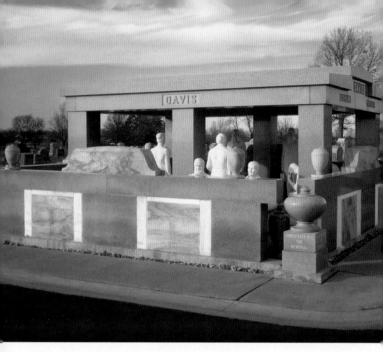

had what would be called a traditional marriage for the time. He was strict but never beat her. He'd go to work and she'd stay at home to do the housework. He didn't want her to even go into town to do shopping. John would buy the groceries and bring them home. Sometimes, though, after he left for the day, she'd go to a neighbor's place for tea and conversation. But when someone saw John on the road on the way home, they'd alert her and she'd scamper back home."

After thirty-five years of living on the farm, John and Sarah bought and moved into a Queen Anne–style Victorian house in Hiawatha. The couple lived there for a number of years before Sarah died of a stroke in 1930. Sarah left a simple will that bequeathed her entire estate to John (they never had any children), which totaled over $54,000, including minor items such as $150.00 for "corn in the crib." The will also instructed John to erect a "suitable memorial" for Sarah at the local cemetery.

And what a memorial it would be. Apparently John did purchase and erect a standard grave marker for Sarah in Mount Hope Cemetery on the edge of town, but he wasn't satisfied with the modest tombstone. So, he conferred with friend and local monument dealer Horace England and came up with a plan for the most elaborate and expensive memorial folks in Hiawatha had ever seen. Some say that Davis had the memorial built to spite Sarah's family, who had snubbed them so

Davis Memorial, Mount Hope Cemetery, Hiawatha, Kansas

This memorial was built by John Davis between 1930 and 1937 as a tribute to his wife, Sarah, and to celebrate their half-century marriage. Estimates of the cost of this unique memorial range from $200,000 to $500,000.

many years before, and additionally to spend all of his money to make sure that none of her relatives would get it after he died. Others say he built the lavish memorial to Sarah because he felt guilty for treating her so badly. And it's also quite possible that old John just didn't know where to stop. The real truth will never be known.

What is true is that the construction of the memorial created quite a stir in Hiawatha. In the 1930s, Hiawatha, like many small farming towns, was affected by the Great Depression that was gripping the country. Hard cash was in short supply, said angry residents of the town, and old John Davis was erecting an outrageous memorial to his dead wife when he should be helping the living by building a hospital or helping out his fellow citizens. Estimates of final costs of the memorial range from about $200,000 to $500,000, a tidy sum for the time. At first, monument dealer Horace England tried to talk Davis out of his plans, but Davis told England that if England

Davis Memorial, Mount Hope Cemetery, Hiawatha, Kansas

Granite statue of John Davis and the "vacant chair," which represents Sarah's absence.

didn't want to work with him because of the ill feelings of the townsfolk, he'd understand, but he'd find another memorial dealer who would carry out his wishes.

England relented and plans were drawn up for a granite canopy that looks something like a carport. The canopy, emblazoned with the Davis name, would shelter the graves of Sarah and John. Also sheltered by the canopy would be marble statues, carved in Carrera, Italy, of John and Sarah dressed to the nines, commemorating their fiftieth wedding anniversary. The statues would be positioned to face their headstones. While this monumental assembly might be a bit grand by Hiawatha standards, it's easy to see why a man with sufficient resources might want to build a tribute to his wife and their marriage. The canopy and statues were assembled and erected in 1931, but John Davis just couldn't seem to stop with one pair of statues.

"I thought it still looked too bare, so I got me another pair," Davis said, referring to the second set of statues he commissioned. The two new additions depicted John and Sarah in 1890, ten years after their marriage. An appropriate gesture, one might say, to bookend their life together. But not enough

for Davis. What followed were a series of additions to the memorial, which give it a somewhat jumbled look. The final addition was a granite marble wall surrounding the memorial to discourage ("kindly keep off the monument") visitors, especially children, from playing on the statues.

In early 1932, Davis deeded his two farms over to English for $31,000 to finance even more statuary. The third pair, installed that summer, were seated figures of John and Sarah in 1898. This pair features a clean-shaven John Davis, an accurate depiction of him at the time since his flowing beard had caught on fire in a raging brushfire and he went clean-shaven for a period of time. Now there were six statues. Next in the series was a depiction of the couple after John suffered a hedge-trimming accident in 1908. Viewers will note that the statue of John is missing its left hand, a result of the accident. Up to this point, all of the statues had been carved out of marble. For the next set, Davis chose granite because he thought it was better for a man's features. Sarah is missing, her absence represented by a vacant chair.

For the final set of figures, Davis returned to marble. Sarah is seen as an angel kneeling before John's grave. It is a very interesting angel. The face does not have the usual young angelic look. It is the face of Sarah, wise and worn with the passage of time. And John's face? Well, apparently it's at the bottom of a local lake. In 1990, vandals beheaded the statue and left a note saying they had tossed it in a nearby reservoir. A few years ago the lake was drained, but the head was not found.

By 1937 most of the work had been done. It delighted Davis to sit in his rocking chair underneath a tree near the memorial and watch the reaction of visitors. Sometimes he would even greet them. *Life* magazine came for a look. Legendary reporter Ernie Pyle traveled to Hiawatha to interview Davis. As a final payment for the memorial, eighty-two-year-old John Davis deeded over his house in town to Horace England for one dollar, with the provision that England would allow Davis to live out his days there. Later that year, Davis was informed by three doctors that he had a fatal illness and had less than six months to live. Davis quickly gave away the last of his fortune (reputed to be about $55,000) in preparation for his exit from this realm. Either the doctors miscalculated or Davis summoned up the will to go on, but he didn't die in six months, or even six years. He went on to live another ten years and died absolutely penniless. His friend

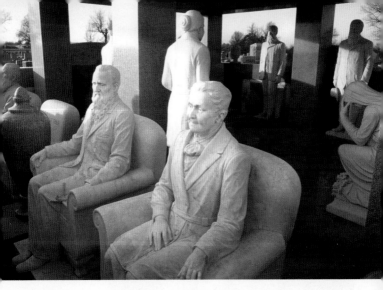

**Davis Memorial,
Mount Hope
Cemetery,
Hiawatha, Kansas**

**Eleven statues of
John and Sarah Davis
at various stages of
their life are housed
beneath a granite
canopy.**

and monument dealer Horace England was at his
side when John Davis died in his sleep at the
Brown County Hillcrest Home, a place some
locals unaffectionately described as "a bug-
infested poor-house."

But John Davis had his way. He built his
memorial and snubbed his nose at the family who
had disinherited him for stealing their daughter
many years before. Nowadays the Davis memorial
is the number-one attraction in Hiawatha. Every
year, thousands of visitors come from all over the
world to view this unique tribute, proving that
maybe you can't take it with you, but you can
certainly leave something behind.

Blocher Mausoleum

It's impossible to stroll by the Blocher
mausoleum in Buffalo's Forest Lawn Cemetery
without wondering what the story is behind this
one-of-a-kind tomb. Indeed, the circumstances
that led to the tomb's construction are an
intriguing mix of fact and fable. It's a tale of love
and passion, loss and sorrow.

The center of attention inside the tomb is
Nelson Blocher, laid out for viewing, clutching a
Bible. Looking at his prostrate form are his par-
ents, John and Elizabeth Blocher. Hovering above
is an angel who, some say, bears a striking resem-
blance to a maid employed by the Blocher family.
It's said that Nelson died of a broken heart.
Accounts of the day say that his mother,
Elizabeth, goaded her husband, John, into con-
structing the tomb as a memorial for their heart-
broken son.

John Blocher was born in 1825 in the small

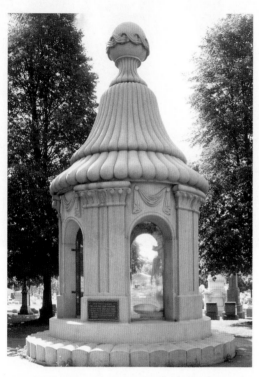

Blocher Mausoleum,
*Forest Lawn
Cemetery,
Buffalo, New York*

town of Scipio, New York. At age ten he became
"the man of the family" following the death of his
father. This left him with little formal education,
but the adult responsibilities that he assumed at a
young age charged him with entrepreneurial
spirit. At age eighteen he opened a tailoring busi-
ness in Buffalo, which he soon developed into a
general store, supplying ready-made clothing, dry
goods, and groceries to Buffaloans. At age twenty,
John married nineteen-year-old Elizabeth Neff.
The union produced one son, Nelson, who was
born in 1847.

John Blocher enlisted in the Union Army at
the outbreak of the Civil War and served one
year in the 78th New York Regiment before
being discharged for ill health. Returning to
Buffalo after his stint in the army, Blocher turned
the war to his advantage and proceeded to man-
ufacture shoes and boots for the army. His pros-
perous footwear business and some shrewd real
estate investments soon turned John Blocher into
one of Buffalo's wealthiest citizens. Fittingly, he
installed his family in an elegant residence on
Delaware Street, Buffalo's answer to Manhattan's
Fifth Avenue.

The Blocher residence, of course, needed the
usual complement of servants. One young maid

in particular, twenty-year-old Katherine, ultimately became the force behind the construction of the Blocher mausoleum. And herein lies the tale.

It seems that Nelson Blocher either wasn't inclined toward marriage or was inept at the social skills necessary to secure a bride. Not only was he still a bachelor at age thirty-four, he was living at home. Nelson made frequent buying trips to Europe to purchase leather goods for the family business and art and furniture for the family home. But when he returned to Buffalo, he was assigned to the rather mundane daily duties of attending to the Blocher business.

Then one day in the spring of 1881, the Blochers hired a new maid. Katherine was twenty years old, pretty, and unattached. Nelson was immediately smitten and made no attempt to hide it. During the spring and summer of 1881, he found ways to be near Katherine and to spend time with her. There is reference to an injured kitten Nelson and Katherine nursed back to health. Some say that Katherine wasn't particularly attracted to Nelson, but she encouraged and continued the flirtation to keep her job, while others say they fell in love. Whatever the case, it's clear that it simply wasn't proper for a well-bred man about town to consort with a lowly maid, no matter how charming she may be.

Nelson's parents did not approve of the romance and quickly made plans to put an end to it. In the fall of 1881, Nelson's father, John, announced that there was business to be attended to in Europe and Nelson needed to make plans to leave for an extended trip. Plainly, Nelson's father wanted to separate the couple and put an end to the romance. One story says that Nelson proposed marriage to Katherine on the eve of his departure to Europe, but Katherine said she needed time to think, while other accounts say that Nelson barely had time to say good-bye.

After Nelson left for Europe, one account says that Katherine had second thoughts about marriage and used the opportunity to depart for parts unknown. But a more accepted account says that immediately after Nelson's departure, the Blochers fired Katherine with a strict admonition never to return. What is true, however, is that in the spring of 1882, when Nelson returned from his travels, Katherine was gone and nobody seemed to know where she went. John and Elizabeth Blocher told their son that two weeks after Nelson left for Europe, Katherine had stolen away in the middle of the night, leaving nothing behind but her Bible.

Whatever the reason for Katherine's departure, Nelson was heart-broken. He couldn't believe she had gone without even leaving a note. There must have been a reason and he was determined to find her and convince her to come back. Throughout the remainder of 1882 he searched for her, and like the lovelorn for eons before him, he neglected his business and health in pursuit of love. By the fall of 1883, Nelson was tired and worn out from his search. Broken in spirit and sick with a fever, Nelson took to his bed. By early winter of 1884 he was drifting in and out of sickness and depression. Soon he became bedridden. His only solace was the Bible that Katherine had left behind. Then on January 24, 1884, Nelson's time in this realm was over. He died with Katherine's Bible clutched to his breast.

Nelson's mother, Elizabeth, no doubt driven by a maternal blend

of love and guilt, insisted that a suitable memorial be erected to her son. The task of designing the monument would fall to the creative hand of John Blocher. At the time of Nelson's death, John Blocher was semiretired. He had taken up sculpting as a hobby and would use those skills in designing the Blocher monument.

The spirit of the Blocher monument belongs to an architectural style all its own. The closest category of architecture that the Blocher mausoleum can be compared to is the "follies" of nineteenth-century Victorian architecture. A folly is defined by Penguin's *Dictionary of Architecture* as "a costly, but useless structure built to satisfy the whim of some eccentric and thought to show his folly . . ."

Supposedly, John Blocher just couldn't find a monument designer to correctly interpret his vision, so without any formal training in construction, he took it upon himself to craft the mausoleum. Blocher's design, which looks more like an elaborate confection rather than a mausoleum, may have been ahead of its time. Nowadays it would be easy to imagine a structure like the Blocher mausoleum gracing an avenue of pillowy shaped buildings in Toontown in Disneyland.

Blocher had two elements to design. The first was for the exterior of the mausoleum. The other was for statues of the Blocher family and an angel (which some folks say looks a lot like the maid) that would be sealed behind glass in the mausoleum's interior. He contracted with the firm of John McDonnell to cut and assemble the pieces of the mausoleum from quarries in Quincy, Massachusetts. Blocher ingeniously designed the mausoleum so that the entire structure could be built with only twenty stones; thus minimizing maintenance problems. The roof, which is frequently a maintenance nightmare in stone structures, is formed by just one piece, a bell-shaped affair. Another stone, shaped like a ball, is used for the capstone. The bell was cut from a ninety-ton slab of granite and whittled down to twenty-nine tons. It is supported by five pilasters.

The pieces of the mausoleum were hoisted into position by massive rigging equipment. All of the elements were precisely set in place. But as the ball, the tomb's crowning glory, was being lowered into its nest at the top of the bell, the timbering gave way and the ball came crashing down, cracking the bell. A lawsuit ensued; the contractor claimed that Blocher's design was at fault, resulting in an inherently weak structure. Blocher claimed that it was a simple case of negligence. Eventually Blocher prevailed and another bell was manufactured. The capstone was finally, ever so gently, lowered into place without incident.

In the openings between the pilasters, Blocher specified four one-inch-thick panes of glass, which were manufactured in Paris, and another one-inch-thick piece of glass with hidden hinges that serves as a door. Before the mausoleum was assembled, work had already begun on the statuary.

For the statues on the inside of the mausoleum, Blocher originally commissioned Paul Roche of Westerly, Rhode Island, to come to Buffalo and carve the statues out of Carrara Marble. Blocher fashioned a plaster model of Nelson Blocher lying on a couch and instructed Roche to carve a life-size replica. Roche chiseled away under John Blocher's constant supervision, but Blocher was less than

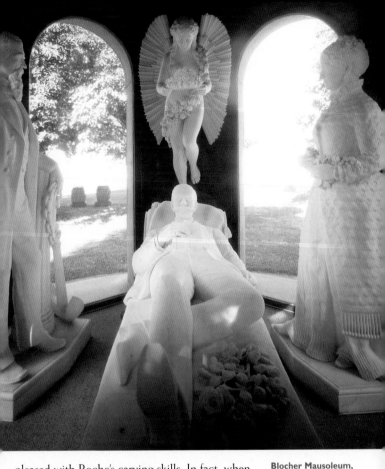

pleased with Roche's carving skills. In fact, when Roche unveiled the finished sculpture, Blocher took an axe to it and chopped it to pieces.

After sending Roche packing, Blocher contracted with Swiss-born Italian sculptor Frank Torrey, a noted artist, in Carrara, Italy. Torrey wasn't about to travel to Buffalo, so Blocher supplied the sculptor with photographs, models, and measurements of Nelson, Elizabeth, and himself. For close to three years, Torrey toiled away, chiseling and shaping the statues. They were finally completed in 1888 and shipped to Buffalo, where they were installed in the mausoleum.

The first resident of the mausoleum was Nelson, who had spent the years since his death in the cemetery's receiving vault. Following him were his mother, Elizabeth Neff Blocher, who died of pneumonia at age seventy-eight on March 31, 1904, and John Blocher, who died of "old age" on June 30, 1911, at the age of eighty-five.

But where exactly are the Blochers spending eternity? They are underneath a movable slab in the floor of the mausoleum. According to a

Buffalo newspaper report published when the mausoleum was being built, there are six crypts. This story led to a rumor that in the safe of the cemetery office there is a quit-claim deed stating that one of the other crypts is reserved for Margaret Katherine Sullivan—the maid. This story became fodder for romantic stories and often ran around Valentine's Day, suggesting that although the love-struck Nelson could not have Katherine in life there was still a possibility he might spend eternity with her.

Alas, Forest Lawn management tells us that there are only three crypts below the Blochers' marble likenesses. Poor Nelson is spending eternity just as he did in life—with his parents. The whereabouts of the maid are unknown.

Visionary

On the banks of the Columbia River in the State of Washington is a replica of Stonehenge, constructed by Sam Hill (as in the phrase, "What the Sam Hill are you doing?") The monument is a cenotaph, a memorial to people who are buried elsewhere, dedicated to the men from Klickitat County who died in World War I.

World War I Memorial, *Klickitat County, Washington*

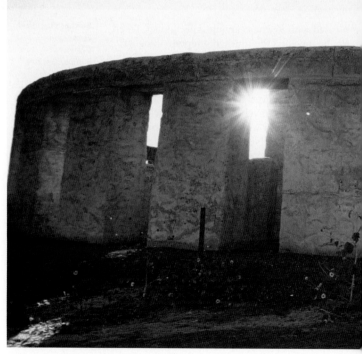

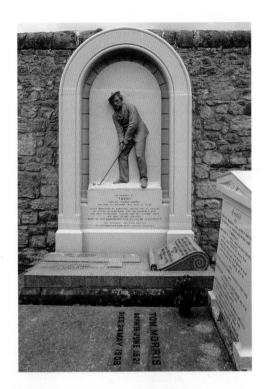

Golfer,
*St. Andrew's
Cemetery,
St Andrew's, Scotland*

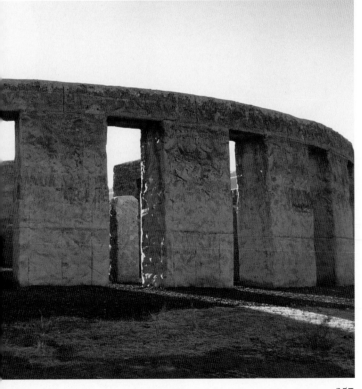

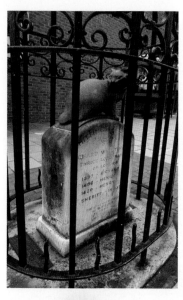

Left:
Cat,
Dick Whittington's,
*near Highgate
Cemetery,
London, England*

Facing:
Inventor,
*Père Lachaise
Cemetery,
Paris, France*

Below:
Pilot,
*Brompton Cemetery,
London, England*

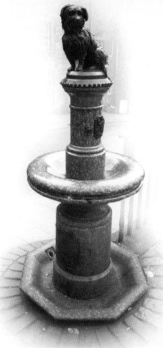

Dog,
Greyfriar's Bobby,
near Greyfriar's Churchyard,
Edinburgh, Scotland

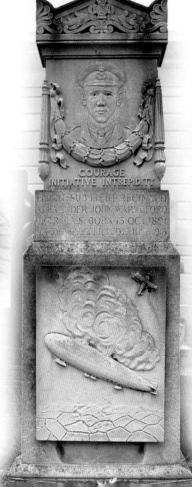

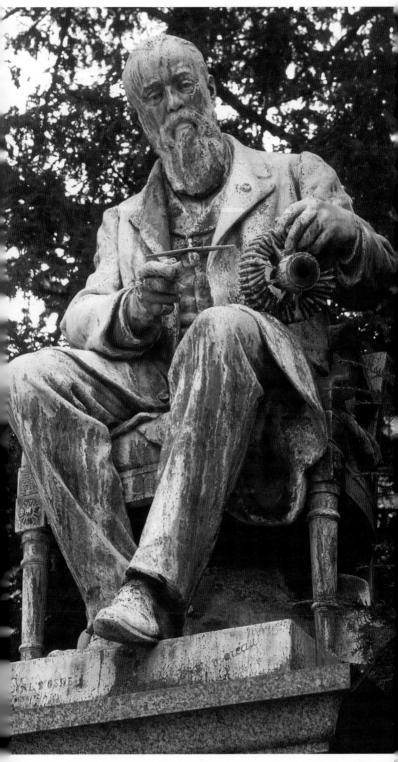

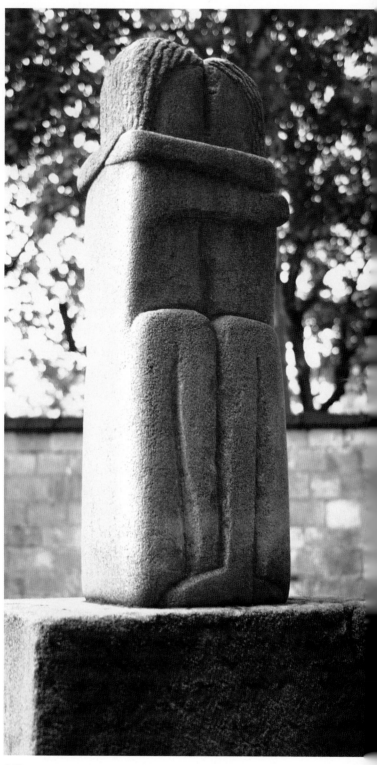

Facing:
Sculptor,
*Montparnasse
Cemetery,
Paris, France*

Right:
Lion Tamer,
*Highgate Cemetery,
London, England*

Below:
Political Thinker,
*Highgate Cemetery,
London, England*

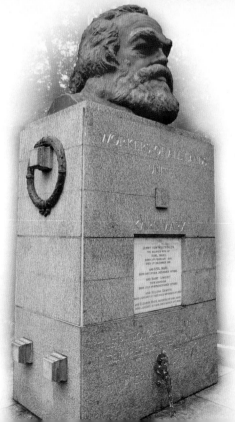

IN THE MEMORY
OF
GEORGE WOMBWELL
(MENAGERIST)
BORN 24TH DECR 1777
DIED 16TH NOVR 1850

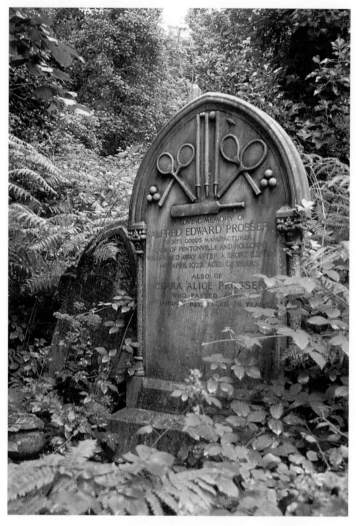

Sporting Goods
Manufacturer,
*Highgate Cemetery,
London, England*

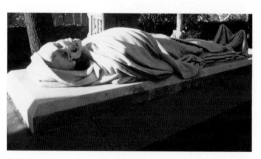

Left:
Anatomist,
*Cementiri del Sud-Est,
Barcelona, Spain*

Facing:
Politician,
*Glasgow Necropolis,
Glasgow, Scotland*

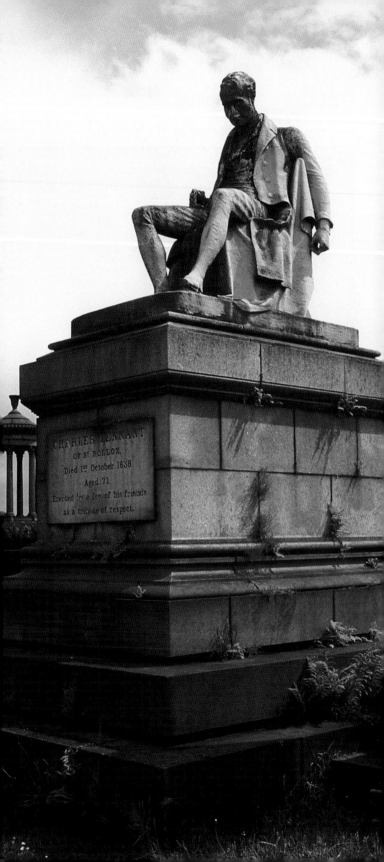

Gondola Maker,
San Michele
Cemetery,
Venice, Italy

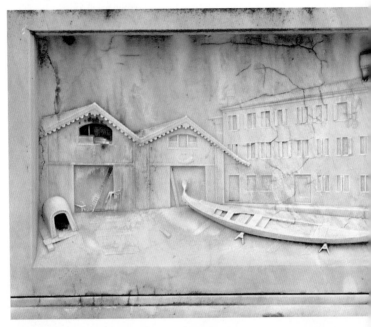

Inventor,
Montparnasse
Cemetery,
Paris, France

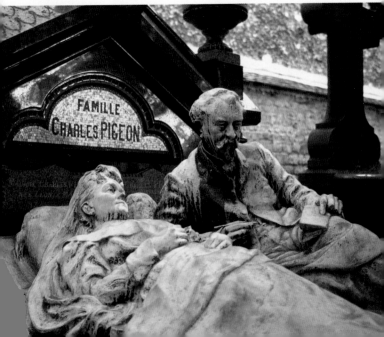

Soldier,
*San Michele Cemetery,
Venice, Italy*

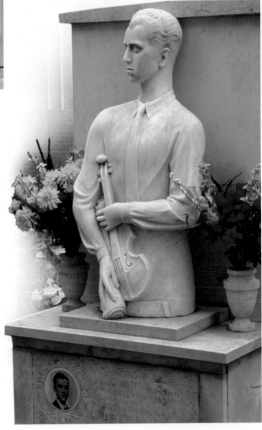

Violinist,
*San Michele
Cemetery,
Venice, Italy*

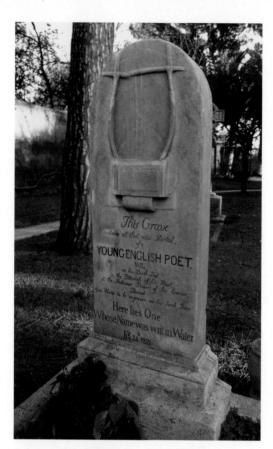

This Grave
contains all that was Mortal,
of a
YOUNG ENGLISH POET,
Who,
on his Death Bed,
in the Bitterness of his Heart,
at the Malicious Power of his Enemies,
Desired
these Words to be engraven on his Tomb Stone
Here lies One
Whose Name was writ in Water
Feb 24ᵗʰ 1821

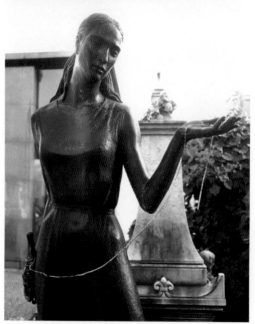

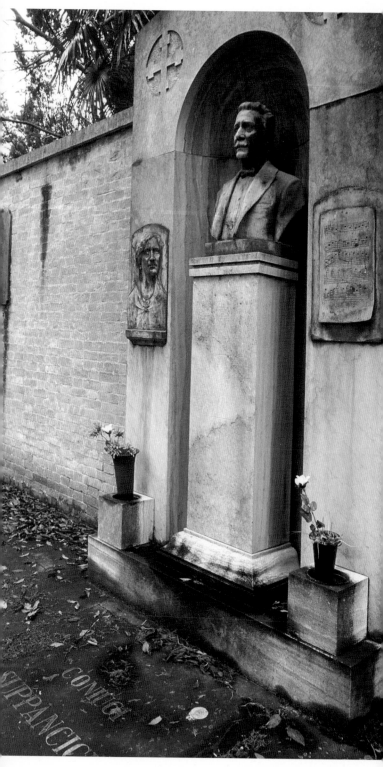

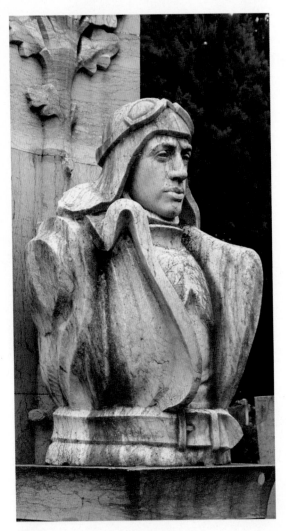

Pilot,
San Michele Cemetery,
Venice, Italy

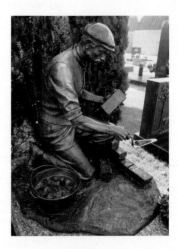

Mason,
Cimitero Monumentale,
Milan, Italy

Weaver,
Cimitero Monumentale,
Milan, Italy

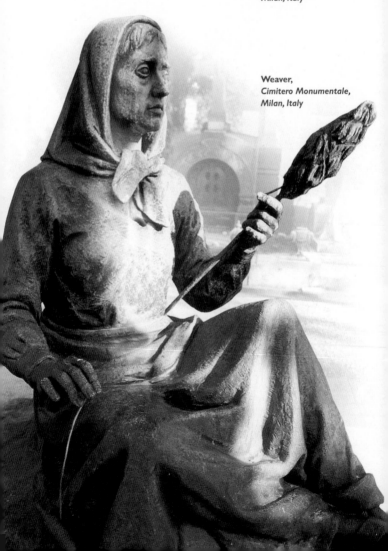

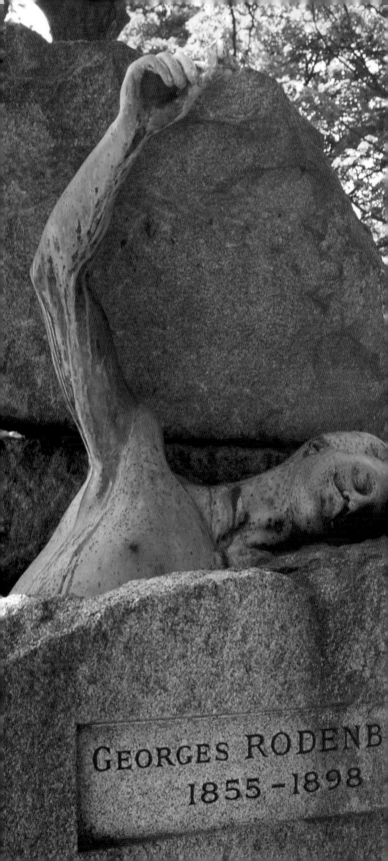

Left:
Sculptor,
*Père Lachaise
Cemetery,
Paris, France*

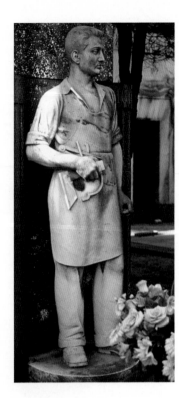

Right:
Mason,
*Cimitero
Monumentale,
Milan, Italy*

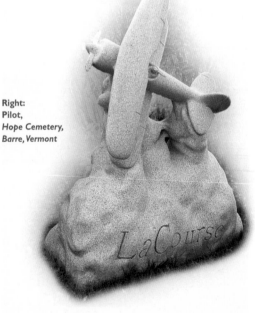

Right:
Pilot,
*Hope Cemetery,
Barre, Vermont*

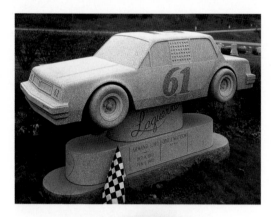

Facing:
Granite Carver,
*Hope Cemetery,
Barre, Vermont*

Driver,
*Hope Cemetery,
Barre, Vermont*

Baseball
Commissioner,
*Graceland Cemetery,
Chicago, Illinois*

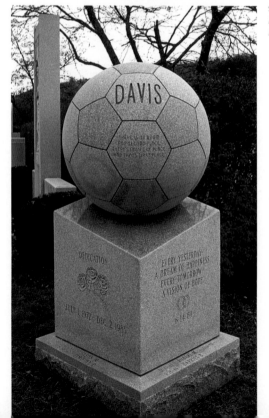

Soccer Player,
*Hope Cemetery,
Barre, Vermont*

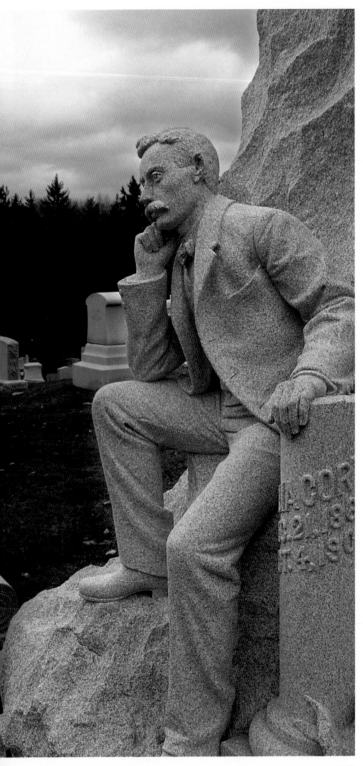

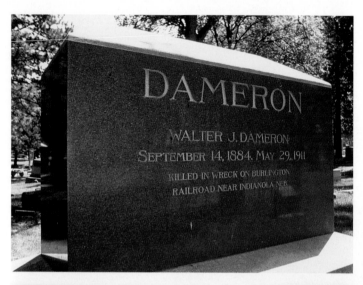

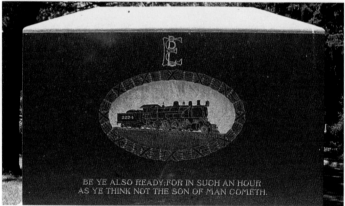

Above:
Engineer,
*Wyuka Cemetery,
Lincoln, Nebraska*

Facing:
Pioneer,
*Oak Hill Cemetery,
Red Bluff, California*

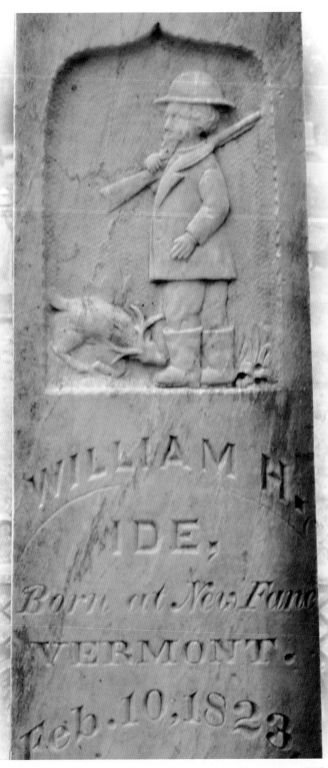

WILLIAM H.
IDE,

Born at New Fane

VERMONT.

Feb. 10, 1823

Rebel,
County Cemetery,
Whiskeytown, California

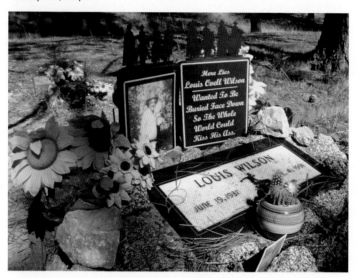

Couple,
Forest Lawn Cemetery,
Glendale, California

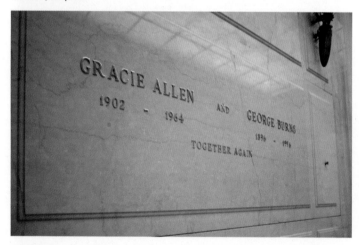

Facing:
Princess,
Oahu Cemetery,
Honolulu, Hawaii

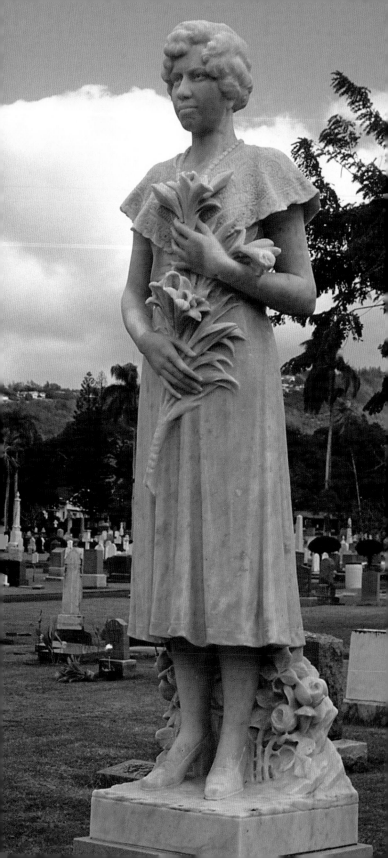

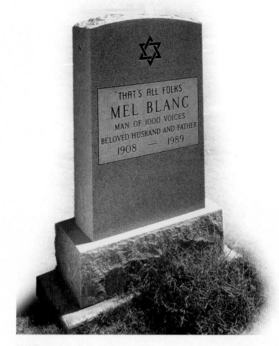

Mel Blanc,
Hollywood Forever Cemetery,
Hollywood, California

Mel Blanc, the man of a thousand voices, is best known as the voice of the characters of Looney Tunes cartoons, including Bugs Bunny, Daffy Duck, Yosemite Sam, Porky Pig, Elmer Fudd, and Sylvester the cat. All of the Looney Tunes cartoons end with the apt utterance on his tombstone, "That's All Folks."

SUGGESTED READING

Axelrod, Alan. *The International Encyclopedia of Secret Societies and Fraternal Orders.* New York: Facts On File, Inc., 1997.

Benson, George Willard. *The Cross: Its History and Symbolism.* Buffalo: Hacker Art Books, 1934, 1983.

Bliss, Harry. *A. Memorial Art Ancient and Modern.* Buffalo: Harry A. Bliss, 1912.

Carmack, Sharon DeBartolo. *Your Guide to Cemetery Research.* Cincinnati: Betterway Books, 2001.

Chevalier, Jean, et al. *The Penguin Dictionary of Symbols.* London: Penguin Books, 1982.

Colvin, Howard. *Architecture and the Afterlife.* New Haven and London: Yale University Press, 1991.

Davidson, Gustav. *A Dictionary of Angels.* New York: The Free Press, 1967.

Ferguson, George. *Signs and Symbols in Christian Art.* New York: Oxford University Press, 1954.

Keister, Douglas. *Going Out in Style: The Architecture of Eternity.* New York: Facts On File, Inc., 1997.

Memorial Symbolism, Epitaphs and Design Types. Olean, New York: American Monument Association, Inc., 1947.

Meyer, Richard, ed. *Cemeteries and Graveyards: Voices of American Culture.* Logan: Utah State University Press, 1989.

———. *Ethnicity and the American Cemetery.* Bowling Green, Ohio: Bowling Green State University Popular Press, 1993.

Ridlen, Susanne S. *Tree-stump Tombstones.* Kokomo, Indiana: Old Richardville Publications, 1999

Willsher, Betty. *Understanding Scottish Graveyards.* Edinburgh: Canongate Books Ltd, 1995.

ON THE WORLD WIDE WEB:
There are hundreds of Web sites that address various aspects of cemetery symbolism and religious beliefs. As a starting point, go to the Association for Gravestone Studies <www.gravestonestudies.org>, then click the links page for more information.

INDEX